Modern
Scottish
Writers

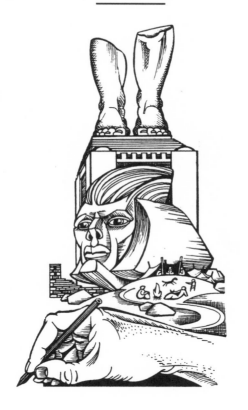

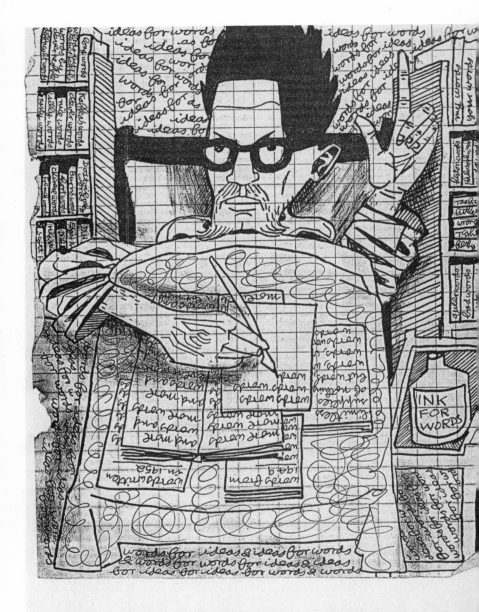

ALASDAIR GRAY, FROM LETTER TO ROBERT KITTS, AUGUST 1955

The Arts

of

Alasdair

Gray

edited by
Robert Crawford
and
Thom Nairn

Edinburgh University Press

© 1991 Edinburgh University Press

Edinburgh University Press
22 George Square, Edinburgh

Typeset in Linotron Garamond 3 by
Photoprint, Torquay
and printed in Great Britain by
the Redwood Press, Melksham, Wilts

British Library Cataloguing in
 Publication Data

The arts of Alasdair Gray. – (Modern Scottish
writers series)
 I. Crawford, Robert II. Nairn, Thom III. Series
 823

ISBN 0 7486 0294 1

The publisher acknowledges subsidy from the Scottish Arts Council towards
the publication of this volume.

Additional illustrative material kindly supplied by Alasdair Gray.

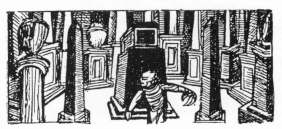

Contents

Acknowledgements

The editors would like to thank Alasdair Gray for his help in the making of this book, not least for his permission to use various copyright materials and to print for the first time the substantial summaries of his diaries in the National Library of Scotland, Edinburgh. All the materials by Alasdair Gray in this book are protected by copyright. Acknowledgement is also due to Alasdair Gray's various publishers, detailed fully on the 'Abbreviations' page of this book. In addition, the editors would like to acknowledge the permission of the Librarian, University of Glasgow, and of the Trustees of the National Library of Scotland, Edinburgh, for permission to reproduce material in their catalogues and collections. We are grateful also to Professor Martin Kemp of St Andrews University, Mr Arthur E. Meikle (formerly of Whitehill School), and Mr Hamish Whyte of the Mitchell Library, Glasgow, for help and advice. Thanks are due to George Oliver, Cordelia Oliver, and the Photographic Unit, University of St Andrews, for supplying and reproducing the illustrations. Finally, no small debt is due to Dr Alice Crawford and Mrs Patricia J. Nairn who put up with the editors while they were at work on this book.

While we were completing the editing of *The Arts of Alasdair Gray*, Martin Spencer, who had commissioned it for Edinburgh University Press, died suddenly. We would like to record our gratitude to him for his enthusiasm, encouragement, and advice. His death is a cruel loss; this book is one of his many memorials.

R.C., St Andrews
T.N., Edinburgh

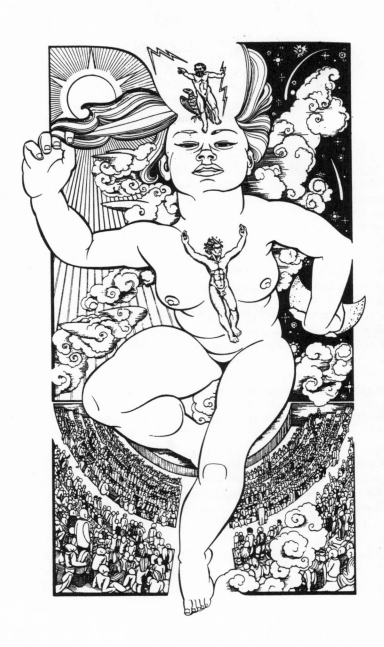

Abbreviations

The following abbreviations of works by Alasdair Gray have been used throughout this book. Some further abbreviations used only in Bruce Charlton's final chapter are detailed at the beginning of that piece.

FSA *Five Scottish Artists* (Gartocharn: Famedram Publishers, 1986)

FKW *The Fall of Kelvin Walker, A Fable of the Sixties* (Edinburgh: Canongate, 1985)

J *1982 Janine* (London: Jonathan Cape, 1984)

L *Lanark, A Life in Four Books* (Edinburgh: Canongate, 1981)

LT *Lean Tales* (with James Kelman and Agnes Owens) (London: Jonathan Cape, 1985)

ML *McGrotty and Ludmilla* (Glasgow: Dog & Bone, 1990)

ON *Old Negatives, Four Verse Sequences* (London: Jonathan Cape, 1989)

SL *Something Leather* (London: Jonathan Cape, 1990)

SSP *Saltire Self-Portraits 4: Alasdair Gray* (Edinburgh: Saltire Society, 1988)

US *Unlikely Stories, Mostly* (Edinburgh: Canongate, 1983)

The Swot [or beastly swot] with his mortal foe,
the common pupil.

Introduction

Robert Crawford

Arthur E. Meikle, who was one of Alasdair Gray's English teachers at Whitehill Senior Secondary School, Glasgow, and who appears under his own name in *Lanark*, recalls a lecture given by Gray in the fourth year of secondary school. Taking as his starting point the fact that the Water Board had dug a large hole at Eglinton Toll, Gray told his classmates that experts from Glasgow University had visited the hole and had discovered in it various strange creatures. Gray then elaborated on these and drew them on the blackboard. The last creature had a globular body. Arthur Meikle remembers that 'Alasdair threw up an amorphous outline on the board, surveyed it for a moment, and then said, "This must be one of Nature's few mistakes. It had no alimentary system, so it could not eat. It had no means of locomotion, so it could not avoid predators. So of course", wiping it off the board, "it is extinct." '[1]

As Bruce Charlton's contributions and several of the other chapters in this book indicate, the beginnings of Alasdair Gray's career as a writer lie in his childhood. In its outline, his schoolboy lecture, delivered in the summer of 1951, resembles several of his later fictions. It moves confidently from the author's own experience of a familiar, actual location into a world of fantasy; it allows Gray to combine several of his various arts — as narrator, visual artist, and creator of performance pieces. It lets him parody academia, and it ends with a flourish, a formal joke which anticipates the farewell gesture of erasure which ends all Gray's major fictions: 'GOODBYE'.

Though Gray had had a prose version of an Aesop's fable (again reflecting an interest in animal fantasy) broadcast on a BBC radio children's hour along with some of his poems, what appears to be one of

his first printed pieces is a story which appeared in the *Whitehill School Magazine* for Christmas 1948 when he was a second-year pupil. Once more the striking thing about it is the way its blend of reality and fantasy anticipates Gray's later writings. Anchored firmly in the world of meat rationing, yet at the same time bizarrely improbable, 'After the Game' is worth quoting in full to demonstrate how close the young Gray was to the adult writer of *Tickly Mince* and those *Unlikely Stories, Mostly*, several of which are not without an element of schoolboy humour.

The Strong Pupil hurried home in a state of high glee from his first rugby match. 'Mum,' he cried, as he charged into the house, 'just look what I've got!' and he rolled an object on to the hall table.

'Peter!' cried his mother. 'Your first head! How did you get it?'

'Well,' said Peter, 'it was in the scrum. The ball had been put in, and we were just heeling it out, when the whole thing cracked up, and the front line were lying at our feet.'

'And then?' inquired his mother.

'We kicked their heads off, of course,' Peter replied. 'I got two heads really, but later some silly ass stood on one, and it was smashed.'

'Good for you,' said mother. 'And now, dear, would you mind taking the head up to Grandpa? He'll stuff it for you, and then we can hang it up in the hall. And remember to bring back the brains, will you? They'll help out the meat ration,' she called after him as he left.

This early, comically violent fantasy parodies social pretensions of the sort represented by hanging up trophies in the hall. Its daft, yet prosaically practical cannibalism also reminds us of the repeated dictum in *Lanark* that 'Man is the pie that bakes and eats himself' (*L*, 101).

It is not 'After the Game', however, but another early story which is recalled in the Mr Meikle episode in *Lanark*, a novel whose remote origins go back to this period of Gray's schoolboy writing. In *Lanark* Mr Meikle, 'Head English teacher', encourages Duncan Thaw to write a story for the school magazine, only to reject it as 'a blend of realism and fantasy which even an adult would have found difficult' (*L*, 155). In fact, Arthur Meikle, who was an assistant English teacher in charge of the school magazine, did not reject Alasdair Gray's story but advised some cuts and an amount of bowdlerisation. It is emblematic of Gray's imagination that in *Lanark* these facts are reworked to emphasise the controlling nature of authority at the same time as paying tribute to Mr Meikle's nurturing of the young writer. Gray's story appeared as 'The

Wise Mouse' in the *Whitehill School Magazine* for Summer 1949. It describes how an enormous monster who has defeated human might is beaten by a mouse who goes to Honolulu, tricks his way into the creature's mouth, then proceeds down its trachea into a lung, and thence to the heart where the mouse lets off a hand-grenade before exiting through the monster's nostril. In the original, unpublished version, Arthur Meikle recalls that

> we were given a much fuller account of the mouse's adventures inside the monster, and his final exit was made through an inferior orifice. I had a man-to-man talk with this Second Year Smout and we agreed that the details were reasonable but unsuitable for a school magazine.[2]

This small but significant incident was probably one of Gray's earliest direct experiences of a form of censorship, of being trapped within the conventions of a particular system – the theme of his finest short story, 'Five Letters from an Eastern Empire', the author's personal favourite among his short fictions. But 'The Wise Mouse' is at least as notable for its fascination with being literally trapped inside an engulfing monster from which one must try to escape. Later, Lanark will be physically swallowed by a giant mouth and so eventually enter the entrapping, labyrinthine Institute from which he will at last exit through an 'inferior orifice'. Lanark has to confront the view that the universe is 'a stinking trap' (*L*, 82), and he is continually in combat with monstrous systems which try to engulf him. Dragonhide threatens to encase his own body, trapping him in his own self, while on the macroscopic scale the Institute, Glasgow, and Unthank are also traps from which in various ways he seeks to escape through physical flight or erotic love, art or fantasy. That Gray's developing imagination was obsessed with monstrous traps is confirmed by the subject of one of his earliest mature works, the remarkably accomplished depiction of 'Theseus and the Minotaur' published in the *Whitehill School Magazine* for Summer 1952 and reproduced in the present book.

In Gray's forceful depiction, the straining figure of Theseus is stabbing the massive, hirsute man-monster at the same time as being encircled by it. The Minotaur's huge, entrapping arm and claw and the bestial legs on either side of Theseus surround the hero, as if the monster itself is part of the labyrinth behind it. In that labyrinth Ariadne stands wearing a skirt whose concentric bands echo the circle of the wall around her. Even Theseus' ship, seen in the distance at the top of the picture, is surrounded by seven or eight concentric rings of water, as if even the means of escape is caught at the centre of a maze. Gray has

described himself rightly as an 'obsessive artist'.[3] This is a picture which powerfully communicates one of his principal continuing obsessions: the struggle against entrapment.

Bohu, writer-hero of 'Five Letters from an Eastern Empire', also arrives by boat at his labyrinth, the crammed chessboard city whose layout is illustrated on page 97 of *Unlikely Stories, Mostly*. Like Gray at school and like Duncan Thaw in *Lanark*, the young Bohu is educated to write within the acceptable structures of authority. But his nurturing is much more extreme and sophisticated as it takes place within the rigid, Kafka-esque design of the Eastern Empire's physical and intellectual architecture whose structure is so labyrinthine that it can turn release into entrapment. *'The emperor grants Bohu permission to do anything he likes, write anything he likes, and die however, wherever, and whenever he chooses'* (*US*, 121), and Bohu achieves what Gray has called elsewhere 'orgiastic release' before attempting a means of escape by 'separating himself from this ruling clique through death' and accomplishing a method of written release which will also let him 'separate himself through language, through the poem'.[4] Yet this release is turned easily by Gigadib into utter bondage to the authority Bohu has sought to defy. Gigadib is not the 'Head English teacher' who suppresses a text as unsuitable; rather, he is the *'Headmaster of modern and classical literature'* (*US*, 133) who subtly alters the text to purify it of dissident meaning. In one way, then, Gigadib's action can be viewed as a grotesque transformation and elaboration of the act of the Arthur Meikle who persuaded the schoolboy Gray to agree to change his story so as to bring it into line with what was expected of a school magazine. The comparison is complicated and ironised when we realise that Gigadib has been responsible for the nurturing of Bohu as a writer as well as for censoring his work. Similarly, Arthur Meikle should be seen not only as authorising a subtle but strong censorship over Gray's schoolboy prose, but also as a powerful early encourager of his writing towards whom Gray feels gratitude as one of those 'schoolteachers [who] deliberately encouraged my imagination' (*SSP*, 14). When Gray left school, Arthur Meikle recalls saying to his pupil that he hoped the boy would one day write a book and illustrate it with some of his own pictures. After he had gone to Art School, Gray returned to show Mr Meikle some of his artwork, insisting that it should not be shown to ladies. As a teacher, Arthur Meikle himself displayed an interest in how far an artist should be allowed to transgress the moral structure of his time. His pupil Alasdair Gray continued to nudge at the boundaries of censorship, while acutely acknowledging the bondage of propriety.

For Gray's imagination the theme of a contest against physical and

intellectual entrapment has remained central. In *1982 Janine* Jock McLeish is at the same time a supervisor of security installations and a man constantly compelled to escape from reality through his own fantasies which not only involve bondage but also become for him a form of entrapment. Again, with horrible ease, escape seems to become another kind of imprisonment. Paralleling Jock's sexual fantasies are his musings on Scottish politics: Scotland too seems in bondage, but no escape is envisaged which would not be another form of enthralment.

If the sexual aspect of *1982 Janine* is the most striking, this is scarcely a departure in Gray's work. *Lanark* had Duncan Thaw writing in his diary about '*June Haig, no, not real June Haig, an imaginary June Haig in a world without sympathy or conscience*' (*L*, 190), while Lanark argues about *No Orchids for Miss Blandish* as 'a male sex fantasy' and denies 'that life is more of a trap for women than men' (*L*, 83). Both *1982 Janine* and *Something Leather* return to such an issue. If the June of the latter novel escapes from entrapment in the lonely routines of her Civil Service department, then it is typical of Gray's imagination that her escape is into literal bondage. Sections of *Something Leather* may represent a pornography which, as S.J. Boyd argues in the present volume, readers must question and condemn. Yet these sections are once more, in part at least, characteristic manifestations of Gray's imagination which, as in 'Five Letters from an Eastern Empire', is fascinated by the artist's pushing against the limits of what is tolerable within a particular system — whether of politics, morality, or literary genre. At the same time as publishing a novel which may be seen as outrageous, Gray in *Something Leather* shows how much his book is caught within the conventions of contemporary publishing and the system which requires him to produce saleable fictions in order to earn his living. As 'Five Letters from an Eastern Empire' demonstrates, the line between the outrageously unsuitable and the eminently acceptable is a hair-fine one, a matter of the finest tuning. It is this line which Gray loves to investigate. When interviewers attempt to domesticate *1982 Janine* as an acceptable feminist tract or an 'exposé of corrupted male sexuality', Gray reacts by straightforwardly nudging his text in the direction of the unacceptably pornographic — 'I quite enjoyed writing the sadistic nasty bits'.[5] Apparently he wishes to stress that if part of his writerly identity is Theseus, then equally part of it is the Minotaur.

Gray's labyrinths continue in *The Fall of Kelvin Walker* as media labyrinths where again, as in the 'Five Letters' and elsewhere, he is preoccupied with the way events and texts are presented, represented and interpreted. In *McGrotty and Ludmilla* the institutional labyrinth not of the Institute but of Westminster is to the fore, with the

variously-interpreted text of the Harbinger Report being manipulated by those who seek to 'weave a fine web', catching 'human flies within' (*ML*, 16). The Minotaur in this book is replaced by a spider, the labyrinth by a web.

'The Ministry of Social Stability', which Gray introduces as 'created at the end of the nineteenth century to counteract the damage done by the spread of literacy and the granting of the vote to all male householders' (*ML*, 11), has not just a Kafka-esque but a Dickensian quality. It is reminiscent of Dickens's Chancery in *Bleak House* or the Circumlocution Office in *Little Dorrit*. These connections make good sense, given Gray's immense admiration for Dickens, an author much obsessed (as Philip Hobsbaum, one of Gray's mentors, has stressed) with the labyrinthine entrapments of the Victorian prison.[6] But Gray's links with Dickens's often grotesque world also serve as a necessary reminder to academic critics that, like Dickens, Gray is a splendid comic writer, and that his labyrinths with their social invisibility, talking lifts, and brilliantly-caught accents are not the least part of his comedy.

Among Gray's most memorably comic scenes is the meeting between Lanark and his author when 'A Damned Conjuror Starts Lecturing' in the Epilogue to Gray's largest novel (*L*, 484). Significantly, with the labyrinthine book scattered round him, the author seems himself 'confused' (*L*, 498), caught within the expanding web of his own fiction which he cannot entirely control or map. As the text itself splits in two, shooting off in innumerable directions through both the 'Index of Plagiarisms' (*L*, 485–99) and the long catalogue of epic books, *Lanark* is revealed as clearly caught in a centreless, postmodern web of intertextuality with which its author aims to fuel critics, to entertain readers, and to demonstrate the condition of authorship. It becomes unclear whether author or protagonist can find a way out of the novel – a predicament no doubt mirroring Gray's own years of struggle to bring the book to conclusion. Eventually, it seems that the protagonist both is and is not a successful escapee, a triumphant searcher for freedom. The final escape of author and character (for it is not obvious whose are the novel's very last lines) records both an incarceration and a movement of release:

> THE LAND LIES OVER ME NOW.
> I CANNOT MOVE. IT IS TIME TO GO.
>
> GOODBYE

Here Gray exits from, yet also inters himself within, his labyrinthine and quasi-autobiographical novel. Such an escape which is also from another perspective an act of enclosure is typical of his imagination as a whole.

It is also very typical of the postmodern imagination, whether of Borges's *Labyrinths* or of *The Prison House of Language*, an imagination preoccupied with systems from which life seems unable to escape. So it is fitting that in the present book Randall Stevenson should discuss Gray in the context of international postmodernism. Still, Gray's immediate labyrinth is also a very specific one: Glasgow. One of the tributes to his power as a writer comes when we realise that, as is mentioned in the present book, Thaw's statement that 'nobody imagines living here' (*L*, 243) is no longer true. *Lanark* is one of the major works which have turned Glasgow into a locus of the imagination. In turn, Glasgow has fuelled Gray's own imagination from his earliest years, which is why Edwin Morgan writes here about the novelist's relations with the city. Between Gray and Morgan, both Glaswegian writers and writers of science fiction, there are various links, yet neither author is circumscribed by being called a 'Glasgow writer'.

Gray's writing is widely indebted to Scottish tradition. In literature, his love of plain style may owe something to the novels of Galt and Stevenson; his genre-busting, footnote-crammed texts have an antecedent (as he has pointed out[7]) in the Carlyle of *Sartor Resartus*; his love of doubling, whether in Lanark/Thaw, in 'The Spread of Ian Nichol', or in Monboddo's 'bilocation' (*L*, 549) surely owes something to that love of doubles examined by such Scottish critics as Karl Miller and John Herdman, which is so strong in the Scottish tradition of Hogg and Stevenson.[8] The very names of Gray's characters — Monboddo, Lanark, Kelvin, and innumerable others — help anchor his work in a Scottish cultural and political milieu considered here by Christopher Harvie and by other contributors. This book aims to provide some useful Scottish as well as international contexts for the appreciation of Gray's work, and to make widely available information and materials which can contribute to the reader's enjoyment of it. A great deal of new light is likely to be shed on Gray's output by the publication here of his own summaries of his diaries in the National Library of Scotland, and other biographical materials, transcribed by Bruce Charlton. Access to much of this material is restricted, but Bruce Charlton's material provides an invaluable guide to the way Gray's own biography has been incorporated into his various works. Throughout this book emphasis is placed both on the protean nature of Gray's talents and on continuities which may be seen throughout his arts.

With his 'Index of Plagiarisms' and his 'Critic-Fuel' (*SL*, 232), his fascination with the interpretation and distortion of texts, Gray both beckons towards and mocks commentators on his work. If his fourth-year lecture to his Whitehill classmates at once relished and sent up an

academic format, then the mature author admits to enjoying producing 'a parody of academicism' at the same time as he confesses 'I do quite enjoy a lot of academicism'.[9] The chapters which follow in this book combine memoir material and new research with various critical approaches, including examination of some works which seem to have influenced Gray according to traditional academic notions of what he terms 'Influenza'.[10] Even an author as concerned as Gray about the way texts may be manipulated and even turned against their authors cannot choose what is written about him. He might disagree (rightly or wrongly) with much of this book and, because, as the first book to afford comprehensive coverage of his work, *The Arts of Alasdair Gray* is a ground-breaking study, it is likely that other more detailed, sophisticated, and extensive studies will appear.[11] What is to be hoped is that this volume will furnish a useful critical and elucidatory introduction to the various arts of this resourceful artist and writer whose accuracy of mimicry and panoptic sweep have developed breathtakingly from the embryonic productions of the Whitehill schoolboy who drew 'Theseus and the Minotaur' and who, encouraged by Arthur Meikle and others, went on to slip past the several Headmasters of literature.

NOTES

1. Arthur E. Meikle gave an account of this lecture to the present writer in a conversation in St Andrews, 10 July 1990, and in a letter of 26 October 1990. I am very grateful to Mr Meikle for pointing out the following pieces by Alasdair Gray in issues of the *Whitehill School Magazine*:

 'A Ghost Comes to Whitehill' (story, signed 'A.J.G. I1.'), Summer 1948, pp.20–1.
 'After the Game' (story, signed 'A.G., II.1.'), Christmas 1948, p.33.
 'The Wise Mouse' (story, signed 'YARG. II 1.'), Summer 1949, pp.10–11.
 'The Gymnasium (A Serious Poem)' (signed 'A.J.G. IV.1.'), Christmas 1950, p.21.
 'It's all very well for you' (cartoon, signed 'AJG'), Christmas 1950, p.27.
 'Drama in Everyday Life' (verse dialogue, signed 'A.J.G. IV. 1'), Christmas 1950, p.45.
 'Don't be selfish, Geraldine' (cartoon, signed 'AJG'), Summer 1951, p.15.
 'Nature Notes' (cartoons, signed 'A.J.G., IV 1.'), Summer 1951, p.27.
 'What's Eatin' You, Hamlet?' (parody play, signed 'A.J.G., V 1.'), Summer 1952, pp.20–2.

'Theseus and the Minotaur' (illustration, signed 'Alasdair Gray'), Summer 1952, opposite p.26.

'Ether' (story, signed 'A.J.G., V 1.'), Summer 1952, pp.34–5.

'And now, Mrs. Claveridge, I'm going to delve deep down into your subconscious' (cartoon, signed 'AJG'), Summer 1952, p.43.

'The Student Christian Movement' (report, signed 'A.J.G.'), Summer 1952, p.47.

At Whitehill School Gray won several prizes for English, was on the committee of the *Magazine* from his fourth year, spoke against Communism in a Literary and Debating Society debate in 1950 (*Magazine*, Christmas 1950, p.25), and was thanked by the *Magazine*'s editors for his 'excellent drawings' (Christmas 1950, p.5). 'A.D.H.' records in the Summer 1952 *Magazine* (p.26) that 'A lecture of special interest was that delivered by Mr Alasdair Gray of the Fifth, who gave "A Personal View of History" '. For more on Gray at Whitehill, see under 'Accession 9417, Box 3' in the third part of Bruce Charlton's 'Checklists and Unpublished Materials by Alasdair Gray' in the present book.

2. Arthur E. Meikle, letter to the present writer, 26 June 1990.

3. 'Alasdair Gray Talking with Elizabeth C. Donaldson', *Verse*, 1 October 1984, p.30; a fuller, unedited typescript of this interview is in the *Verse* archive, Department of English, University of St Andrews.

4. *Ibid.*, p.33.

5. Alasdair Gray, 'An Interview with Sean Figgis and Andrew McAllister, 6th February, 1988', *Bête Noire*, 5, Spring 1988, p.19.

6. *Ibid.*, p.27; see Philip Hobsbaum, *A Reader's Guide to Charles Dickens* (London: Thames & Hudson, 1972), pp.13–14.

7. Gray, interview cited in note 5 above, p.22.

8. Karl Miller, *Doubles: Studies in Literary History* (Oxford: Oxford University Press, 1985); John Herdman, *The Double in Nineteenth-Century Fiction* (Basingstoke: Macmillan, 1990).

9. Gray, interview cited in note 5 above, p.21.

10. *Ibid.*

11. The first of these, Beat Witschi's *Glasgow Urban Writing and Postmodernism: A Study of Alasdair Gray's Fiction* is due to be published by Peter Lang in the same year as the present volume.

" Don't be selfish, Geraldine! "

One

The Story So Far

Bruce Charlton

Alasdair James Gray was born on 28 December 1934 in the family home at 11 Findhorn Street, Riddrie, Glasgow.[1] At the start of a short self-portrait written for the Saltire Society he gives this concise list of the people who made him, to which I have added some dates:

> Early last century a Scottish shepherd whose first name is now unknown fathered William Gray, a shoemaker who fathered Alexander Gray, a blacksmith in Bridgeton, east Glasgow, a district then brisk with foundries, potteries and weaving sheds. And Alexander married Jeanie Stevenson [1896], powerloom weaver and daughter of a coalminer, who became his housewife and bore another Alexander [1897], who became clerk on a weighbridge on a Glasgow dock, then a private in the Black Watch regiment in France [First World War], then a quartermaster sergeant there, then worked a machine which cut cardboard boxes in a Bridgeton factory until another world war began. While some of this was happening Hannah, wife of a Northampton hairdresser called William Fleming bore Henry Fleming who became a foreman in a boot-making factory, and married Emma Minnie Needham [1898]. Henry, nicknamed Harry, also became a trade-unionist, and his bosses put his name on a list of men not to be employed in English factories. He and Minnie came to Glasgow where she bore Amy Fleming [1902] who first became a shop assistant in a clothing warehouse, then married Alex Gray [1931] the folding box maker, thus becoming a housewife. She and Alex lived in Riddrie, a Glasgow corporation housing scheme where she bore Alasdair James Gray [1934] who became a maker of imagined objects, and Mora Jean Gray [1937] who became a physical exercise and dance teacher . . . (SSP, 4)

Gray's parents belonged, then, to the skilled and semi-skilled working class, living in 'a good dull place', as he has called Riddrie, with his father and neighbours in regular employment.[2] His father was a socialist member of the Left Wing book club, read the *Daily Worker* and *New Statesman*, and owned the complete plays of Shaw and Ibsen; his mother sang in the Glasgow Orpheus Choir (which had a national reputation) and his sister played the piano. The family regularly attended plays at the Citizens' Theatre, and the visiting D'Oyly Carte Opera Company.

From 1918 to 1939 Alexander Gray worked as a factory operative, but his hobbies were hillwalking and helping to set up and run hostels for the Holiday Fellowship, Camping Club of Great Britain, and Scottish Youth Hostels Association. As a result, during the Second World War he first assisted setting up a hostel for munitions workers in Reading; then in 1941 became manager of a hostel for one thousand munitions workers in Wetherby, Yorkshire — where he was joined by his wife and children. Amy Gray and the two children had first been evacuated to a farm in Perthshire, then moved to Stonehouse, a Lanarkshire mining town (memories of the farm were later used in the oracle's 'Prologue' in *Lanark* (L, 108–17), those of Stonehouse as the setting for Jock McLeish's childhood in *1982 Janine*, and the hostel and school at Wetherby were relocated to an imaginary West of Scotland island for the chapter of *Lanark* entitled 'A Hostel' (L, 130–5)).

Alasdair's parents gave him strong encouragement in his studies in hope that he would ultimately train for a secure profession. He seems to have been a precocious child — at 11 years old he won a BBC competition and read some of his own verses and an adaptation of an *Aesop's Fable* on Scottish radio children's hour. On the negative side, during childhood and throughout his life he was plagued by asthma and sometimes eczema. The asthma attacks started after the evacuation from Glasgow with his mother and sister in 1939, disappeared when the family were reunited in Wetherby, but resumed when they returned to Riddrie after the war. Gray attributes the latter relapse to the feeling of insecurity when his father failed to get a professional middle-class job like his previous one, and had to work first as a labourer on a building site, then as a wages clerk. There was a noticeable decline in the family living standards, and Gray's mother was later forced to take jobs, firstly as a shop assistant, then as a clerk at Collins publishers. The asthma made him bad at vigorous sports and exaggerated a tendency to regard himself as an outsider. He was, however, not a recluse — singing in the Church of England choir at Wetherby and the school choir at Whitehill, where he was an active member of the Literary and Debating Society. These intellectual pursuits, together with his bespectacled appearance, often resulted in the nickname of 'Professor'.

At all Gray's local primary schools his teachers encouraged his love of writing and drawing, but at Whitehill Secondary he was in conflict with both teachers and parents who wanted him to get a firm grounding in Latin and mathematics for the university entrance requirements. As a result of his father's difficulty in getting suitable work, Gray was beginning to turn against the notion of money-getting, and to devote himself to imaginary worlds. As a result, half the later schooling bored him, the other half stimulated. He read voraciously, at first comics and adventures and later mainly adult fantasy and allegory.[3] Gray began writing at an early age using similar material, and from the beginning sought to make it public. At Wetherby primary school he wrote and directed a six minute play from an episode in the *Odyssey*, acting the part of Polyphemus. In the first year at secondary school he edited and illustrated a class magazine, and in his early teens had drawings, verses and fantasy stories in *Whitehill School Magazine*. From the age of fourteen onwards he had several stories published in *Collins Magazine for Boys and Girls*, including 'The Star', which was later used in *Unlikely Stories, Mostly (US* 1–3).

Despite this early start, Gray was not to see his first novel published until 1981 at the age of forty-five. These 'years of struggle' were not without their literary successes – plays broadcast and performed, fiction published in magazines, a stint as a writer in residence at Glasgow University – but nevertheless, this period was financially tough and recognition came slowly. It is possible to regard the interval between the commencement and completion of *Lanark* as Gray's 'first period' – a time lasting roughly from 1952 to 1976.

On the eve of his eighteenth birthday, while a first-year student at the Glasgow School of Art, Gray wrote:

> Tomorrow is my 18th birthday . . . there are so many useful ideas to be caught before memory loses them . . . just now I have pictures, and good ones, and a novel which may thrive, and a few small poems, and an epic (in intention) – these seem at last to be coming off.[4]

Lanark was descended from a combination of the above-mentioned novel and the epic. Even before leaving school, Gray reports telling a girl he admired that he wanted to write '[a] book about ordinary life, the life about us, but with a difference, bringing in an element of strangeness, of unreality. Not science fiction, you understand – I suppose you might call it escapist fiction.'[5] This would make a valid description of *Lanark*.

Lanark's most remote ancestor is the improbably titled *Obby Pobbly* from 1951, featuring as its semi-autobiographical protagonist 'a potato-headed intellectual schoolboy . . . [who would] go on a

pilgrimage which would lead him out of the everyday drabness of post-war respectable working class Glasgow, through a fantasy pilgrimage, ending in an era of untrammelled artistic production . . .'6 This progress from 'the drably commonplace to realms of wonder' is the common thread which ties together all subsequent conceptions of the novel. From this point onwards, Gray worked at a series of books which combined or juxtaposed a realist semi-autobiography with an epic allegorical fantasy in ways which culminated in the solution achieved by *Lanark*.

Verse was always a part of the early work, often arising from, and marginal to, diary entries in which he was self-consciously amassing material for his epic. Drawings and doodles were interwoven with the written word in the notebooks, along with designs for books, ironical cartoons illustrating the day's events and sketches for works suggested by teachers at Whitehill Secondary and the School of Art.

The big novel continued to develop throughout Gray's time at Art School, always named after its protagonist who mutated from Obby Pobbly to Edward Southeran, Gowan Cumbernauld, then becoming Ian, Hector, Gowan and finally Duncan Thaw. After reading E.M.W. Tillyard's *The English Epic and its Background*, Gray had the idea of blending genres normally kept apart, in this case the story of an artist growing up in Glasgow (i.e., Books 1 and 2 of *Lanark*, which were already well advanced in conception by 1953) with a 'Kafkaesque adventurebook of politics in an underworld' which was the other sort of book he was plotting to write.7

When Gray obtained his Art School diploma in 1957 he went abroad on a Bellahouston Travelling Scholarship intending to visit Spain, see galleries, and paint. Readers of *Lean Tales* will know what actually happened. A combination of severe asthma and having his money stolen resulted in the trip being more or less abandoned after reaching Gibraltar, where he spent some time in hospital writing a few more chapters of *Lanark*. The ironical 'report' which he submitted to the Trustees of the Bellahouston Fund sometime after his return to Glasgow in March 1958 (shortened and edited for *Lean Tales*) was a hand-bound production, with a fantastically illustrated cover, photographs, and characteristically witty text. Unfortunately the Trustees were unappreciative and the travelling scholarship scheme was subsequently wound up.

On returning to Glasgow, Gray now wanted to live as a full-time artist, making money by painting murals and writing books. During his last two years at Art School he had painted a big mural at the Scottish–USSR Friendship Society. In 1958 he began another at Greenhead Church. His only payment was in materials, but he hoped the murals would establish his reputation and lead to other work. A

drawing of the marriage feast at Cana was to be exhibited at the Royal Scottish Academy show of 1958, so things looked promising. But the plan to live by artistic work did not thrive. After supporting himself by part-time unqualified art teaching in Lanarkshire, he attended Jordanhill teacher training college from 1959 to 1960, then taught for a year in Glasgow, while exhibiting paintings and trying to continue writing.

In the summer holiday of 1961, he was involved in a nightclub (*Festival Late*) on the fringe of the Edinburgh International Festival where he decorated the walls, wrote revue sketches for the cabaret, acted and sang. This changed his life: he met a Danish student nurse called Inge Sørensen and married her six weeks later. Furthermore, the success of the cabaret acts raised hopes of making a career in the theatre, and he was promised some artistic commissions. The result was that Gray did not return to school at the end of the summer holiday, but sent his resignation.

Alasdair and Inge returned to stay with his father in Riddrie, Glasgow, but the cabaret work and commissions did not materialise, and the young couple needed a place of their own. They moved to a flat at 158 Hill Street between Sauchiehall Street and the Cowcaddens district, and Gray returned reluctantly to teaching. He was unhappy, plagued by asthma and eczema, and not able to do useful creative work. After six months he stopped teaching to become a scene painter, a job which lasted until his son Andrew was born in 1963. For a year after this he lived on unemployment benefit, painting and writing – but not yet selling.

Despite financial difficulties, it began to look as if Gray's career was going to take off. In 1963 he completed Book 1 of *Lanark* a few months before the birth of Andrew, and, although it was only part of the projected epic, he sent it to the literary agents Curtis Brown as a novel in itself (it was rejected). Gray also completed painting his cityscape *Cowcaddens, 1950* and the creation mural for Greenhead Church of Scotland. But the most promising event was a television programme about him made for the BBC by a friend of his Art School days, Bob Kitts, now a television director. The programme was called *Under the Helmet* (broadcast 14.1.1965) and exploited the unusual device of implying, without ever quite stating, that its subject was dead. Despite (or because of) this interesting idea, the programme did not lead directly to any further opportunities.

However, during the process of developing *Under the Helmet*, Gray visited London to discuss the project with producer Huw Weldon and this gave him the idea for his first play, *The Fall of Kelvin Walker* (eventually broadcast by the BBC in 1968). The relatively generous fee

opened up a possible new direction for making money by writing plays
and TV scripts. During the next fifteen years Gray wrote more than a
dozen plays for TV and radio. Several were broadcast, and others
received dramatic performances, either professional or amateur. The
venture into playwriting was therefore a partial success (in financial
terms) but after the middle 1970s Gray failed to get any more work in
this line, partly through the BBC no longer commissioning scripts for
Scottish Schools television, and partly through the death of his agent.
He was to return to drama in the middle 1980s with the TV adaptation
of R.L. Stevenson's *The Story of a Recluse*.

So, from the middle 1960s to late 1970s Gray eked out a living by
writing plays and by commissioned art work of various kinds. He
painted several murals, had exhibitions at the Armstrong and
Blythswood Galleries in Glasgow (1966 and 1967) and the Traverse
Gallery, Edinburgh. The Scottish Arts Council gave him a grant to
make prints for his poems in 1969.

At the end of 1968, the Hill Street home was about to be demolished
to make room for a motorway. The Grays moved to a flat in 39 Kersland
Street, Hillhead. Two years later Gray left his wife and son there, and
eventually lodged nearby in Turnberry Road, Hyndland. In 1972
Frances Head became Gray's London agent, and over the next four years
she sold three completed plays to Granada and the BBC, and obtained
commissions and payment to write five more. The London theatre
impresario Binkie Beaumont was also induced to consider *The Fall of
Kelvin Walker* for West End production (negotiations broke down after
Gray could not be persuaded to supply a happy ending). Quartet Books
paid an option on *Lanark* after seeing the completed versions of Books 1
and 3, but refused it due to it being too long when a final version was
sumbitted in 1976.

In 1976 Gray's son entered Kilquanity House boarding school in
Kirkcudbrightshire, his wife went to work in England, and he returned
to the Kersland Street flat. A difficult period started. By this time,
Frances Head had died of lung cancer, and there were no more play
commissions. A few months after the rejection from Quartet, Gray sent
Lanark to Canongate Publishing, Edinburgh. Meanwhile, there was the
problem of paying Andrew's school fees. Gray got a job as head of the
art department at Washington Street Arts Centre (then called Glasgow
Arts Centres) but resigned after three months. He painted a mural at
the Ubiquitous Chip restaurant, Hillhead, in return for meals. Perhaps
the most useful commission was his period working as 'Artist Recorder'
in the People's Palace (Glasgow's local history museum) in the summer
and autumn of 1977, when he painted more than thirty portraits of

contemporary Glaswegians in surroundings of their choice, and streetscapes of the city's east end as it was being redeveloped. However, the wage under the Government's Job Creation scheme, while adequate for his own needs, was not sufficient to pay for the school fees.

Security came for two years from September 1977 as the writer in residence at Glasgow University. This involved running creative writing groups and helping students with an interest in creative work, but left plenty of time for Gray's own endeavours. In early 1978 he heard that Canongate were prepared to publish *Lanark*, although three years were to pass before this actually happened.

The publication of *Lanark* resulted in its immediate recognition as a classic of Scottish Literature.[8] One influential critic hailed *Lanark* as 'a shattering work of fiction in the modern idiom.'[9] At this point Gray had written most of the work he has subsequently published, although this was often subjected to considerable revision. The bulk of *Unlikely Stories, Mostly* was completed, *Kelvin Walker* and *McGrotty and Ludmilla* existed as plays (both were later adapted to novellas), and the other plays and the poems from *Old Negatives* were finished (most of the poems dating from before the middle 1960s). Some time after the completion of *Lanark* in 1976, Gray embarked on a highly productive creative burst – his 'second period' – which produced *1982 Janine* and several ambitious short stories such as 'Logopandocy', 'Five Letters from an Eastern Empire' and 'Prometheus'.

1982 Janine was originally intended as a short story to be named 'If this is Selkirk, this is Thursday, Janine' (for a projected 'likely stories' volume which eventually became part of *Lean Tales*). This was to be 'in the Russian manner, an inner monologue' of just a few pages in length.[10] This character sketch was then integrated with some 'detailed fetishistic porn fantasies' which Gray had noted during a rather miserable visit to Pitlochry in 1977.[11] The story evolved rapidly under composition, and moved from an intended short story to novella, and finally a full-length novel. Gray started expanding the short story during late 1979, but only began work in earnest in late 1980 while awaiting the publication of *Lanark*. In the middle of 1981 Gray ran out of money and had to stop writing at approximately half way through the completed manuscript. Nearly a year later he got an advance from Jonathan Cape which enabled him to finish the book in the following couple of months at the beginning of 1982. So the 'second period' runs from some time after the completion of *Lanark* in 1976 to the completion of *1982 Janine*.

It was about the time when *1982 Janine* was published in 1984 that Gray at long last found himself on a secure financial basis from royalties,

advances and performances at readings (together with his work in visual arts). This initiated the 'third period' which was announced in *Lean Tales* as resulting from him having run out of ideas for fiction – a period of adapting and publishing previous work (*McGrotty and Ludmilla, Lean Tales, The Story of a Recluse* [BBC 2], *Old Negatives, Tickly Mince*) and compiling the forthcoming anthology of prefaces. The fiction of the third period is essentially work from Gray's first period which has, for one reason or another, not previously seen the light of publication. It is obvious that in Gray's *œuvre*, the order of publication is not a guide to the order of composition.

1986 also brought Gray's major endeavour to make his mark as a visual artist – the 5 *Scottish Artists Show* – a big retrospective exhibition collaboratively organised by Gray and fellow artists which included work by Gray, Alasdair Taylor, Carole Gibbons, John Connolly and Gray's deceased friend Alan Fletcher. This was shown in the McLellan Galleries in Glasgow and the Talbot Rice and 369 Galleries in Edinburgh, but it was not well publicised and resulted in a substantial financial loss.

There are signs of an impending fourth period beginning in 1987, and marked by the publication in 1990 of *Something Leather*. This developed from an idea which emerged during an interview with Kathy Acker, that Gray should write something from a woman's point of view.[12] Another impulse was financial – the advance was needed to cover the expenses of the 5 *Scottish Artists* exhibition. What emerged was a series of linked short narratives, seven newly composed and six adapted from one-act plays written between 1968 and 1974.

Alasdair Gray is now an established figure in the Scottish literary scene, has a high profile within the wider world of Britain, and has been translated into Swedish, Dutch, German, Polish and Russian. He has at last achieved a satisfactory degree of financial security (given his extremely modest needs) and remains active in both writing and painting. At present it seems probable that his reputation will flourish in the long term.

NOTES

1. This account of the life and works of Alasdair Gray was derived primarily from material in the archive at the National Library of Scotland. Subsequently, Alasdair Gray gave freely of his time and energy to check the information, and to expand it in crucial places. Wherever possible, his recollections were checked against contemporary documentation – but this was not always possible. Any remaining mistakes or discrepancies are my own responsibility. I am

very grateful to Alasdair Gray for his help and encouragement both in this present task, and during the work for my MA thesis (University of Durham, England) from which it has been developed.

2. Alasdair Gray interviewed by Jennie Renton. *Scottish Book Collector*, No. 7 (1988), pp.2–5.
3. *Ibid.*
4. Accession 9417, box 1, notebook 11 dated 1952, National Library of Scotland.
5. Accession 9417, box 1, notebook 4, dated 1950, National Library of Scotland.
6. Accession 9417, box 3, National Library of Scotland.
7. Letter to Bruce Charlton, 12.5.88.
8. See Cairns Craig, 'Going Down to Hell is Easy', *Cencrastus*, no. 6 (1981), pp.19–21, and Isobel Murray and Bob Tate, *Ten Modern Scottish Novels* (Aberdeen: Aberdeen University Press, 1984), pp. 219–39.
9. Anthony Burgess, *Ninety-nine Novels: The Best in English Since 1939* (London: Alison & Busby, 1984), p.126.
10. Accession 9417, box 1, notebook 53, National Library of Scotland.
11. Alasdair Gray, draft of a 1981 letter to Tina Reid, Accession 8799, boxes 2 and 3, National Library of Scotland.
12. Kathy Acker, 'Alasdair Gray Interviewed', *Edinburgh Review*, No. 74, 1986, pp.83–90.

CHRONOLOGY

1934	Born 28 Dec at 11 Findhorn Street, Riddrie, Glasgow; child of Alexander and Amy (née Fleming).
1939–40	Evacuated to a farm in Auchterarder near Perth with mother and sister. First asthma attack.
1940–1	Moves with mother and sister to Stonehouse, Lanarkshire.
1941–5	Family reunited in Wetherby, Yorkshire, where his father is managing a hostel for munitions workers. Attends local Church School.
1946	Returns to Riddrie, attends local primary school, then Whitehill Senior Secondary School. Reads some of his verses and a prose version of an *Aesop's Fable* on Scottish radio children's hour.
1949–51	Has stories published in *Collins Magazine for Boys and Girls*. Starts *Obby Pobbly*, the remote ancestor of *Lanark*. Paints watercolours to illustrate lecture on *A Personal View of History* for school debating society.
1952	Is accepted for Glasgow School of Art. Mother dies.
1952–7	Attends Glasgow School of Art. Specialises in mural painting. Meets Malcolm Hood, Alan Fletcher, Bob

Kitts, Carol Gibbons. Working on his 'epic' novel, at this time called *Thaw*. Writes some early 'Unlikely Stories'. Artworks include *The Beast in the Pit* (1952) and *Marriage Feast at Cana* (1954).

1955 Admitted to Stobhill Hospital with severe asthma. Starts painting mural of a modern *Triumph of Death* at Scottish–USSR Friendship Society.

1956 Performance of *Jonah* puppet play at Art School.

1957–8 Bellahouston Travelling Scholarship to Spain is aborted in Gibraltar by severe asthma attack.

1958 Returns to Glasgow. Works as unqualified art teacher in Lanarkshire. Starts creation mural at Greenhead Church of Scotland, Bridgeton, Glasgow. Completes painted firmament on ceiling of new synagogue, Belleisle Street, Crosshill. Alan Fletcher dies in an accident in Milan, Italy.

1959–60 Attends Jordanhill teacher training college. Takes part in CND demonstrations against the Holy Loch Polaris submarine base.

1959 April: 'A Report to the Trustees of the Bellahouston Travelling Scholarship' (later published in *Lean Tales*).

1960 Starts teaching full-time in Wellshot Road and Riverside schools, Glasgow. Visits Milan to help arrange Alan Fletcher's gravestone. Writes 'The Answer' (*Lean Tales*).

1961 Edinburgh Fringe *Festival Late* revue. Meets Inge Sørensen and marries her six weeks later (3 November). Moves to 158 Hill Street, Cowcaddens.

1962 Stops teaching, becomes scene painter at Pavilion Theatre. Completes *Creation* mural in Greenhead Church.

1963 Leaves Pavilion to paint scenery for the Citizens' Theatre. Birth of son, Andrew. Leaves Citizens', has exhibition of paintings in the theatre foyer.

1964 Book 1 of *Lanark* (half of the Thaw section) submitted as a complete work to Curtis Brown, literary agents; and rejected. Painting *Cowcaddens, 1950*. Lives on the dole as unemployed scene painter while writing and painting in hope of selling. Bob Kitts makes a film of Gray's paintings and verses for the BBC called *Under the Helmet*.

1965 Broadcast of *Under the Helmet* by BBC TV. Comes off the dole and lives by writing, painting and part-time lecturing on art appreciation. BBC buys *The Fall of Kelvin Walker*.

1966 Completes TV play *The Night Off* but fails to sell it.
 Exhibition at Armstrong Gallery, Glasgow.

1967 Working evenings in Glasgow Art School library.
 Exhibition at Blythswood Gallery, Glasgow.

1968 Paints murals in Pete Brown's flat, Montague Square,
 London. *The Fall of Kelvin Walker* broadcast by BBC TV.
 BBC commission the play *Agnes Belfrage*, but reject it.
 Moves to 39 Kersland Street, Hillhead, Glasgow.

1971 Moves to 6 Turnberry Road, Hyndland, Glasgow, leaving
 wife and son in Kersland Street.

1971 *Lanark* Books 1 and 3 finished. Paints large series
 illustrating a poem sequence by Liz Lochhead, for a film
 project, later abandoned.

1972–4 Attending Philip Hobsbaum's creative writing group
 with Tom Leonard, Robin Hamilton, Liz Lochhead,
 Anne Stevenson, James Kelman, Aonghas MacNeacail,
 Donald Saunders, Angela Mullane, Chris Boyce and
 others.

1972 *The Fall of Kelvin Walker*. Professional production by The
 Stage Company: Scotland, McRobert Centre, Stirling.
 Begins painting mural of *The Book of Ruth* in Greenbank
 Church of Scotland, Clarkston, Glasgow – uncompleted.
 Frances Head becomes Gray's literary agent.

1973 Father dies. *Story of a Recluse* submitted to Scottish BBC
 as a treatment, but rejected. Quartet Books buy an
 option on *Lanark*.

1974 Working on *Lanark* Books 2 and 4 – half the chapters of
 Book 2 being written, the rest sketched, and Book 4 still
 in fragments. Painting the ecological cycle at Palace Rigg
 nature reserve, New Cumbernauld. Large retrospective
 exhibition at the Collins Gallery, Strathclyde University.

1975 *McGrotty and Ludmilla* broadcast by BBC radio.

1976–7 Son goes to Kilquanity boarding school. Returns to live
 in Kersland Street. Death of Frances Head. *Lanark*
 rejected by Quartet Books. Gets teaching job as head of
 art at Glasgow Arts Centres.

1977 Leaves Glasgow Arts Centres after three months. Paints
 mural at Ubiquitous Chip restaurant. Artist Recorder at
 the People's Palace, Glasgow. Becomes writer in residence
 at University of Glasgow. Starts work on 'Logopandocy'.

1978 Signs contract with Canongate for *Lanark* and a book of
 short stories. *The Continuous Glasgow Show* at People's

Palace, exhibiting work done while Artist Recorder. Writes 'Five Letters from an Eastern Empire'.

1979 Stops being writer in residence and lives partly by sub-letting rooms in his flat.

1980 Conceives 'Prometheus' story and starts work on *1982 Janine*

1981 Publication of *Lanark*. Completes *Unlikely Stories, Mostly*.

1983 Publication of *Unlikely Stories, Mostly*.

1984 Publication of *1982 Janine*. Attains financial self-sufficiency.

1985 Publication of *The Fall of Kelvin Walker* as a novel.

1986 5 *Scottish Artists* show – publication of catalogue. Loses financial self-sufficiency until advance from *Something Leather* in 1987. *McGrotty and Ludmilla* at the Tron Theatre, Glasgow. *The Fall of Kelvin Walker* broadcast BBC Radio 4 'A Book at Bedtime'.

1987 *The Story of a Recluse* broadcast on BBC2, Christmas Day. Starts work on *The Anthology of Prefaces*.

1988 Publication of *Saltire Self-Portrait*.

1989 Publication of *Old Negatives*. Decanted to St Vincent Terrace, Anderston, Glasgow. Completes filmscript of *Lanark*.

1990 Publication of *McGrotty and Ludmilla* in novel form, and *Something Leather*.

1991 Two books completed, but not yet published: *Ten Tales True and Tall* and *Poor Things*, a medical romance set in nineteenth-century Glasgow.

Projects planned: Publication of the last two books mentioned, also the revue *Tickly Mince*, also completion of *The Anthology of Prefaces*, and a proposed study of life in modern Britain from the perspective of a Glasgow housing scheme: *The State We Are In*, written in collaboration with Angela Mullane.

Two

Alasdair Gray, Visual Artist

Cordelia Oliver

Already, while still a student at Glasgow School of Art, Alasdair Gray had singled himself out as a force to be reckoned with as someone well able to attract and sustain the respect of his contemporaries and teachers alike. A series of colour transparencies taken by a fellow student are all the evidence that now remains of the astonishingly accomplished décor he conceived and helped to carry out for the art school Christmas Ball in 1956.[1] By its nature an ephemeral work, this none the less mammoth task is something traditionally entrusted to certain of the more able final-year students.

The chosen subject that year was 'Monster Rally', and Alasdair Gray conjured up a memorable *galère* of grotesque, chimerical creatures in the school's Assembly Hall. Contained within bold, linear blacks and coloured mostly in flat primaries, his creatures cavorted and writhed along the walls and round the doors and windows, dwarfing not only the human activity down below but also the students' much-used grand piano on the platform, painted a garish chrome yellow for the occasion. That the creator of this fabulously impressive *mise-en-scène* also possessed a wry and impish sense of humour might be guessed not just from the work itself but also from some of his colleagues' photographs which show Alasdair reclining histrionically on the floor among his own monsters.

Earlier still, and on a very different scale, in an exercise set as a test of the second-year students' ability to compose to order with a minimum of three figures (the given subject was 'Washing Day') it was entirely typical of this particular student to tie himself to an even more stringent set of rules than that demanded by authority, coming up with a drawing that transcends all normal expectations of a teenage work. This was an

essentially linear image in which the back court of an ordinary Glasgow tenement was transformed into a Piranesi labyrinth where certain elements — tall, narrow close-mouths, female figures, basins of washing, *etc.* — come in threes, to be played with in a visual game, without repetition.

Even at that early age, then, Alasdair Gray was showing himself to be an artist with an unusually fertile imagination and a prodigious gift for effective space-filling, capable, on the one hand, of expanding his visual concepts to occupy large areas of wall and, on the other, of condensing them to fit neatly into the page of a sketchbook. His work as a visual artist, indeed, may be roughly divided into three sections: full-scale mural painting, book design and illustration (for an early example see Plate 1), and portraiture often in the form of tinted drawings.

The need to express his ideas on a large scale, composing with determination and, it must be said, remarkable fluency at best, on any sympathetic wall that offered itself, goes back a very long way to the time when, at thirteen or so, as a 'regular' in Riddrie Public Library, he read *The Horse's Mouth* for the first time and found Joyce Cary's vivid description of the Creation mural painted by Gully Jimson in a derelict church sticking in his mind like a leech and firing his imagination.[2] 'The greatest act of intelligent heroism I could clearly imagine', he was to write nearly four decades later, 'was making a great art work for folk who could not like it' (*FGA*, 'Introduction').

Possibly his first mural attempt was a painting which had covered the wall of a fellow student's bedroom; the bedroom belonged to a girl who had also been a pupil at Whitehill School in Dennistoun. This early work was papered over when the girl eventually left home to be married. Reminded of this, Alasdair's reaction, accompanied by a cheerful giggle, is entirely typical. 'Oh, I don't blame Mae's mother — the subject was Death.' The subject, indeed, was God playing Chess with Death for the Future of the Universe, Death being seen as a crowned skeleton and God as a curious monkey-like creature. Behind the foreground figures and their giant chessboard was a distant townscape and above it, in a dark sky, was an eclipse of the moon.

A far more ambitious enterprise of the same sort was undertaken while Alasdair was still an art student. This was a mural which takes for its theme 'man's inhumanity to man', of which the Crucifixion is the supreme example. This work covers the east and west walls of the rear section of a double room on the ground floor of a house in Belmont Crescent in Glasgow's west end, home of the Scottish–USSR Friendship Society. In spite of the young painter's obvious inability to match his style to the immensity of his concept — the very different attitudes of the

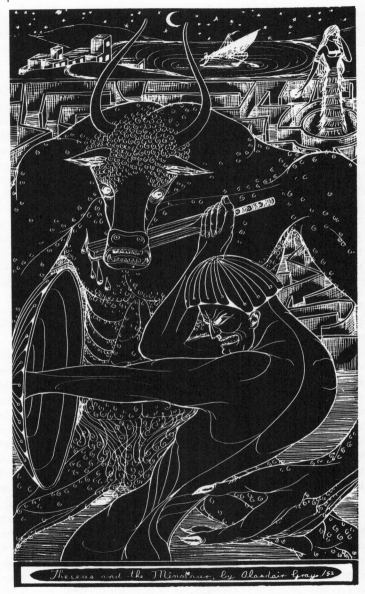

Plate 1 *Theseus and the Minotaur* (1952), drawing on scraper board, reproduced from *Whitehill School Magazine*, Summer 1952.

painter and the draughtsman continually come into conflict – this is a student work that, with remarkable if partial success, tries conclusions with meaningful, polemical, imaginative figuration more than thirty years before the fashion changed in its favour, to bring fortunes to young painters of the next generation for large-scale figurative work of a far more simplistic nature.

On the east wall the central image is the Crucifixion, no gentle High Renaissance image but a harsh modern-gothic conception with contemporary grieving figures down below. Adam and Eve, young, life-size nude figures, stand facing one another but at least eight feet apart while all around and far beyond is 'a panoramic background representing the modern world as it appears to the artist, an amalgam of industrial Scotland with distant mountains and firths'.[3] It is, as always a fantasy involving serpents and skulls and sinister flayed figures but with occasional passages of pure painterly enjoyment for its own sake – the wealth of subdued colours in an elderly woman's knitted cardigan, for example. Not surprisingly, however, it is a fantasy not yet stylistically coherent.

On the deep frieze above the opening between the rooms, and linking the east and west walls, is a series of three unashamedly Picasso-esque figures, one suckling an infant and another with a foetus in her womb. But it is in the painting that covers – is, indeed, crammed into – every available inch of space on the west wall that the familiar style of Alasdair's imagery is seen emerging, more coherent in manner, despite the overcrowding. Here, in a welter of tall tenements, factories, railway bridges and viaducts, monuments, cemeteries and cooling towers, all stretching to infinity, is evidence of 'the terrible psychological forces that lead to war' – distraught families, grieving women, workmen, schoolchildren, brutalised male figures, some clearly inhuman, while above it all a blind, flayed male creature tosses balls.[4] For all its overall lack of expertise (yet there are elements, not least the tiny distant figures and incidents so quick with vitality, which are reminiscent of medieval woodcuts),this remains a truly remarkable young man's work.

Since that time Alasdair Gray has painted murals in churches and other public places, and in domestic interiors, some extremely ambitious and others unashamedly decorative. For example, when invited to decorate a pop singer's London living-room, he contrived to turn the space into an enchanted glade in what he calls 'a purely decorative piece of visual entertainment which will certainly be painted out by now'.[5]

Not long after completing the Belmont Crescent mural Alasdair found himself emulating the fictional hero of his boyhood, Gully Jimson.

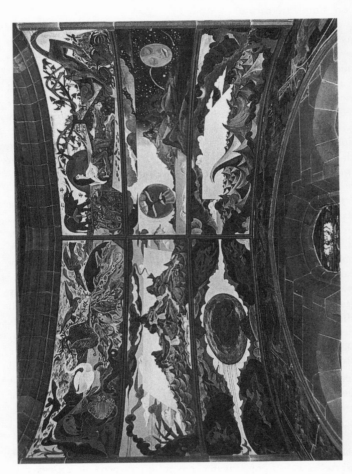

Plate 2 *Genesis* (1958–62), mural in Greenhead Parish Church, Bridgeton, Glasgow (now demolished).

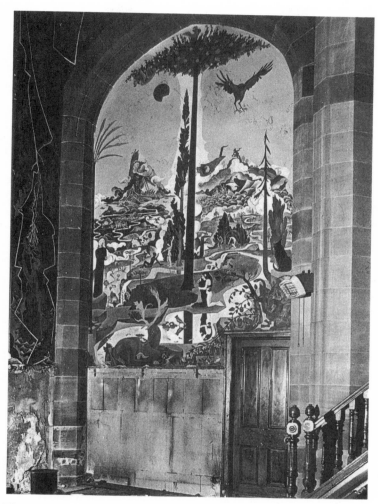

Plate 3 *Genesis* (1958–62), mural in Greenhead Parish Church, Bridgeton, Glasgow (now demolished).

Invited to decorate the chancel of a church in Glasgow's east end he decided on Genesis as his subject, hoping that the success of the work and the eventual publicity might not just make him famous but, more important, attract more work of the same kind. Alas, that hope was not fulfilled. Greenhead Parish Church in Bridgeton failed to survive the demolition fervour that overtook Glasgow. Finished in 1962, the mural lasted just a few years. Only a few photographs and colour transparencies survive to give some idea of the scale of the enterprise and of the painter's success in enlivening the given space with memorable imagery.[6]

The murals filled the chancel of the red sandstone church interior. On the round vaulted ceiling the six days of Creation were depicted (Plate 2), and on the great arched wall above the vestry door was the Garden of Eden with God surveying his handiwork (Plate 3). In this Eden, dominated by an immensely tall Tree of Knowledge (not the only tree in this highly decorative garden, be it said), a dark brown Adam and a pale Eve kneel with arms entwined beside a still, reflective pool while a tall, white-bearded God figure stands to one side surveying not just his present handiwork but also the future of the world he has created, as seen in the distant landscape.

This mural took much longer than expected to complete and legend has it that, during prolonged periods of labour upon it, there were occasions when Alasdair would virtually live in the church day and night, sleeping in the pulpit as often as not. His train of thought when in travail with the massive work, and in particular with the Garden of Eden wall, is surely reflected in his novel *Lanark* in the account of the thoughts of his *alter ego*, Duncan Thaw, when involved in a similar work of art. Thaw's trouble, of course, began in the background of the mural,

> where history was acted in the loops and delta of the river on its way to the ocean. The more he worked the more the furious figure of God kept popping in and having to be removed: God driving out Adam and Eve for learning to tell right from wrong, God preferring meat to vegetables and making the first planter hate the first herdsman, God wiping the slate of the world clean with water and leaving only enough numbers to start multiplying again, God fouling up language to prevent the united nations reaching him at Babel, God telling a people to invade, exterminate and enslave for him, then letting other people do the same back. Disaster followed disaster to the horizon until Thaw wanted to block it out with the hill and gibbet where God, sick to death of his own violent nature, tried to let divine mercy into the world by getting hung as the criminal he was. (*L*, 320–1).

Indeed, the first seeds of the future first novel were already being sown at this period, and Alasdair's verbal account of the mural of his imagination reveals the chasm that is bound to yawn between concept and form in the work of any young artist, no matter how gifted. The mural in the Bridgeton church was a remarkable accomplishment for a young painter scarcely out of art school, but existing photographs tend to corroborate my own memory in suggesting that what predominated was, in the end, the decorative element.[7] The manner in which the panoramic landscape, the birds, the animals, prolific vegetation and human figures are integrated into the overall design is reminiscent of Indian or Persian miniature painting. And the God figure whose personality loomed so large in the mind of Alasdair Gray's fictional counterpart is here depicted as a tall, curiously benign, black-coated clerical (even Presbyterian) personage observing his Creation from a pulpit-rock set to one side much as pulpits normally are in the real world.

The arched ceiling with its six panels must have presented a formidable challenge from the painting position alone (did Alasdair have Michangelo in mind, I wonder, while he laboured on his scaffolding?). The result, however, was a triumph, from the abstract simplicities of Day One to the proliferation of wild, then human, life on Days Five and Six. The destruction of that particular part of the work at Greenhead Church is all the more tragic since the essence, at least, of the imagery on the adjacent wall is still visible in a much smaller panel *Eden and After* painted a few years later. Though somewhat different in its composition – it lacks the central Tree of Knowledge that dominated the mural, and the high Italianate sky with its dark, predatory bird hanging in the clear blue space – it does give, none the less, a fair idea of the style and technique involved in the earlier, much larger work. In style, then, the Greenhead mural was more coherent, if scarcely as highly charged, as the Belmont Crescent example which, fortunately, still exists.

Most artists would be expected to feel at least a stab of resentment to know that some of their most ambitious past work is no longer visible. Alasdair seems to worry less than most, no doubt because he knows that under the images created by, and contained in, the written word are far less destructible than paintings. The story-teller and the maker of visual images in line and colour were already Siamese-twinned in the boy from Riddrie who, from an early age, found that 'drawing pictures and telling stories were both legitimate ways of getting attention from teachers and contemporaries both'. At home, pencil and paper were always available as far as memory takes him, and at school, at least so far

as Art and English were concerned, he never felt, as some art-oriented children do, that his education was pulling him apart.

Illustrated books were fodder to be gobbled up, not least those in which, like *Alice in Wonderland*, the pictures were exceptionally well integrated into the text. Kipling's *Just So Stories* are also remembered with affection, not least the decorative capital letters, as a source of interest, pleasure and inspiration. 'Of course he is a good writer', says Alasdair, 'but Kipling still gives me more satisfaction as an illustrator'. Hugh Lofting's *Doctor Dolittle* was another favourite and, in the days when Riddrie Public Library offered a regular book bonanza to this exceptional small boy, Hendrik Van Loon's *History of Mankind* and other books, 'with drawings that were not very good, maybe, but undoubtedly dramatic', demonstrated how the world would look if, for example, the Atlantic Ocean or the Mediterranean ran dry. Informative and exciting stuff this was to an imaginative, visually-oriented child, offering ideas to be stored away for future use.

For Alasdair, history, fiction and graphic illustration are simply 'different ways of showing similar things'.

> In the *Just So Stories* when you read about the cat that walked by itself you were taken to look into the stone age. Thomas Hardy's Wessex sketches are as vivid, in their own way, as his writing: there is the same sense of a particular quality of landscape and of human interest too. And I can remember one drawing in particular, of a coffin being carried downstairs — he had no interest in the heads of the people, just the coffin, the hands and the legs. The heads of the people carrying it simply disappear off the top margin.

The descriptive faculty in words, he feels sure, is inevitably linked to visual creativity.

> Dickens had it to an abnormal degree; Thomas Hardy painted portraits and landscapes in words, and Tolstoy even painted great historical battle scenes. The difference is that writing, or drama for that matter, operates through the medium of time, whereas painting and sculpture operate through the medium of space. But the one implies the other, and painting, after all, abides contemplation.

The two are more closely and effectively linked in Alasdair Gray's own work than in that of any other Scottish artist of our time, with the possible exception of his contemporary John Byrne. Gray's first novel, *Lanark*, reveals the same dichotomy which has always been present in his visual art. On the one hand there is an obvious delight in allegorical fantasy, in the construction of, at best, vastly impressive symbolic compositions of great complexity, what he himself has called 'cities

built on the backs of elephants'. Looking at his work in this field, even in the art school period (remembering the labyrinthine tenement drawing) you sense the sheer pleasure taken in solving difficult compositional problems — not in every case successfully as Alasdair would be the first to agree — which would cause many artists to give up and settle for something simpler. But Alasdair admits that he relishes the process of invention.

Another drawing from the art school period, a lithograph in fact, deals with the story of Jonah and the whale, depicting the act of ejection into a sea teeming with little fish, with Leviathan's great gaping mouth reminiscent of a series of Romanesque brick arches stretching to infinity.[8] He had already begun work at Greenhead Church when he conceived and carried out an even more ambitious print, *Faust's Dream of the Universe*. This is a truly phantasmagorical concept, Faust in his study looming large at one side with, above him, God in the act of supporting the beam balance of the steam engine that drives the universe: wheels within wheels, great towering structures (towers of Babel?), seas full of fish, writhing snakes (and ladders) all on one densely packed sheet of paper no bigger than 15″ × 25″. Only someone who genuinely enjoys the process of invention would have had the patience to bring a composition of such complexity to a reasonable conclusion.

On the other hand there is a large body of work, not least in the portraiture for which Alasdair Gray has a notable gift, in which he gives full rein to what is obviously an equal relish for depicting visual reality in meticulous detail — what he himself has called 'submission to appearances'. The collection of likenesses of Glasgow individuals in their domestic setting, workplace or other familiar environment, some in pencil, ink or watercolours, some in oils, demonstrates Gray's ability to delineate an individual character with accuracy and style. And indeed, by setting the scene so completely and yet with such obvious sympathy and enjoyment of every detail, the portrait is often rounded out, made complete in a way that seldom happens in the more pretentious sort of large-scale, official likeness.

It was in 1977 that, subsidised by the Government's Job Creation scheme, Alasdair found himself the recipient of a modest wage for a nine-to-five job with a difference. Elspeth King, curator of the People's Palace, Glasgow's major local history museum, commissioned him to record people and places in contemporary Glasgow. He was given space in the museum's store in the former Templeton's carpet factory, alias 'the Doge's Palace', also on Glasgow Green. And it was from that base, in what was clearly a highly productive period, that Alasdair made a

Plate 4 *London Road Looking West from Arcadia Street* (1977), pen drawing now in the collection of the People's Palace museum, Glasgow. At the foot of the drawing, Gray has written, 'London Rd, Looking west from the intersection with Arcadia Street, drawn in the warm July of 1977. The four ladies on the right work in Templetons carpet factory.'

succession of fascinating likenesses of present-day Glaswegians, well known and unknown, but always within the domestic or working habitat.[9]

Edwin Morgan is seen at home among his books and pictures; Alex and Cathy Scott in the local 'Pewter Pot' pub; Tom McGrath, then Director of Third Eye Centre, in his busy, cluttered office; Pastor Jack Glass among the tombs and mausoleums of the Necropolis; producer Malcolm Cooper and reporter Fidelma Cook in the BBC news gallery. All 'weel kent' faces, they took their place with a construction worker, bartender, police constable, children and the unemployed in a set of drawings and paintings which were given a room to themselves in the 'Continuous Glasgow Show' at the People's Palace that year.

In all of these, the 'willing submission to appearances' is uppermost, except perhaps in the liberties occasionally taken with perspective, almost as though the artist's eyes were fitted with the wide-angle lens beloved of some photographers – the same trick was used by the early nineteenth-century Glasgow painter, John Knox, in the famous panoramic view of the Clyde from Glasgow Bridge, a work with which Alasdair Gray would no doubt have been familiar.[10] His own panoramic pen drawing of *London Road Looking West from Arcadia Street* (Plate 4), made in July 1977, is a typical feat of observation of the essential character of place and posterity.[11] Most artists with the necessary sleight of hand to perform this feat would lack the empathetic imagination to endow it with this quality of life.

Most artists, of course, are – or by their own limitations are driven to be – content to specialise in one field of expression. They find, if they are fortunate enough, a way of working, of giving form to their vision, objective or subjective as it might be, which they can develop into a personal 'style' which then becomes familiar through repetition and greater expertise. But Alasdair Gray's all-enveloping imagination and intensely curious mind have together opened to him whole galaxies of subject matter which few, in our time at least, would even attempt to enter.

I have called him a draughtsman, which he primarily is. There are whole areas of painting which are closed to him; the schools that descend from Raphael, Titian, Rembrandt and Rubens, whose exponents find sustenance in rhythms and relationships of colour and of brushwork which can be expressive as such. Alasdair Gray's painting is of a different breed altogether. His forebears range from Hieronymous Bosch and, I feel sure, Piero della Francesca, to Aubrey Beardsley and the Surrealists. 'The reason why I loved biblical subjects and Genesis in particular', he tells you, 'was that I put in all the fabulous monsters –

like Satan as half-man, half-serpent – which I enjoyed inventing. It offered an opportunity of painting the "marvellous" but not detached from reality.'

As we have seen, Alasdair is nothing if not prolific: he draws as he writes as he thinks as he talks. But over the years it has happened more than once that his imagination has been stimulated by a commission like, for example, the People's Palace job, or a certain project even when in the end abortive. Early in the 1970s there was a plan to make a film for television using a series of small tinted drawings to bring to life a script by Liz Lochhead. The subject was to be a girl remembering her days with a former lover while moving round her bed-sittingroom. The project never materialised for the simple reason that Alasdair's ideas and the resulting drawings became more and more expansive (this has tended to happen again and again) taking years, not months, to complete. The works in question, however, are as beautiful as anything he has done in that line; flat, floating, shimmering colours, each contained within its own descriptive or decorative boundary (FSA).

In spite of his own extraordinary dexterity with pen and ink in complex and meaningful linear embellishment of a page – something that is best seen in the illustrations to his own books, Lanark not least – where the great engravers like Dürer and Altdorfer are brought to mind by some measure of the same ability to mingle Baroque structure and embellishment with a sense of the immensities, vast differences in scale and phantasmagoric subject matter; in spite of this exceptional draughtsman's gift, always at his disposal, Alasdair Gray still hankers after the mural as the perfect means of visual expression, regretting that most of his work, if sold, would become just private property. The trouble about painting murals, however, is to find adequate means of keeping body and soul together in the necessarily long process. And even though he learned long ago that to be too ambitious can court disaster, that work taking much longer than even he expected (a painting on a wall of a transept in a wealthy suburban church, illustrating the book of Ruth, was left slightly unfinished for a time while Alasdair pondered the precise quality of the flesh tones which were temporarily left white: in the meantime, someone else was brought in without his knowledge to 'finish' the work), he would, he says, still love to paint a really fine mural some day.

One idea that clearly still simmers at the back of his mind, although 'in present circumstances I doubt if it will ever be carried out', is a project suggested by Elspeth King for the People's Palace. This would be a large 'mobile mural', a vision of Scotland as a pictorial wheel, an all-embracing panel pierced with holes, which when revolved, would

reveal likenesses of famous Scots, 'not just Burns and Scott, but Harry Lauder too'. Meanwhile his more conventional murals still exist at Palace Rigg Nature Reserve, Cumbernauld, 'an ecological cycle dependent on the oak tree'; in the Ubiquitous Chip restaurant where he decorated a stairway; and – an early extravaganza, full of fantastic incident – on the high stair wall of a private terrace house in Glasgow's west end. This last example, though not normally visible to the public at large, forms the background to Oscar Marzaroli's photograph of a typically quizzical Alasdair Gray, published in the latter's book, *Shades of Grey*.[12]

One easel painting is almost on a mural scale, at 4' × 8', the size of a sheet of hardboard. This is perhaps Alasdair's masterpiece in the genre. It is, once again, a panoramic view, this time of *Cowcaddens, 1950*, finished in 1964.[13] It features a rich, sombre, super-real but somehow also theatrical quality which is reflected in the pages of *Lanark* as

> a place where several broad streets met . . . though the dark had made it difficult to see far. And now, about a mile away, where the streets reached the crest of a wide shallow hill, each was silhouetted against a pearly paleness. Most of the sky was still black for the paleness did not reach above the tenement roofs, so it seemed that two little days were starting, one at the end of each street . . . He [Lanark] ran with his gaze on the skyline, having an obscure idea that the day would last longer if he reached it before the light completely faded. (*L*, 11)

Unthank and Cowcaddens on a murky day are one and the same.

Alasdair's more recent work has tended to be narrower in scope and smaller in scale than before, but with no loss of individuality. A gradually expanding body of figurative, often tinted, drawings with an ancestry that surely includes the finest Japanese woodcuts, has given us a gallery of likenesses, some commissioned, some not. But it is greatly to Alasdair Gray's credit that one cannot be sure from the end result which were done for payment and which 'for love'.

NOTES

1. The present whereabouts of these transparencies is unknown.
2. This and other unspecified quotations derive from conversations between the artist and the present writer.
3. Explanatory caption written by Alasdair Gray to accompany his murals at the Scottish–USSR Friendship Society, 8 Belmont Crescent, Glasgow.

4. *Ibid.*
5. The pop singer was Pete Brown, whose flat was in Montague Square.
6. George A. Oliver's photographs.
7. *Ibid.*
8. Private collection.
9. All the work done under Job Creation is in the collection of the Old Glasgow Museum at the People's Palace.
10. The original painting is in the People's Palace; it is illustrated in colour in the catalogue, *Scenic Aspects of the River Clyde* (Glasgow: Glasgow Art Galleries, Kelvingrove, Summer 1972).
11. Collection, People's Palace.
12. Oscar Marzaroli and William McIlvanney, *Shades of Grey: Glasgow 1956–1987* (Edinburgh: Mainstream Publishing, 1987), p.177.
13. The original painting is in the collection of the University of Strathclyde and is the concluding colour illustration in Hamish Whyte, ed., *Noise and Smoky Breath: An Illustrated Anthology of Glasgow Poems 1900–1983* (Glasgow: Third Eye Centre and Glasgow District Libraries Publications Board, 1983) (also in *FSA*).

Three

The Process of Jock McLeish and the Fiction of Alasdair Gray

Marshall Walker

Sandy-moustached, small-eyed Alasdair Gray comes from his self-portraits (words or pictures) candidly everything but long-bearded. It is not surprising, therefore, that long-bearded criticism has a hard time with him and with his works. The approach via sources and influences, for example, soon explodes so munificently beyond the manageable that only the longest, doggedest beard would persist with it. *Lanark's* Unthank and Institute, of course, prompt reference to Kafka; and the spirit and example of Italo Calvino, master of the playful nightmare, occupy a perch of vantage over *Unlikely Stories, Mostly, Lanark* and *1982 Janine*. This is to name but two of Gray's circus of Plutarchs and Holinsheds. The back cover of the paperback edition of *Lanark* advises readers that the author has been compared to, 'among others', Dante (the journey, infernos and purgatories, a few glimpses of paradise), John Bunyan (pilgrimage and allegory), William Blake (hostility towards exploitative industrial society, innocence versus experience), Lewis Carroll (fairy-tale surrealism), James Joyce (formal experiment and wordplay), Arnold Bennett (realism on way), Orwell and Huxley (dystopias regained), Stanley Spencer and Hieronymous Bosch (distortion of image with a social message).

A good list, to be sure, despite the absence of Jerzy Kosinski, Fielding, Sterne and, given Gray's predilection for unfortunate travellers, Thomas Nashe, though when it comes to painters Francis Bacon, surely, is the model for Duncan Thaw's vision of the faces of a boy and girl in the school refectory:

> . . . potatoes with crawling surfaces punctured by holes which opened and shut, holes blocked with coloured jelly or fringed with bone stumps, elastic holes through which air was sucked or squirted, holes secreting salt, wax, spittle and snot. (*L*, 232)

More important than any debate about literary forebears or the influential painter behind such a passage is the recognition of Gray's power to take his reader into the darkest interstices of consciousness and to bring him/her out again, a survivor of some of the worst or cheekiest the mind can do, bidding him/her a quizzical, take-it-or-leave-it 'Goodbye' and leaving him/her waiting for the next chirpily surgical, headlong, unnervingly original and comprehensive account of the human condition in our time. The tone of voice (admonitory whimsy, slightly pursed) often recalls that of J.M. Barrie as exemplified, say, by the elaborate opening stage directions for *The Twelve-Pound Look*.

It is clear from the loose, baggy monsters — tumultuous *Lanark* and anti-pornographic *1982 Janine* — that the mature Gray is still in touch with the earlier self who 'particularly liked *The Water Babies* because of the business of mixing genres'.[1] In the range of his imagined objects, from the dragonhide of *Lanark* through the rise and fall of Kelvin Walker to the provisional pornographies of *1982 Janine*, there are two common factors. The first is the insecure identity of the author; the second is the simultaneous flaunting and evasion of that problem in the joy of making 'imagined objects' (*SSP*, 12) with language. The objects transcend the problem, but the problem is the clue to the phenomenon of Gray and the development of his fiction.

Certainly, the approach by way of theme yields more than the contemplation of sources. Gray hates exploitation enough to portray it repeatedly in detail on public and personal levels. The 'cunning, straightfaced, pompous men' who use the puppet emperor in 'Five Letters from an Eastern Empire' (*US*) in a quaintly horrific reworking of the familiar Orwellian *1984* situation are the same people who run the omnipotent Institute in *Lanark* or, south of the border, perpetuate the class system variously represented by Harriet Shetland's mother and dangerously liberal headmistress in *Something Leather*. These people are deadly: Lanark arrives among them by being swallowed by the Glasgow Necropolis, by first becoming symbolically dead. They supply society's authority figures — doctors, teachers, ministers — and dispose of the unmalleable drones by relegating them to the central Pit where they become food and fuel to sustain their betters. The imaginative detail of Gray's bizarre invention in *Lanark* brilliantly reanimates simple Marxist propositions about class and power. As the court poet Bohu puts it in his poem for the Emperor in 'Five Letters', 'It is sad to be unnecessary' (*US*, 127). In *1982 Janine* exploitation on the personal level is at the centre of Jock McLeish's night of wilful schizophrenia and self-recrimination. Like William Golding's Sammy Mountjoy in *Free Fall* McLeish needs to find the point in his life where he went wrong. 'We all

have a moment when the road forks and we take the wrong turning',
McLeish says (*J*, 26) and goes on to find his crucial moment in the
discovery of Helen's pregnancy and his arranged marriage to her. At this
stage of the book, towards the end of Chapter 1, he has not peeled back
enough of the past to diagnose his life accurately. Golding's Sammy is
made wretched by his desertion of Beatrice Ifor; McLeish is in his
present self-destructive rhythm of drink, fantasy, anger and self-
excoriation because of his 'anti-Denny demolition job' (*J*, 244). Before
leaving Denny he teaches her about her position in the great chain of the
British exploitative system:

'. . . our own Sunday-supplement-swallowing middle class . . . if
they ever notice you, Denny, will find your wish to understand the
trap you are in amusingly naive, quite charmingly pathetic and
touching, really. But if you go on strike and demonstrate for better
wages (you won't, you have no union, but if you do) then cabinet
ministers drawing salaries of twenty-nine-thousand-nine-hundred-
and-fifty-a-year (on top of interest on private investments) will
appear on television to explain in brave, loud, haw-haw voices that
there is not enough money to help you, that your selfish greed is
the thing which has reduced Britain to its present deplorable
plight. And if you are asked to say something in your own defence,
Denny, your voice over the wireless waves will sound stupid and
funny because you don't know how to address the public. Your
school did not teach you to speak or think, it taught you to sit in
rows and be quiet under strong teachers or rowdy under weak ones.
The people who manage you, Denny, have been taught to make
brazen speeches in firm clear voices, THAT is FAR more
important than geography or technology, because RHETORIC
RULES, O.K.?' (*J*, 215)

McLeish proceeds to sin against his own light, preferring the high-
toned artificiality of Helen's drama-school accents and the convoluted
camaraderie of the festival players to Denny's integrity, plain speaking,
humility and devotion. He instructs Denny that she is one of the
exploited, and proves it by exploiting her himself.

Among the exploiters, the duplicitous banking nations, the eastern
communists, the Ozenfants and Mad Hislops, the English are the
supreme élite in Gray's warrantably paranoiac Scottish opinion, hence
the London-based business and media power structures over which
Kelvin Walker briefly triumphs, the Ministry of Social Stability in
McGrotty and Ludmilla which 'had been criticised in the House for
employing nobody but Etonians' (*ML*, 15), and the great theatrical
producer, Binkie, who, having 'once owned the whole of the West

End', can afford to show condescending tolerance towards McLeish's objections to a world where 'most folk were ignorant wee nails' (*J*, 258). Gray's plot is seen to thicken when we realise that he not only manipulates his hero Jock McLeish into manipulating Denny and manipulates his fantasised Janine to the point where she realises she is trapped in his narrative (*J*, 332), but also manipulates us, exploiting our habits of reading — the willingness with which we suspend disbelief for the sake of a story, especially one with so many dirty bits — to draw us into the transaction of the novel. Gray is doubtless acquainted with the nattier versions of contemporary reception theory, but his capacity for mischief would surely have been enough to enable him to pull us more winningly than any other contemporary writer I can think of (Calvino and possibly E.L. Doctorow apart) into the machinery of his book. This is the trick that makes him truly distinguished as a craftsman. The concept of split personality is interesting, perhaps, but even in Stevenson's time unexceptional; the creation of Jekyll and Hyde is a work of genius. So is Gray's creation of Lanark and Duncan Thaw to express a split of a different kind. A sequence of parental disconnections, broken relationships and bitter compensatory job-satisfaction is sad, but it is Janine, Superb, Denny, Helen, Mad Hislop and the involving oscillations between fantasy and fact that make it shapely and moving, and it is the experience of involvement that teaches us as we read that exploitation is the name of Gray's Hello-Goodbye game. From Gray himself with his urge to write to Jock with his urge to know and evade, to care and not to care, to Janine stuck in her sexy script, to Denny and Helen caught in their traps, to us caught in the novel until the releasing valediction (after the Epilogue) rhetoric rules, OK. Yet we are left with solidly human things: poor Lanark, after his surrealist purgatories is 'a slightly worried, ordinary old man' last glimpsed with the dignity of pleasure in seeing the light in the sky; poor Jock, chastened by the failure of whisky and sexual fantasy to provide the needed anodyne, will be kind to his sex-object. In both books, as in *Something Leather*, goodness of heart is displayed, tentatively perhaps, as a real if fragile possibility and, as in Dickens, the only reliable cure for all the ills modern man and woman are heirs to.

Scotland is another theme. Gray, together with James Kelman and Agnes Owens, co-authors of *Lean Tales*, lives, the book's blurb announces, 'in a British region containing the greatest number of unemployed Scots in the world, the biggest store of nuclear weapons in Europe, and very large lovely tracts of depopulated wilderness'. If England is the great external enemy, the arch-enemy is the one within, the Scottish character itself:

Who spread the story that the Scots are an INDEPENDENT people? Robert Burns . . . The truth is that we are a nation of arselickers, though we disguise it with surfaces: a surface of generous, openhanded manliness, a surface of dour practical integrity, a surface of futile maudlin defiance like when we break goalposts and windows after football matches on foreign soil and commit suicide on Hogmanay by leaping from fountains in Trafalgar Square. Which is why, when England allowed us a referendum on the subject, I voted for Scottish self-government. Not for one minute did I think it would make us more prosperous, we are a poor little country, always have been, always will be, but it would be a luxury to blame ourselves for the mess we are in instead of the bloody old Westminster parliament. (*J*, 65–6)

To this diatribe the writer of the festival play about Eustace McGrotty adds the contribution of 'wee hard men':

'The curse of Scotland is these wee hard men. I used to blame the English for our mediocrity. I thought they had colonised us by sheer cunning. They aren't very cunning. They've got more confidence and money than we have, so they can afford to lean back and smile while our own wee hard men hammer Scotland down to the same dull level as themselves.' (*J*, 288)

But if Scotland is exceptionally well-endowed with arselickers and wee hard men, it has not cornered the market in them. Towards the end of his night in the hotel in Peebles or Selkirk McLeish tells God, '*I no longer think Scotland worse than elsewhere*' (*J*, 311). The admission universalises the subject matter of the novel. As Gray's special place, Glasgow attracts particular criticism. Lanark's wish to leave the city is 'powerful and complete and equalled by a certainty that streets and buildings and diseased people stretched infinitely in every direction' (*L*, 46). Gray unmistakably specifies his city in *Lanark* with places Glaswegians of his generation will recognise: his Elite café is surely the old Curzon café at Charing Cross where in a dingy perpetual twilight they used to serve over-priced coffee in glass cups and saucers above a cinema that specialised in arty, continental and dirty-raincoat movies; there are Cowcaddens and the Glasgow School of Art, the Necropolis beside the Cathedral, the Clyde and the Saracen Street foundry recast as the Turk's Head forge. In *Something Leather* there are drinks in the bar of the Lorne Hotel, lodgings to be had in Minard Road, an exhibition planned for the McLellan Galleries in Sauchiehall Street, and a splendid view over Kelvingrove Park towards the pseudo-Gothic pinnacles of Glasgow University. In Chapter 22 of *Lanark* Kenneth McAlpin observes to Duncan Thaw that Glasgow is 'a magnificent city' and asks,

'Why do we hardly ever notice that?' Thaw's answer is, 'Because nobody imagines living here.' He explains further:

'. . . if a city hasn't been used by an artist not even the inhabitants live there imaginatively. What is Glasgow to most of us? A house, the place we work, a football park or golf course, some pubs and connecting streets . . . Imaginatively Glasgow exists as a music-hall song and a few bad novels. That's all we've given to the world outside. It's all we've given to ourselves'. (L, 243)

Gray has done more than any other writer of fiction to make this view of Glasgow obsolete, giving his city the imaginative life Thaw finds lacking. (To find his peers we must turn to the poets: Tom Leonard, Liz Lochhead, Edwin Morgan.) Thaw's comments were valid some twenty-five years ago at the time in which the novel is set, and *Lanark*, like any novel, demands to be read in terms of all its codes, including historical ones. In *Something Leather* Harriet's art dealer asks Linda to tell her 'about the European Cultcha Capital thing . . . Why Glasgow? How has a notoriously filthy hole become a shining light?' (*SL*, 171). From the perspective of Glasgow as European City of Culture for 1990 it is easier to detach local and historical elements and to see Gray's work in *Lanark* as a satire on the unreal city, the urban waste land produced by cynically exploitative political and commercial forces whose impact on the individual is illustrated by the fragmentation of the novel's eponymous hero into Lanark and Duncan Thaw. The two characters are one, yet they cannot cohere in this world any more than the assorted shadowy figures of Eliot's desert-city kaleidoscope cohere except in the teasing device of the ambiguous Tiresias.

1982 Janine develops this aspect of *Lanark*; it is about the problem of achieving a coherent self in the contemporary world. Gray's own confessed insecurity of self, projected in the compound fracture of Lanark-Thaw, is apparent in his *Saltire Self-Portrait* where he is either a birth certificate or a passport or a Beckettian inventory of physical characteristics or, somehow, something that emanated from his mother and the father whose autobiographical narrative accounts for nearly half the length of the pamphlet or the occasion of an art exhibition catalogue available for only five pounds from an address in Edinburgh. In *Lanark*, *1982 Janine* and *Something Leather* he tackles extremes of human emotion, but in *The Fall of Kelvin Walker* and *McGrotty and Ludmilla* pace and laconism suggest someone like Jill as perceived by Kelvin at their first meeting. 'Her voice was clear and curt and could have been called emotionless if the quick utterance had not suggested a wish to evade emotion' (*FKW*, 4). If he is possibly Kelvin Walker, capable of rebel Scottish assertiveness, but more susceptible to Calvinist extinction,

he is certainly his name itself, 'Gray', an amalgam of protesting growl
('Gr . . .') and fade (' . . . ay'). 'So what are you for, Gray?' he asks in
1988 in the Saltire pamphlet, and answers, 'At present I do not know'
(*SSP*, 3). It is the same question that can be seen in the canny eyes of his
human still lifes, Archie Hind, James Kelman, Liz Lochhead, Agnes
Owens or himself, as they look out at us like beefed-up yet oddly
unfinished Modiglianis, eyed in a watery Northern light, coolly waiting
for something definitive to happen. The poem 'Wanting' from the
sequence 'To Lyric Light, 1977–83' in *Old Negatives* is explicit:

I am new born.
I want to suck sweet and sing
and eat and laugh and run and
fuck and feel secure and own my own home
and receive the recognition due to a man in my position
and not have nobody to care for me
and not be lonely
and die.

(*ON*, 58)

Of course the cliché, 'recognition due to a man in my position'
underscores the absurdly overweening ambition of such elemental
aspirations. Perhaps the simple life was never really available. The
facing page of the book offers 'Awaiting', a more likely profile:

He was, and educated, and became
residing and remaining and intending,
then on became in, and again,
and later and later again.
He still is, and hopes, and intends,
and may
but is certain to –
one day.

(*ON*, 59)

This state of being unfinished, of sceptically becoming, perhaps unto
death, is the picture Gray provides of himself in the drawing that
prefaces his contribution to *Lean Tales*. The face looks down and out at
the reader while the pen continues to make the image (*LT*, 182). The
hand that holds the pen may more easily be imagined at the end of the
reader's arm than at the end of Gray's, although, of course, it is there
too. The invitation to finish the portrait in this drawing is like the
imposition on the reader to rearrange the order of material of *Lanark* or
Something Leather. It is analogous to the transaction between narrator and
reader in *1982 Janine*: from the opening sentence of the novel, 'This is a
good room' – an echo of Beckett's 'I am in my mother's room' at the

beginning of *Molloy* — we are buttonholed into a transaction by which Jock McLeish is to be rescued from becoming, from remaining and intending, and to be given definition. This is hard to give because McLeish is more process than character. Despite the specifics of his life and background he is an amorphous soul kept formless until the last page of the novel by the rivalry between fantasy and politics.

Jock McLeish personifies both the impulse to run from the past — 'Oh forget it forget it forget it' (*J*, 23) — and the power of the past to assert itself over the arts of escape. 'I want to be free, and freedom is freedom from other people', Lanark tells Ozenfant (*L*, 70). The past is other people for McLeish who wants to be free from his failure to recognise his mother's frustration, his failure to connect with his father, his failure to live in terms of Denny's goodness. He tries to obliterate his record of failure by elaborate pornographic fantasy and by competing, equally elaborate excursions into political analysis. His final success is another failure: neither sexual fantasy nor political hectoring can suppress the demand of the self to be solid. 'Enjoyable wicked fantasy' (*J*, 25) yields to the pressure of reality and towards morning the admission erupts, a *cri perçant* that cuts the pornography to a few remaining broken images of Janine in cowhide breeks reading about 'nudeunderwhiteskirtshirt' Nina: 'I can put up with a lot of present misery if it is solidly based, but if I am wrong about my past WHO AM I?' (*J*, 329) You are, of course, Mr Alasdair Gray, making an 'imagined object' which demonstrates at once the allure and the insufficiency of evasion by sexual fantasy.

Politics is McLeish's other bolt-hole. 'Everything I know, everything I am has been permitted or buggered up by some sort of political arrangement' (*J*, 232), he says, passing the buck and invoking anger to deflect the guilt of his manipulation and betrayal of Denny. The reader must be impressed: in energy and range his political pronouncements are engaging and plausible, that is, they as nearly sidetrack attention from the real problem of Jock McLeish as the pornographic narratives nearly displace the real story of their creator's desperate case. The apparent simultaneity of McLeish's self-concern and his concern for the world is seductive to the contemporary liberal mind. Here is a man whose personal life is a mess, agonising about the failure of socialism, the condition of the British working class, boat people, Vietnamese orphans and the failure of space exploration to discover extraterrestrial intelligence. Here is a man so involved in his time that he dreams his skin is newsprint:

> I lay in the water feeling very relaxed and watching the skin unwinding from around my chest in broad strips. As the strips floated up and flattened out on the surface I saw they were printed

like newspapers with columns of words, dim photographs, an occasional headline. I was not interested in this old news, I wanted to see what was underneath. In a leisurely way I picked and peeled off the layers of skin-newsprint which still stuck to my chest until I had exposed the whole ribcage. I could see only blackness inside but I knew it contained a rare work of art, a white ivory figure of a girl, obscenely mutilated. I pushed my fingers between the ribs and almost managed to touch her. (*J*, 132)

The moral gain of McLeish's panoptic social conscience is undercut by the end of the paragraph. His political moralising about the condition of the world slips, slides and perishes because in his own life the figure of a girl is obscenely mutilated. The situation illustrates an especially damaging effect of the 'more brutal standard', the 'new terminal standard, indifferent to persons' to which Saul Bellow's Herzog refers in his variation on Gresham's law:

Public life drives out private life. The more political our society becomes (in the broadest sense of 'political' – the obsessions, the compulsions of collectivity) the more individuality seems lost.[2]

Bellow expresses this idea more fully in notes he wrote for *Encounter* about mid-century American fiction:

There is not much we can do about the crises of international politics, the revolutions in Asia and Africa, the rise and transformation of masses. Technical and political decisions, invisible powers, secrets which can be shared only by a small élite, render the private will helpless and lead the individual into curious forms of behaviour in the private sphere.[3]

The passion of McLeish's political rhapsodies is the passion with which he wants to blame this 'more brutal standard' for his curious forms of behaviour, for injuries inflicted by his helpless will. His arts of evasion derive, paradoxically, from true aspects of himself. It is because he is genuinely in need of sexual fulfilment and genuinely concerned about the world that he knows how to dodge, at least for a while, the painful issue of the central self by immersion in pornography and politics. Pornography and politics become subtexts that attempt to displace text; both are ploys that finally do not work. It is McLeish's victory that, in the end, he triumphs over the power of his own imagination and re-enters the real world in which responsibly willed private life comes first. The text wins over its antibodies and the new story of Jock McLeish is ready to begin.

After breakfast, purged by his night of clarifying anguish, McLeish will stand on a railway platform, an image of Alasdair Gray the maker, processed enough to be ready for new destinations after *Lanark*, the big

book of his city and *1982 Janine*, the big book of his becoming. He knows his place now and the scope and limits of imagination. These preliminaries behind him, he can proceed to the compressed comic moralities of *The Fall of Kelvin Walker* and *McGrotty and Ludmilla*, and the rather less compressed fable of women in love (and men on the margin), *Something Leather*. The uncertain Gray self, tented and steadied by the projections of *Lanark* and *1982 Janine*, is the self secure enough to let the story-teller relish the joy of making his imagined objects and robust enough to take Kathy Acker's advice and overcome his writer's block by making a story about a woman from a leather-suited girl glimpsed in Queen Street Station (*SL*,232–3)

Kelvin Walker, a Scottish modification of Denry Machin, protagonist of Arnold Bennett's *The Card*, with a hint of Melville's weirdly resolute Bartleby (*FKW*, 47), tries to be a wee hard man, but Calvin has him by the thrapple, or, more exactly, by the father — a perfect illustration of the Scottish character ensuring its own downfall. Kelvin is from Glaik (trick, prank, deception) but semantically his derivation also means that he is 'glaikit' (senseless, foolish, stupid; thoughtless, giddy, inattentive). Possessed of a 'blank, nearly characterless face' (*FKW*, 1) he is clumsily equal to any situation, behaving by formulae and quite unable to follow Jill's advice 'just to act naturally' (*FKW*, 10). The substitution of Nietzsche's formulae for God's is merely the temporary replacement of one kind of self-righteousness with another, and the capitulation of Jill sends him back to the God who always commanded belief even when dead (*FKW*, 120). Kelvin would have appreciated the graffito spray-painted on an underpass of the Los Angeles freeway system: 'Nietzsche is dead, signed God'. Nietzschean or Free Seceding Presbyterian, Kelvin is interested only in power (*FKW*, 52) and is easily cued back to the foetal position (*FKW*, 132) and a career in Scottish Church politics by the Session-Clerk father who represents a power the supremacy of which was never really in doubt even when posthumous. McGrotty, just as blank at the beginning of his story as Kelvin is on his first day in London, succeeds in becoming a wee hard man — and scourge of the smug, dissipated English — because he grasps 'the consolidations of mere power, little though he valued them' (*ML*, 100) for the sake of winning Ludmilla. *Amor vincit omnia*, including even the stigma of Scottish origin. Sexual power yields to deeper feeling in *Something Leather*. Characters who might have played their part in the Janine/Superb script of *1982 Janine* promote expectations in the reader like those Jock McLeish pornographically stimulates in himself. Jock emerges from fantasy into reality; and in the context of corrupt and corrupting class and sexual systems June, Senga, Harry and Donalda

find, to the reader's surprise, under the kinks and the comedy of upper-class English phonetically rendered, good old-fashioned love. It is Gray's only sentimental story so far.

So far. Any discussion of a living, active artist faces special difficulties. Given a sense of the writer's stature, the opportunity to salute and encourage is invaluable, and the essays in this collection are offered in the conviction that Alasdair Gray's stature is established. But the evidence is not all in and the stature not yet measurable. The process, happily, continues.

NOTES

1. 'Alasdair Gray Interviewed by Jennie Renton', *Scottish Book Collector*, August/September 1988, p.3.
2. Saul Bellow, *Herzog* (London: Weidenfeld & Nicolson, 1965), p.162.
3. Saul Bellow, 'Some Notes on Recent American Fiction', *Encounter* 21 (5), 1963, p.23.

Four

Alasdair Gray and the Postmodern

Randall Stevenson

'Aren't you sick of being a Post-Modernist?' asks a man from the colour supplement of a Sunday newspaper. He is famous for his articles on artistic topics because he refers knowingly to famous foreigners in a way suggesting that no intelligent Briton need bother with them. (*SL*, 145)

I

Alasdair Gray sounds rather sceptical about postmodernism in the extract above, and has elsewhere denied knowing what it means.[1] So it is worth starting with an outline of how and why the term has come to be used, and of how it may apply to Gray's writing. Two of the best of many recent commentators on postmodernism suggest a natural shape for this outline. Ihab Hassan remarks: 'The first impulse of every critic of postmodernism . . . is still to relate it to the semanteme it contains: namely, modernism.' Brian McHale, in his study *Postmodernist Fiction*, chooses 'to emphasize the element of logical and historical *consequence* rather than sheer temporal *posteriority*. Postmodernism follows *from* modernism, in some sense, more than it follows *after* modernism.'[2] As they suggest, making sense of postmodernist fiction involves going back to the technical innovations introduced to the novel by the modernists and identifying what consequences – extensions, adaptations, reorientations – have followed in the writing of the past half-century or so.

This identification, however, is not uniformly straightforward. Some of modernism's best acts were also the hardest ones to follow, or at any rate to take further. Modernist stream of consciousness and interior monologue, for example – satisfying Virginia Woolf's demand that the

novel 'look within' and 'examine the mind' – continue to provide a technical resource for later fiction, without often being taken forward into further innovation. Nevertheless, the sort of mind which later writing has chosen to examine does create some new challenges for the stream of consciousness. Some of these appear, for example, in Malcolm Lowry's *Under the Volcano* (1947), transcribing the thoughts of a permanently drunk protagonist; or in the twilit states created by Samuel Beckett's monologues in the triology *Molloy, Malone Dies, The Unnamable* (1950–2); or, more recently, in the failing, geriatric consciousnesses B.S. Johnson dramatises in *House Mother Normal* (1971). None of these developments much affects Alasdair Gray, except in *1982 Janine*. Presenting a mind wandering in and out of semi-consciousness, warped by marauding fantasies and increasing immersion in alcohol, Gray's first-person, present-tense narrative shares ways in which stream of consciousness has developed since Joyce, in Lowry's work particularly.

'Logical and historical consequences' follow more obviously, and more generally, from modernism's new views of time and history. In her essay 'Modern Fiction' (1919), Virginia Woolf adds to her view that the novel should 'look within' the suggestion that movement within consciousness shows life as something other than 'a series . . . symmetrically arranged'.[3] A feature of modernism, nearly as distinctive as its invention of new registers for dramatising thought, is its abandonment of conventions of chronological narrative arrangement. Long histories of personal development in Victorian fiction are replaced in *Ulysses* (1922) or *Mrs Dalloway* (1925) by concentration within a single day of consciousness, into which past events are randomly inserted by memory. Time and history grow less and less conceivable by means of the logical, measured progress of clock and calendar. Shredding and slicing life, in Woolf's view, or menacing it with madness, in Lawrence's, clocks provide for modernist fiction more of a threat than a plausible, reliable sense of order.

This sense of order has been further, often more extravagantly subverted in later writing. William Golding's *Pincher Martin* (1956), for example, an influence Gray records in *Lanark*, practises an extreme form of modernism's abbreviation, reflecting the whole life of its protagonist supposedly in the single instant of his death. Lawrence Durrell sustains in his own way in *The Alexandria Quartet* (1957–60) what he calls the 'challenge to the serial form of the modern novel', following the same set of events, successively, from three different points of view. In *The Connecting Door* (1962) and *Two Moons* (1977), Rayner Heppenstall simultaneously presents two different periods of time. Comparable double-narrative tactics appear in Brigid Brophy's *In*

Transit (1969), and in Peter Ackroyd's *Hawksmoor* (1985), which sets alternate chapters in modern and in early eighteenth-century London. Serial form is most radically undermined by one of the most determinedly experimental of recent British novelists, B.S. Johnson, whose famous novel-in-a-box *The Unfortunates* (1969) is made up of loose-leaf sheets, intended, as a note on the box explains, 'to be read in random order'.

Widespread appearance of random or non-serial assemblages of this kind confirms the judgement of the Italian postmodernist Italo Calvino, who suggests that for the contemporary novel 'the dimension of time has been shattered, we cannot love or think except in fragments of time . . . time . . . seems[s] to have exploded.'[4] Alasdair Gray's writing, particularly in *Lanark*, obviously shares this sense of a fragmented, incoherent, even apocalyptic history. With its individual books ordered Three, One, Two, Four; a prologue inserted between Books One and Three; and an epilogue somewhere towards the end of Book Four, *Lanark* thoroughly challenges serial form – its author, or his spokesman, explaining 'I want *Lanark* to be read in one order but eventually thought of in another' (*L*, 483). Temporal and other orders are further subverted in the Intercalendrical Zone which Lanark and Rima drift into in Book Four. As in an earlier, modernist, post-mortem fantasy, Wyndham Lewis's *The Childermass* (1928) – as usual, Gray acknowledges his debt in the 'Epilogue' – dimensions not only of time but of space have been shattered. Up and down are interchangeable, forward direction impossible to pursue, and duration unmeasurable in any conventional way. Shifting and resistant to definition, Gray's Intercalendrical Zone is a summary figuration of a wider postmodernist vision in which, as various of Gray's characters remark, 'we don't bother much with time, now . . . none of the clocks . . . can be relied on, least of all the ones that go' (*L*, 18, 273).

Lanark also provides some evidence of *why*, since modernism appeared early this century, the clock has continued to seem such an unreliable, even invidious instrument. Modernism's new chronologies are often critically assessed – sensibly enough – as a response to the collapse of a coherent history in 1914. Contemporary views of time, however, were also pervasively influenced by developments reaching Britain at least a decade earlier. By the 1890s, technology had become available to ensure that employees had to 'clock in' and 'clock out' of their place of work. Around the same time, the theories of Frederick Taylor began to disseminate ideas of 'scientific management' – ways of minutely controlling a labour force, devoted to repetitive mechanical tasks whose value and duration were established by 'time and

motion study'. Some of the results of these systems, for industrial organisation and the individuals caught up within it, are summarised in 'The Industrial Magnate' chapter of D.H. Lawrence's *Women in Love* (1921):

> Everything was run on the most accurate and delicate scientific method, educated and expert men were in control everywhere, the miners were reduced to mere mechanical instruments . . . [in] a new order, strict, terrible, inhuman . . . a great and perfect system that subjected life to pure mechanical principles . . . the substitution of the mechancial principle for the organic.

Considering the mines and their organisation, Lawrence's heroine Gudrun thinks of human beings who have 'become instruments, pure machines, pure wills, that work like clockwork, in perpetual repetition', and fears

> the wheels within wheels of people, it makes one's head tick like a clock, with a very madness of dead mechanical monotony and meaninglessness.[5]

No wonder, then, that modernism turned against the clock, emblem as well as agent of a dehumanising new industrial regimentation. Everyday life in the later twentieth century has been subjected to a steady strengthening of 'mechanical principles', and postmodernist writing – in certain phases at least – has continued to be concerned with them. The first of the above passages, in particular, could almost as aptly be used to describe the Institute in *Lanark* as the mine in *Women in Love*: Gray, throughout *Lanark*, concerns himself with what is only a later, expanded version of the industrialised capitalism which horrified Lawrence. The differences between the two visions mostly follow from the ways technology has enlarged possibilities for establishing 'a great and perfect system'; for consolidating new orders, 'strict, terrible, inhuman'. *Lanark* expands these possibilities still further, into nightmare and fantasy. Technology enables 'the creature' – 'a conspiracy which owns and manipulates everything for profit' (L, 410) to make entirely literal what used to be only metaphors of commodification and consumption: men and women, in the Institute, are actually turned into food and eaten.

The task of turning everything to profit is also assisted by advertising, by the sort of slogans that assail Lanark in Unthank:

MONEY IS TIME. BUY TIME . . . QUICK MONEY IS TIME IN YOUR POCKET – BUY MONEY . . . MONEY IS TIME. TIME IS LIFE. BUY MORE LIFE FOR YOUR FAMILY . . (THEY'LL LOVE YOU FOR IT.) (L, 432–3, 454)

Against this Taylorised, technologised, late capitalist equation of
money, love and time, the vagueness of the Intercalendrical Zone
actually provides some relief. Hardly a pastoral idyll nor a restoration of
'organic principle' — it is full of sand, wrecks, and toadstools — it is
nevertheless the place where Rima discovers herself absorbed in one
natural cycle of time, pregnancy. And the feelings which the child
arouses come as close as anything to providing a sense of hope, or of a
viable future, anywhere in Unthank. Learning of her pregnancy at the
end of Chapter 33, 'A Zone', Lanark feels 'a burden lifted from him, a
burden he had carried all his life' (L, 386). Emblematically and
actually, the zone and what happens in it offer an escape from 'the
material of time . . . respect for the decimal hour' (L, 416) which are
used by the creature to control the reified humanity in the Institute and
Unthank.

The novel's own playing with orders of reading likewise lifts from
readers the burden of control by conventional chronology. This non-
chronological structure in *Lanark*, and the more general postmodernist
disinclination to 'bother much with time', suggest that the 'logical and
historical consequences' of modernism need to be understood not only
within literary history, but within the wider political history of the
twentieth century as a whole. Responses to the pressures of their own
age, the literary innovations of modernism enlarged the repertoire of
convention-breaking forms available to later writers. Expanding stresses
of a late capitalist age have continued to direct the formal choices
authors make, adapting or reshaping their antecedents to find new
imaginations which can resist system, 'mechanical principle', and the
dead hand of the clock.

Another area of modernist innovation, perhaps with greater conse-
quences for later writing even than its fractured chronologies, appears in
its frequent, self-reflexive concern with art. Wyndham Lewis's *Tarr*
(1918), for example, or Joyce's *A Portrait of the Artist as a Young Man*
(1916), each shows an author chasing his own tale, following the
development of a partly-autobiographical hero who discusses aesthetics
of interest to the writer himself. The development of Joyce's writing, in
Portrait and beyond, sets a pattern for later fiction's self-reflexiveness,
focused on matters of language and style. Joyce's hero Stephen wonders
in *Portrait* if he may not love 'words better than their associations'.[6]
Competition between love of words and the world they represent
expands in the huge parodies of *Ulysses*, directing interest as much upon
the novel's own means of expression, and upon the linguistic resources
of fiction generally, as upon anything they may be used to express. The

'Work in Progress' with which Joyce followed *Ulysses* greatly extends this interest. Constant playful forging of a self-referential language is summed up by the phrase 'say mangraphique, may say nay por daguerre'.[7] 'Work in Progress', eventually published as *Finnegans Wake* in 1939, is primarily 'graphique', not 'por daguerre': it is writing for itself, not as daguerrotype or any other semi-photographic attempt to represent reality. In an essay written at the end of the 1920s in support of Joyce's methods, Eugene Jolas explained:

> The epoch when the writer photographed the life about him with the mechanics of words redolent of the daguerrotype, is happily drawing to its close. The new artist of the word has recognised the autonomy of language.[8]

Many other critics have seen Joyce's 'autonomy of language' as marking a decisive break with earlier epochs of writing, realist or modernist. Ihab Hassan calls *Finnegans Wake* 'a "monstrous prophecy of our postmodernity" . . . both augur and theory of a certain kind of literature'.[9] *Finnegans Wake* also helps confirm the distinction between modernism and postmodernism established by Brian McHale. McHale sees modernism dominated by epistemological questions about how reality can be known or assimilated by mind, language or text. Postmodernism, on the other hand, assumes reality to be non-existent or inaccessible and investigates instead what worlds texts can project — the sort of question Nastler raises in *Lanark*, for example, when he talks to his hero about 'this book . . . this world, I meant to say . . . our printed world' (*L*, 480, 485). In Joyce's case, Stephen's uncertainty about relations between word and world shows in *Portrait* the epistemological concerns of modernism. In *Finnegans Wake*, the breach between word and world is no longer a matter of doubt but of certainty, even celebration, allowing the creation of a self-contained world, ontologically disjunct, ostentatiously made of words fleeing their denotative function.

If, as Hassan claims, all this is an augur and a prophecy, what literature did it inaugurate, and what is Alasdair Gray's place within it? Two other Irish writers served as intermediaries between Joyce and later developments. Aware of Joyce's work throughout its progress, Samuel Beckett extends the 'automony of language' into his trilogy, which, as the Unnamable remarks, 'all boils down to a question of words . . . all words, there's nothing else'.[10] Each of Beckett's narrators spins endless stories while discussing and demonstrating the inadequacies of the medium he employs, and the failure of an imagination which cannot long sustain a narrative separate from an unutterably empty life. Language

and story-telling become central subjects of the trilogy, but in a desolate vision that finds their consolations simultaneously unsustainable yet absolutely necessary.

Like Beckett, though more cheerfully, Flann O'Brien also follows in the wake of Joyce, whom the narrator of *At Swim-Two-Birds* finds 'indispensable . . . to an appreciation of the nature of contemporary literature'.[11] The material of 'Work in Progress' unfolds in the dreaming mind of a Dublin publican: the story told in *At Swim-Two-Birds* concerns a publican who operates his imagination more systematically, locking up his fictional characters 'so that he can keep an eye on them and see that there is no boozing' (p.235). Unfortunately, they break free while he sleeps, take over his story themselves, and use it to take revenge for his previous despotic treatment. Like Beckett's trilogy, *At Swim-Two-Birds* is a story about telling stories about storytelling. Extending the 'augury' of *Finnegans Wake*, each work is a postmodernist paradigm, a prophecy of the self-reflexive foregrounding of language and fiction-making which has become the distinguishing characteristic of postmodernism. In the years since Beckett and Flann O'Brien wrote, novels in which authors or author-figures discuss their own work, or tell stories about story-telling, have appeared almost too frequently to be conveniently listed. In *The Alexandria Quartet*, for example, Lawrence Durrell's narrator discusses aesthetic paradoxes, including ones affecting the text in which he figures, quite often enough to justify Durrell's conclusion that nowadays 'the novel is only half secretly about art, the great subject of modern artists'.[12] Similar discussions occur in *The French Lieutenant's Woman* (1969), John Fowles (or a spokesman for him) appearing at the start of Chapter 13 to outline authorial tactics and explain that 'this story I am telling is all imagination'. In *Christie Malry's Own Double Entry* (1973), B.S. Johnson takes time out from his story to talk over its progress and likely conclusion with his hero. Comparable commentaries on their own practice and proceeding, or enactments in their texts of problematic relations between language, fiction and reality also appear in the recent work of John Berger, Julian Barnes, Christine Brooke-Rose, David Caute, Giles Gordon, Muriel Spark and many others. Alain Robbe-Grillet, admired in *The French Lieutenant's Woman* as a mentor of Fowles's own tactics, once remarked:

> After Joyce . . . it seems we are more and more moving towards an age of fiction in which the problems of writing will be lucidly envisaged by the novelist, and in which his concern with critical matters, far from sterilising his creative faculties, will on the contrary supply him with motive power . . . Invention and imagination may finally become the subject of the book.[13]

For some time now, it has been clear that this postmodernist age has arrived: Alasdair Gray, sharing many of the forms and priorities of the writers mentioned above, is most appropriately seen to be working in it. 'Concern with critical matters', first of all, is a frequent, obvious feature of his writing, and usually a source of humour or irony rather than sterility. The Epilogue in *Lanark*, for example, cheerfully offers 'critical notes which will save research scholars years of toil' (*L*, 483); while further 'critic fuel' also appears in the Epilogue to *Something Leather* and the 'Epilogue for the Discerning Critic' in *1982 Janine*. A parodic gesture at criticism even spills over into Gray's book covers and dust-jacket notes, typically of postmodernism's ludic urge to take fiction and imaginative play beyond their usual limits. Gray also achieves this in another way, by including in his novels so many icons and drawings, complexly related to a text which is itself often transformed by alternations of typeface or unconventional typographical layout.

Confrontation between author and character is likewise a device Gray shares with other recent authors, such as John Fowles and B.S. Johnson; or with Flann O'Brien, whose construction of a story about story-telling in *At Swim-Two-Birds* is also a source for tactics which reappear throughout Gray's fiction. *At Swim-Two-Birds* provides the epigraph for *Something Leather*, really an explanation of the novel's structure, which is further clarified by the 'Dad's Story' section, its central character a kind of figuration of the author himself. The same role is filled by Nastler in *Lanark*, trying to explain in the Epilogue the principles of construction of the fiction in which he appears, a task also undertaken in somewhat different terms by Jock McLeish in *1982 Janine*.

Flann O'Brien's narrator provides a further, facetious suggestion about the proper construction of fiction, apparently taken up seriously in *Lanark*, when he remarks in *At Swim-Two-Birds*:

> The entire corpus of existing literature should be regarded as a limbo from which discerning authors could draw their characters as required, creating only when they failed to find a suitable existing puppet. The modern novel should be largely a work of reference. (p.25)

Lanark is a thoroughly derivative novel, with many characters largely 'puppets' drawn from 'existing literature' – Thaw, for example, an extension of Joyce Cary's artist heroes; Lanark an amalgam of figures from H.G. Wells and the posthumous heroes of Wyndham Lewis. In form and story as well as character, *Lanark* is so obviously a 'work of reference' that the playful list of references and plagiarisms in the Epilogue is almost superfluous – though as Gray explains, it does function as a timely, if partial, deflection of criticism, making a virtue,

or a joke, of necessity. It also shows Gray highly self-conscious about using self-conscious forms of fiction: postmodernism, once largely directed by the urge to parody and subvert conventional forms of writing, becomes in its turn a recognised, accepted form to be parodied and played with itself. Perhaps this makes Gray a post-postmodernist, though that might really be a term to puzzle him.

1982 Janine is a less obviously derivative novel than *Lanark*, though its epilogue still includes mention of *At Swim-Two-Birds* as the model of 'an elaborate fantasy within a plausible everyday fiction' (*J*, 343). *1982 Janine*, however, is so much bleaker than anything in O'Brien's largely comic vision that it seems closer in spirit, if not in style, to Beckett in the trilogy. Jock McLeish's description of his drab, anonymous, 'good room' makes it resemble some of the amorphous domains confining Beckett's characters. His compulsive, self-consoling, self-titillating narrative, constantly qualified by commentary on how best it can be conducted, is likewise comparable to the attempts by Beckett's narrators to distract themselves with precariously-projected imaginative worlds. Like them, McLeish is unable to keep details of his own life safely disjunct from the story he tells. Even when most entranced by his 'Superb' erotic heroine, he asks himself:

> Why does this imaginary stuff seem familiar? IMPORTANT DIFFERENCES BETWEEN SUPERB AND MY FORMER WIFE . . . Superb is imaginary. Helen was real. Why can't I keep them apart? . . . I wanted to keep fantasy and reality firmly separate. (*J*, 33, 41)

Despite his efforts, misery punctures McLeish's fantasies, letting reality haemorrhage back into his tortured mind. Its expanding confusion and torment are graphically signified in Chapter 11 by the sort of wild typographical chaos Christine Brooke-Rose uses in *Thru* (1972): its eventual silence and stillness is indicated by a section of blank pages, the device B.S. Johnson employs in *House Mother Normal* (1971) to indicate unconsciousness or death.

1982 Janine, then, as much as *Lanark*, shows Gray's writing sharing in styles and concerns which can be traced logically and historically back to modernism. *1982 Janine* also helps suggest the place of fantasy within this logic and history. Modernism's epistemological concerns fretted over fissures between mind and reality, and a concomitant crisis in language was defined and fuelled by Ferdinand de Saussure's linguistics, published in 1916, showing signifier and signified, word and world, related only arbitrarily. *Finnegans Wake* illustrates one extension of this thinking, its language, detached from a secure representative function, forming instead an autonomous world of its

own. An extension of another sort appears in the growth of the genres of science fiction and fantasy throughout the twentieth century. If reality cannot be wholly known, nor language any longer conceived as tightly connected to it, why should not words be used to create other worlds? Especially if as Jorge Luis Borges suggests in his postmodernist parable 'Tlön, Uqbar, Orbis Tertius' – and Jock McLeish believes in *1982 Janine* – such artificial domains can be richer and more seductive than anything offered by the political actualities of twentieth-century life. Something of postmodernism's ontological shift, in other words, also informs fantasy's cheerful other-worldliness. As Brian McHale suggests, postmodernism and science fiction can thus be seen as siblings, sharing a common descent in the twentieth century:

> . . . the two ontological sister genres, science fiction and postmodernist fiction, have been pursuing analogous but independent courses of development . . . along parallel but independent tracks. (p.65)

In fact, the tracks are not always so independent, and several contemporary writers switch fairly frequently between them. Brian Aldiss, for example, principally a writer of science fiction, moves into a kind of postmodernism in *Barefoot in the Head* (1969), while Christopher Priest, Doris Lessing, or Angela Carter in *The Infernal Desire Machines of Dr Hoffman* (1972) show an equal capacity to move the other way, towards fantasy or science fiction. Despite Nastler's furious assertion '*I am not writing* science fiction' (*L*, 497–8), it is really in this recent context of combined science fiction and postmodernist forms that *Lanark* belongs. Fantasy is nevertheless very particularly used by Gray, not as escape but as satire. *Lanark* offers anything but Tlön's orderly refuge from twentieth-century history. Instead, Gray's dystopian vision uses fantasy to enlarge and make objective some of the problems of this history, emphasising how urgently they need to be addressed.

II

Gray's work, then, belongs with a phase of fiction which does descend from modernism, however much or little Gray himself may appreciate description of it, or of his own writing, as postmodernist. His scepticism, however, does have at least one good excuse. Postmodernism is a word nowadays used more often with modish vagueness than with any logical or historical particularity; as Umberto Eco complains: 'Unfortunately, "postmodern" is a term *bon a tout faire* . . . it is applied today to anything the user happens to like.'[14] Placing contemporary postmodernism in relation to twentieth-century literary history, showing how it follows from modernist innovation, is increasingly

necessary if the term is to continue meaning anything specific for literary criticism. There is a further, particular need for this historical perspective in the context of British writing, which is often thought to lack direct or consequential descent from modernism almost altogether. Malcolm Bradbury, for example, talks of a 'shift or lapse' in the 'experimental tradition', and B.S. Johnson laments the generations of British novelists who have dropped the 'baton of innovation' passed on to them by Joyce.[15] There are many other commentators who, in talking about postmodernism, cheerfully follow the journalist in *Something Leather* who 'refers knowingly to famous foreigners in a way suggesting that no intelligent Briton need bother with them'. Discerning readers may already be puzzled by a discussion of postmodernism which has followed almost opposite tactics, so far using Umberto Eco, Alain Robbe-Grillet, Italo Calvino and Jorge Luis Borges only as critical commentators, while making no mention at all of Gabriel García Márquez, Julio Cortazar, Robert Coover, Thomas Pynchon, or Milorad Pavić. Omitting these and other famous foreigners has the advantage of leaving more space to show Gray's writing as part of a postmodernism which does exist, if perhaps less illustriously, in the domestic as well as the international scene.

The domestic scene so far surveyed, however, is itself significantly international. The experimental tradition outlined begins with one Irishman, Joyce, and is carried forward by two others, Beckett and Flann O'Brien, while several of the later writers who continue in it — John Berger, John Fowles, Muriel Spark or Christine Brooke-Rose, for example — have been at least as influenced by French writing, especially the *nouveau roman*, as by anything in English. Yet there is reason to think that what critics have sometimes construed as a limitation in native British postmodernism — its need to borrow creative energies from abroad — may also be part of a wider condition of potential strength, or, at any rate, a natural response to a world increasingly multinational in culture as well as commerce. International influence or inspiration is anything but unique to postmodernist writing in Britain: it is a useful, perhaps even a necessary condition for any such writing. Awareness of another nation's literature helps establish for authors a sense of the particular character and limitations of their own, encouraging pursuit of alternative possibilities and creating the conflict of codes and expectations on which postmodernism thrives.

Something similar results from tensions which grow up among different languages and dialects. Such tensions the Soviet theorist Mikhail Bakhtin has shown, in general, fundamental to the creation and development of the genre of the novel, whose discourse he sees as

essentially polyphonic, as 'a *system* of languages that mutually and ideologically interanimate each other'.[16] *Re*creation and *re*development of the novel genre – the business of postmodernism – may be likeliest to occur at points where conflicts between national languages or dialects particularly intensify the kind of polyphony Bakhtin outlines. One such point is indicated by Stephen Dedalus in *A Portrait of the Artist as a Young Man* when he remarks of an English priest:

> His language, so familiar and so foreign, will always be for me an acquired speech. I have not made or accepted its words. My voice holds them at bay. My soul frets in the shadow of his language.
> (p. 189)

'Fretting' against the English language and its accepted forms helps account for the range of parodies in *Ulysses* and the revolutionary, self-conscious linguistic of *Finnegans Wake*. The continuing inventiveness of Irish literature may be owed partly to a permanent sense of existence in the shadow of an English language and culture authors feel they must adapt or resist rather than 'accept'.

Writers within mainland Britain are increasingly likely to experience comparable feelings. While the affluent, Conservative-dominated south-east of England grows further apart from the rest of Britain, yet retains control over the language and ideology of most of its media, a sense of separateness and of the need for separate speech and form is likely to gain ground elsewhere. It is already apparent, in one way, in the work of writers such as Salman Rushdie and Timothy Mo, whose novels exemplify the postmodernist potential created by the many immigrants, multilingual and multicultural, now fretting against the familiar yet foreign forms of English language and British society. Since Scotland has a longer and still more fretful history of cultural, linguistic, and desired political separateness, it would be logical to expect a postmodernist writing – essentially a writing of 'difference' – to appear here as well. In Alasdair Gray's work; in some of James Kelman's; in Ron Butlin's *The Sound of my Voice* (1987) – which one recent critic sees clearly allied to Michel Butor and the *nouveau roman* – there are signs that this logic is beginning to have effect.[17] If, as Linda Hutcheon suggests, postmodernism offers particular opportunities for 'the contesting of centralisation of culture through the valuing of the local and peripheral', it seems likely that Scottish authors will continue to contribute, alongside other post-colonial minorities, to a postmodernism which may develop much more strongly in Britain, by the end of the century, than it has in the past.

There is a body of opinion, however, which would view this eventuality less than cheerfully. As Linda Hutcheon also points out in

A Poetics of Postmodernism (1988), there are now too many critics to list who
find postmodernist writing 'a form of solipsistic navel gazing and empty
ludic game-playing'.[18] Self-reflexiveness, for such critics, replaces with
sterile narcissism the novel's conventional responsibility to human
realities in the world it surveys: indulgent aestheticism evades the
historical and political. For Fredric Jameson, for example, postmodernism
is 'an alarming and pathological symptom of a society that has become
incapable of dealing with time and history'.[19] Increasingly, postmodern-
ism may be seen not just as a symptom, but even as a contributory cause
of social malaise. It may once have been a site of radical challenge to
conventional forms and structures, or of subversive questioning of the
means through which reality can be conveniently moulded, mediated
and made consumable. What was once challenging, however, has
grown increasingly familiar, even chic; institutionalised into fashions
and styles which can be used to assist rather than subvert the processes
of a consumer society. Such styles are now used with equal confidence in
slick television detective serials, for example; or in advertisements for
coffee; and are discussed with glossy confidence, as Gray notices, in the
colour supplement of *The Sunday Times*. Postmodernism may simply
have been domesticated, tamed into feeding the 'creature' it once
seemed equipped to threaten and condemn.

Gray's own writing cannot be completely cleared of doubts raised by
these trends, or by critics of them such as Jameson. His novels, and
their epilogues in particular, are hardly innocent either of narcissism, or
of a modish, often naïve urge simply to flirt with fashionable styles, or
to flaunt a new, post-postmodernist pretentiousness. Yet if Gray's
postmodernism cannot be entirely defended, nor should it be wholly
condemned. Postmodernism may have lost its inherent radicalism, but
there are still radical ends it can be used to achieve. Gray's insistence on
his work as a constructed artefact, for example, is in certain ways as
much an act of responsibility as of indulgence. *Lanark*, in particular,
illustrates the paradox that the most transparently, ostentatiously
artificial texts may be the ones most likely to redirect their readers'
attention upon reality: as Bertolt Brecht showed, an undermining of
seductive, secure containment within illusion encourages spectators to
take responsibility for reshaping the world beyond the stage. In one
way, *Lanark* does have something to offer in terms of seductive illusion:
if Glasgow is 'the sort of industrial city where most people live
nowadays but nobody imagines living' (*L*, 105), the novel helps redress
this poverty of imagination through the diverse inventiveness of its
means of envisaging the city. Yet neither readers nor characters can long
be securely contained in worlds so clearly shown to be the results of

Nastler's conjuring tricks. The real achievement of *Lanark* is not in seducing readers with illusion, but in allowing them to escape from it; in forcing them to consider conjuring and to examine and experience imagination as process rather than securely finished product. Since Lanark fails in his attempt to save the city, its redemption, if any, lies outwith the text, in the continuing processes of imagination of readers, empowered by Gray's dystopian fantasy to recognise the destructive forces which prey upon the life of modern industrial cities, and on Glasgow's more than most. Like the treatment of time and history discussed earlier, such strategies ensure that 'POLITICS WILL NOT LET . . . ALONE' (*J*, 231–2) readers of *Lanark*, any more than they will Jock McLeish in *1982 Janine*. Whatever 'games' may be going on in Gray's texts tend, on balance, not to diminish but to add to the satiric, political directions which are a central feature of his work.

1982 Janine illustrates other ways in which Gray has helped to introduce to Scottish writing more than solipsistic game-playing. Postmodernism's particular potential for Scotland relates not only to the country's position within the increasing cultural diversity of Britain, but also to aspects of its native tradition in literature and imagination. As discussed earlier, postmodernism often incorporates a double narrative, split between different worlds, as in Peter Ackroyd's *Hawksmoor*, or between narrative and meta-narrative, as in Fowles's telling, and telling about the telling, of Sarah Woodruff's story in *The French Lieutenant's Woman*. In the view of McHale and others, postmodernism is characterised by ontological shifts into worlds variously, often fantastically, disjunct from any real one. Double worlds and double narratives also figure in the Scottish imagination's Jekyll-and-Hyde, antisyzygical splits, and in its almost seamless transitions from real worlds to fantastic domains beyond them. The relevance of the 'Caledonian antisyzygy' to the various splittings in Gray's work is discussed elsewhere in this volume: for the present, it is worth pointing out that however different the antisyzygy and the experimental tradition of postmodernism may be in origin, they naturally, fruitfully, fall into alignment with each other. The Thaw/Lanark and Glasgow/Unthank pairings, or the entanglement of erotic fantasies with miserable reality in *1982 Janine*, show how suggestively the two traditions can coincide and coalesce within single works. Postmodernism has much to offer Scotland, and *vice versa*. In discovering this potential, Gray has probably done more than any other recent novelist to suggest opportunities for the future development of Scottish literature and imagination in the late twentieth century.

His writing also suggests how much such forward movement is still

needed; how worthwhile further visits to the international postmodernist
circus might be. Mikhail Bakhtin traces the polyphonic nature of the
novel — the 'system of languages' that compete within it — back to
origins in the popular practice of carnival. Brian McHale sees the
heterogeneous, convention-breaking forms and ludic linguistics of
postmodernism as the particular heir of such practices; as an essentially
'carnivalised literature' (p.172). *Lanark*, and even more clearly the
indulgent miseries of *1982 Janine*, offer symptoms as well as analyses of
a country still trying to free itself from a politically-engineered
dreariness of daily life; a mechanical education system; churches which
'teach us to be ashamed of . . . our whole bodies' (*J*, 49); emotions
which oscillate uneasily between violence and sentimentality. This
country has something to gain from the fantastic, ludic, grotesque,
parodic, subversive, sexy energies of a carnivalised literature. Maybe
under its influence, as the millennium approaches, infernal desire
machines will prowl their way at last toward the liberation of Scotland's
dour cities. Alasdair Gray has given them a direction, and some fuel.

NOTES

1. When asked for his views on the subject during an address to the
 Scottish Universities' International Summer School, 7 August 1990.
2. Ihab Hassan, *The Postmodern Turn: Essays in Postmodern Theory and
 Culture* (Ohio: Ohio State University Press, 1987), p.214; Brian
 McHale, *Postmodernist Fiction* (London: Methuen, 1987), p.5;
 subsequent references are to these editions.
3. Virginia Woolf, 'Modern Fiction' in *Collected Essays*, Vol. 2
 (London: Hogarth Press, 1966), p.106.
4. Italo Calvino, *If on a Winter's Night a Traveller* (London: Picador,
 1982), p.13.
5. D.H. Lawrence, *Women in Love* (1921; rpt. Harmondsworth:
 Penguin, 1971), pp.259–60, 522, 524.
6. James Joyce, *A Portrait of the Artist as a Young Man* (1916; rpt.
 Harmondsworth: Penguin, 1973), p.167. Subsequent references are
 to this edition.
7. James Joyce, *Finnegans Wake* (1939; rpt. London: Faber, 1971),
 p.339.
8. Eugene Jolas, 'The Revolution of Language and James Joyce', in
 Samuel Beckett and others, *Our Exagmination Round his Factification
 for Incamination of Work in Progress* (1929; rpt. London: Faber, 1972),
 p.79.
9. Hassan, *op. cit.*, pp.xiii–xiv.
10. Samuel Beckett, *The Unnamable*, in *The Beckett Trilogy* (1959; rpt.
 London: Picador, 1979), pp.308, 381.

11. Flann O'Brien, *At Swim-Two-Birds* (1939; rpt. Harmondsworth: Penguin, 1975), p.11. Subsequent references are to this edition.

12. A view Lawrence Durrell accepts in his interview in Malcolm Cowley, ed., *Writers at Work: The 'Paris Review' Interviews* (London: Secker & Warburg, 1963), second series, p.231.

13. Alain Robbe-Grillet, *Snapshots and Towards a New Novel*, trans. Barbara Wright (London; Calder & Boyars, 1965), pp.46–7, 63.

14. Quoted in Linda Hutcheon, *A Poetics of Postmodernism: History, Theory, Fiction* (London: Routledge, 1988), p.42.

15. Malcolm Bradbury, *Possibilities: Essays on the State of the Novel* (London: Oxford University Press, 1973), p.86; B.S. Johnson, *Aren't You Rather Young to be Writing your Memoirs?* (London: Hutchinson, 1973), p.30.

16. Mikhail Bakhtin, 'From the Prehistory of Novelistic Discourse', in *The Dialogic Imagination*, ed. Michael Holquist, trans. Caryl Emerson and Michael Holquist (Texas: University of Texas Press, 1981), p.47.

17. See Peter Zenzinger, 'Contemporary Scottish Fiction', in Peter Zenzinger, ed., *Scotland: Literature, Culture, Politics,* Anglistik & Englischunterricht, Band 38/9 (Heidelberg: 1989).

18. Hutcheon, *op. cit.* (note 14), pp.61, 206.

19. Fredric Jameson, 'Postmodernism and Consumer Society' in Hal Foster, ed., *The Anti-Aesthetic: Essays on Postmodern Culture* (Washington: Bay Press, 1983), p.117.

I am very grateful to Vassiliki Kolocotroni for her advice and comments during my work on this chapter.

Five

Gray and Glasgow

Edwin Morgan

If Glasgow has provided a rich seam of subject matter to Alasdair Gray, this is hardly surprising, in view of his long and close association with the city. From early days in Riddrie, where as a schoolboy he borrowed masses of books from the local public library and read them everywhere from the Whitehill School playground to the banks of Loch Lomond, through his studies at the Glasgow School of Art, his work as a scene painter at the Pavilion Theatre, his murals for Greenhead Church at Bridgeton Cross, the Ubiquitous Chip restaurant off Byres Road, and the Scotland–USSR Society in Belmont Crescent, his work as official artist recorder for the People's Palace, his stint as Creative Writing Fellow at Glasgow University, to the general sense one has of him as a man settled in the city, loyal to friends and acquaintances who have either stayed there or who have gone elsewhere and returned – the feeling we get is not of some breast-beating commitment or some vacuous local pride but of an at-home-ness with a place where he can work and where a remarkable array of human material offers itself continuously for transformation into art. Links and cross-references abound. The murals in Belmont Crescent, a jagged and colourful panorama, may suggest the human story from Adam and Eve to the Apocalypse, but the industrial imagery makes any apocalypse seem more Glaswegian than biblical, and the shifts and perspectives of *Lanark* seem not far off. The imperial poet Bohu, installed uneasily in his palace room in 'Five Letters from an Eastern Empire', is also Gray in his Writing Fellow's room at the University of Glasgow. The Greenhead mural is described as Thaw's mural in Book 2 of *Lanark*. And conversely, the oil painting *Cowcaddens, 1950*, with its swirling streets, louring clouds, misty moon, and unnerving foreground figures,

has an atmosphere that is almost as surreal and fictionalized as its title is totally local and down-to-earth.

Even in what may be called non-fiction, an almost but not quite fantastic quirkiness, juxtaposed to serious social criticism, seems natural and proper to Gray as he leafs through the history of Glasgow. Three of his entries in *The Glasgow Diary* invite a comment.[1] The item on 24 May 1973 refers to the death that day of an eccentric character called Bill Skinner whose life seems an amalgam of many of the interests and qualities which would attract Gray: a life outwardly uneventful, an unmarried man living with his widowed mother in an old all-gas tenement flat at Kelvinbridge, but this man a combination of artist, scientist, alchemist and politician, painting clear-edged pictures not unlike Gray's own, rigging up a little laboratory for the study of 'Particle compression and the Origins of Life', collecting fossils, pressed plants, a seagull's skull, supporting CND, drinking a home-made brew concocted from pharmaceutical alcohol, founding a political party (Communist, Labour and Nationalist) of which he was eventually the only member. What is stressed is his 'imaginative' and 'utterly independent' approach to life, and for all his eccentricities he is regarded as having made a success of things, even if this success was no more than the pleasure his conversation and ideas gave to a large circle of friends. Gray, however, is not Skinner. Although he might not be unwilling to be called an eccentric, he is capable of a much more hard-headed social and political analysis, and indeed it is his ability to combine the imaginative and the analytical that is distinctive. The other entries in *The Glasgow Diary*, for 19 September 1845 and 14 October 1859, make a contrasting pair of incidents in the city's commercial and municipal history, signalled by Gray's thumbs-down and thumbs-up symbols in the margin. In 1845, a wrangle between two private water companies over the right to supply water to Glasgow is used by the author to counter the 'romantic notion' that ruthless Victorian industrialism was tempered by beneficent works. However, he allows romance to stage a comeback in 1859, when Queen Victoria turned a handle at the entrance to a tunnel on Loch Katrine and inaugurated the flow of pure municipal water to Glasgow which not only allowed the city to escape the widespread cholera epidemic of 1866 but became a byword for good healthy public water service, overturning the previous demands for 'competition' (which in the cyclical way of things have been revived in very recent times). Gray, or the socialist part of him, likes the idea of an efficient public service; but his imaginative-romantic side cannot resist pointing out that Loch Katrine as the locus of this waterwork scheme looks back to Walter Scott's poem *The Lady of the Lake* and forward to

Jules Verne's science-fiction novel *Child of the Cavern* which describes
the building of a modern city in a huge cavern beneath Loch Katrine.
(The title of the English translation is given by Gray as *The Child in the
Cave*; the French title is *Les Indes noires*, 1877.) So a romantic past of
history and legend is linked to 'the romance of modern science'. And in
that context he uses the phrase without irony.

The Loch Katrine tunnel, Verne's city tunnelled out of the bed of the
loch, the tunnel under the School of Art in 'The Cause of Some Recent
Changes' (*US*, 11–15), and the various tunnels in *Lanark*, do perhaps
suggest the ambiguous subterraneity of someone who can appreciate the
engineering expertise of tunnelling works, who can fear (as an
asthmatic, fear all the more) the claustrophobia of tunnels, and who at
the same time, as a citizen of Glasgow, can be aware of the underground
transport system, to say nothing of its underground honeycomb of
abandoned railway tunnels and worked-out mines. Here, before we
allow the imagery to run away with us, it will suffice to say that as early
as 1957, when 'The Cause of Some Recent Changes' was first published,
the sense of a subterranean Glasgow in addition to the overground one is
something that can readily move out towards the apocalyptic, as is seen
when at the end of the story Glasgow is flooded and almost destroyed by
characters tinkering with little-understood forces. And a submerged or
subterranean history of Glasgow's part in the Industrial Revolution is
contrived in the story 'The Crank that Made the Revolution' (*US*, 37–
43). Vague McMenamy is an eighteenth-century Bill Skinner, a crank
who invents (of course) a crankshaft which enables him to prefigure the
paddle-steamer, the ironclad and the knitting-frame from his cottage
and duckpond in Cessnock.

In the books by which he has become best-known, *Lanark* (1981),
1982 Janine (1984) and *Something Leather* (1990), Gray never lets
Glasgow slip out of his sights, though *Lanark*, written over so many
years and including so much autobiographical material, embodies the
major part of his feelings and thoughts about the city. In the
autobiographical story 'A Report to the Trustees of the Bellahouston
Travelling Scholarship' (*LT*, 185–213), dated 1959, at a time when he
had already written a part of *Lanark*, he boards a train for London at
Glasgow Central Station and already begins to feel homesick – partly,
no doubt, because he has plenty of time to brood on the overnight train
where in order to save money he has not booked a sleeper. In the rainy
gloom it is the first syllable of 'homesickness' that he emphasises. 'I do
not love Glasgow much, I sometimes actively hate it, but I am at home
there.' This may seem lukewarm praise from a man who has evidently
received such sustenance from the city, but it has an honesty that one

remembers when the multifaceted Glasgow of the novels looms up or flashes past or is held up in rough or fine, long or short tongs. In interviews, Gray has tended to play down the meaningfulness of his Glasgow connection, though this may well be a self-protective act, when so many reviewers or critics or social commentators have been so eager to pin down 'the new Glasgow' and its luminaries or to identify a 'school' of Glasgow writers. One particularly interesting example is an interview he gave at Queen's University, Belfast.[2] After an attack on the wealthy Glasgow entrepreneurs of the eighteenth and nineteenth centuries who adopted the 'crappy motto' of 'Let Glasgow Flourish' by lopping off 'by the Preaching of the Word', he was asked by the interviewers, in a proper spirit of riposte, why in that case he spent time drawing and therefore paying tribute to the buildings and architecture 'built by this wealth'? In a less than convincing reply, Gray spoke of his People's Palace commission, as if otherwise he would have had no desire to draw the city, and quickly went on to claim that he would have gone to London if there had been any likelihood of paid work there. Staying and working in Glasgow gets a half-hearted defence. 'But anybody anywhere takes the bit of the universe they know best as the ground of their thought and art . . . He might just as well be in his own town as anywhere else.' Obviously he does have a point; Joyce did not have to remain in Dublin to make that city the inspiration of his life's work. But it seems clear to me that the high-spirited and multivocal performances which Gray disburdens himself of for interviewers do not necessarily lay bare the deeper levels his literary works show he moves in, feeling along many walls for the pulse of the Glasgow dragon.

The deeper responses permeate *Lanark*, but the other two novels offer much that is instructive. *Something Leather*, which charts the lives and loves of four women during the last thirty years, is set mainly in Glasgow, partly in a very expensive girls' boarding-school near Bath, and also involves a motley collection of other characters who are jerked or forced into some connection with the main story. It is the least persuasive of these three novels, very episodic, recycling much earlier material, and finishing off with an epilogue called 'Critic-Fuel' which confirms, in typically teasing fashion, some of the points I have just made. It mentions various real places by name, especially shops and restaurants — the House of Fraser, Brown's tearooms, the Grosvenor Steakhouse, the Ubiquitous Chip, the Rotunda — but also 'posh new housing schemes like Easterhouse, Castlemilk, Drumchapel' (which they once were). At the same time the book's blurb, which bears the mark of Gray, warns us that 'no characters are based on real people, not even the Glasgow comedian'. Look so far and no further, in other words.

Yet the back flap restores what the front flap had cast doubt on. The book is indeed about Glasgow and Scotland. 'It describes a society resembling a badly run trading post: full of predators, parasites and victims, where the majority are *not* employed in feeding, clothing and housing each other's bodies or finely informing each other's minds. And the setting is Scottish.' And quite apart from the socio-political implications, Glasgow is a big enough place to be able to provide 'something leather' and to be a suitable venue for the lesbian orgies which the reader will come to in due course.

Lesbian orgies and badly run trading posts are all very well, but we need something ordinary too, as a foil. In Chapter 7, 'Quiet People', Mr and Mrs Liddel are a decent quiet elderly couple who are so sober, so even-minded, so uneccentric that they have no television set 'because the things shown on it strike them as too surprising for comfort'. Whatever gentle mockery there may be in the portrait of the couple, Mr Liddel is allowed to stand for a certain view of the post-war years in Glasgow which we are meant to recall with some sympathy when the later theme of 'Glasgow 1990' makes its appearance.

> A tram-driver from 1928 to 1961, he fails the army medical exam and is promoted to ticket inspector a year before trams are replaced by buses. He never learns to love the buses as he loved the trams and his world-view is shaped by this. He remembers when Glasgow tram lines reached to Loch Lomondside and most of industrial Lanarkshire; when the head of Glasgow Public Transport was invited to cities in North and South America to advise them on the running of municipal light railway systems. The scrapping of Glasgow tramcars is mingled in his mind with the Labour Party's retreat from socialist intentions. (*SL*, 117–8)

Chapter 10, 'Culture Capitalism', is a funny but sustained attack on Glasgow as European City of Culture, done by the well-known device of having an enthusiast for the idea condemn herself out of her own gushingly patronising mouth. Linda, who is English, is now living in Glasgow as an arts administrator, and is trying to persuade her old school chum, Harry (short for Harriet), a sculptor, to mount a big retrospective in the McLellan Galleries in 1990. Glasgow has now been spruced up and rendered safe for civilised people by making culture an item of commerce to replace the lost industries. 'Cultcha and tourism a the same thing', Linda says. Harry, even at school in Bath, had shown ability to do modelling in clay and had created an exhibit which caused quite a stir and began to make her famous: it was called the Bum Garden and consisted of a series of well rounded and cleft forms representing the human backside. Linda persuades her it is time for a

new and better bum garden in Glasgow, and Harry thinks she will do it this time on a larger scale, in glazed ceramic and polished steel. 'Has Scotland a steel industry?' she asks. Much of the satire is fairly knockabout stuff, but the device of indicating English speech by cutting out the r's which the English do not pronounce is surprisingly effective, as a sort of counterblast to what Linda says about Glasgow *writas*:

> Some novels by Glasgow writas have had rave reviews in the *Times Lit. Sup.*, but I'm afraid they leave me cold. Half seem to be written in phonetic Scotch about people with names like *Auld Shug.* (SL, 174)

The most interesting part of the chapter is the moment when Linda and Harry, exploring the city, come to Paddy's Market with its bizarre array of seemingly unsaleable clothes and other goods which nevertheless are being sold. Linda, 'working class by breeding and bourgeois by education' as she describes herself, hates the place and hopes and believes that it will be pulled down, even although she is 'not a socialist'. Harry, high-born and wealthy, likes the market and says she will visit it again. 'I think these people', she says, 'have as much right to exist as you or me.' Linda, realising that her desire to have such salient reminders of poverty swept out of sight must make her seem cold-hearted, rounds sharply on Harry and attacks *her* for being the hard-hearted one. 'It's easy for you to be cold-blooded: yaw an artistocrat.' This is a nice political transvestism. Linda, non-socialist, would make herself into a temporary socialist to have a centrally-organised cleaning-up of the city. Harry, non-socialist but an artist, allows her sympathetic involvement with the whole scrabbling scene to override any suggestion that the blatant poverty might be ameliorated. The author's view, in so far as it can be discerned, would appear to be that although even the cheapest markets must by their nature be entrepreneurial rather than socialist, they perform an undeniably useful function in a society which is badly run. Linda's shrill little nervous attack on Harry is counterproductive; Harry is an aristocrat, but *not* cold-blooded. Gray is dealing here, in his own original fashion, with arguments that have peppered the local press in recent years, regarding the closure or transformation of Paddy's Market and similar run-down places.

1982 Janine is a much better book, taken as a whole. It is not set in Glasgow, but contains Glasgow scenes in flashback as the central character, a supervisor of security installations who is an alcoholic and a sex fantasist, survives a suicide attempt and recalls his earlier years in an effort to exorcise the guilts that have been gnawing at him. He knows he has treated some people, especially women, badly, and he tries to

remember some good deed that would save him (rather like Everyman in the old play), finding this eventually in the incident at school when he had boldly prevented a sadistic teacher from belting a boy with an incurable lisp. The main Glasgow scenes that are evoked belong to the 1950s, when the hero, John McLeish, is a student at the Royal Technical College (as it then was) doing engineering and mathematics, and also works with a theatre company at the former College of Drama in the Athenaeum, helping with stage lighting. Remembering a train trip to Edinburgh at that time allows him to launch into a long disquisition on trains and trams and the general state of the Glasgow of those post-war years. He is quite nostalgic about the steam trains and the multicoloured trams; no ring roads, no spaghetti junctions, no leisure centres, no commercial television – he likes that period:

> Oh, Britain was a primitive country in those days, primitive but in working order. We had come through a war, built a welfare state, had full employment and were still the richest country in the world after the U.S.A., the U.S.S.R. and Switzerland. (*J*, 231)

But the Firth of Clyde was preparing at that time to become a huge nuclear arsenal for the Americans, and because McLeish's job is to look after security installations he knows a lot about this, would be a protected person if war broke out, and speaks with a sort of informed cynicism that lets Gray use him, in part, and through touches of black comedy, as a mouthpiece for more real underlying anger that Glasgow should now be one of the epicentres of potential annihilation. As he says in one of his longer reveries:

> But the Clydeside has outlived its usefulness . . . Glasgow now means nothing to the rest of Britain but unemployment, drunkenness and out-of-date radical militancy. Her nuclear destruction will logically conclude a steady peacetime process. It's a pity about Edinburgh. It has almost nothing to do with Glasgow but stands too near to go unscathed. Let us hope that only the people die and the buildings and monuments are undamaged, then in a few years the Festival can resume as merrily as ever. It is mostly the work of foreigners, anyway. (*J*, 136)

McLeish is presented as a man who is not by nature inclined towards politics but who is gradually forced, by public events as well as by self-examination, to become more aware of society's needs, disasters, and hopes. 'I am very sorry God, I would like to ignore politics but POLITICS WILL NOT LET ME ALONE.' As a person with a technological background he knows what real benefits science and technology have brought and can bring, but suddenly it seems not

enough. The moon landing in 1969 excites him but leads to nothing; earth and its political arrangements are none the better for it.

When did my job start to sour? When did my marriage start to stale? When did I start drinking too much? When did capital leave Scotland in a big way? When did the depression come to Britain? When did we start accepting a world without improvement for the unlucky? When did we start accepting a future guaranteed *only* by the police, the armies, and an expanding weapons race? There was no one point after which things got worse but my last spasm of scientific, social delight was in 1969. (J, 309)

At the end of the book, McLeish writes a letter of resignation to the security firm he has been working for in Glasgow, and prepares to begin a new life, totally undefined, but at least not a life linked to any military-industrial complex. He cannot remove the all too meltable nuclear umbrella over the Glasgow conurbation and the Clyde, but he has come to understand something of the realities of power. 'Nobody will guess what I am going to do. I do not know it myself. But I will not do nothing. No, I will not do nothing' (J, 341).

Interesting as they are, the more declamatory set-pieces of social history in *1982 Janine* do not always seem well integrated into the fiction, and there is some uneasiness with the didactic element even in *Lanark*, but *Lanark* shows Gray unrolling his full force over an astonishing range of imaginative and discursive presentations, and the centring of the book on Glasgow (and, indeed, the author's life in Glasgow) seems to have provided both a home base and a launching-pad for everything he needed.

This novel is basically a man (Lanark), a place (Glasgow), and a time (the second half of the twentieth century). If we want to take it on the most literal level, it is about someone who is a boy of five in a good council house in Riddrie in 1939 at the beginning of the story (though not of the novel, which is not told chronologically), and who dies as a man of sixty sitting on a granite slab in the Necropolis in 1994. But of course it is very much more than that, since the story takes place in more than one dimension, and Lanark has more than one life and death in the course of his adventures. What Gray must have felt he had to do, and has done with so much power, was to open Glasgow up ·imaginatively, make it real, yes, but also more than real in terms of art, as Joyce's Dublin is and is not Dublin, as Dickens's London is and is not London, as El Greco's Toledo is and is not Toledo. W.F.H. Nicolaisen's caveat about how works of fiction establish their own onomastics, even when they use real names, is useful here:

[T]he 'Glasgows' of Scott's *Rob Roy*, of McArthur and Long's *No*

Mean City, of Chaim Bermant's *The Second Mrs Whitberg*, of Robin
Jenkins' *A Would-Be Saint*, of George Blake's *The Shipbuilders* and
of William McIlvanney's *Laidlaw* are, in spite of the identity of
name, very different 'Glasgows' . . . [T]he imaginary cities of
Glasgow . . . never will be built.[3]

When Duncan Thaw, the earlier avatar of Lanark, is out walking
through Glasgow with a fellow art student, and they are looking over
the city from one of its many hills, his friend McAlpin says, 'Glasgow is
a magnificent city. . . . Why do we hardly ever notice that?' And
Thaw's reply is, 'Because nobody imagines living here.' And he goes on
to elaborate the point:

> But if a city hasn't been used by an artist not even the inhabitants
> live there imaginatively. What is Glasgow to most of us? A house,
> the place we work, a football park or golf course, some pubs and
> connecting streets. That's all. No, I'm wrong, there's also the
> cinema and library. And when our imagination needs exercise we
> use these to visit London, Paris, Rome under the Caesars, the
> American West at the turn of the century, anywhere but here and
> now. Imaginatively Glasgow exists as a music-hall song and a few
> bad novels. (*L*, 243)

'Anywhere but here and now.' So this book really is about the Glasgow
we know, but opened out into suggestions of epic, of fable and allegory,
of science fiction. You begin the novel in the city of Unthank (a
common place-name in Scotland, a thankless place, with poor soil).
This is in one sense the Glasgow of the 1950s, which Duncan Thaw, as
Lanark, has now entered; but it is also a subtly altered, fantasy
Glasgow, where the Clyde has nearly dried up, where there is no traffic,
where the sun seldom appears, where there may or may not be ships
being built, where the money is notes and coins of several different
currencies — it is like a combination of *The City of Dreadful Night* and
Blade Runner, with everything just slightly wrong, slewed out of kilter,
yet vaguely recognisable, down to the Elite Café where the characters
meet and which is clearly the café above the old Curzon Cinema at
Charing Cross. It is one of many transformations — Glasgow, Unthank,
Provan, through time and space — but the city, and Scotland, are still
there. Just as Glasgow is very clearly the setting for the realistically
described boyhood of Thaw in Books 1 and 2, with districts, buildings,
and landmarks mentioned by name, so it seems to me that even Provan,
in Book 4, is able to be interpreted (though there has been disagreement
about it) as another manifestation of the city. It is true that Lanark, as
Lord Provost of Greater Unthank, flies from Unthank to Provan, but he
flies through an intercalendrical zone, and as his bird-machine gradually

descends and he looks down at the landscape it is obvious that he sees
such familiar places as the Firth of Clyde, the River Kelvin and Glasgow
University. The city is clean, sunlit, attractive, a fine setting for the
international conference he is to speak at; nothing could seem further
from the image of Unthank; but it is still a metamorphosis of Glasgow,
and not necessarily to be relished because it looks appealing. Indeed its
Wellsian glitter may be a façade for essentially destructive forces. We
have therefore to read with care the dialogue between Lanark and his
'author' in the Epilogue which follows Book 4. If Unthank is a 'city of
destruction', so Provan may be too, in a different sense, with its great
scientific achievements and discussions ranged rather against than for
humanity. (We are reminded of McLeish and his disillusionment after
the moon landing in *1982 Janine*.) Just before he has his interview with
his 'author', Lanark is told by the morose but possibly clearsighted Odin
that the delights of Provan are mere 'bread and circuses' before Provan is
'turned into another Greater Unmentionable Region'. We remember that
'unmentionable' when the 'author' talks to Lanark:

> 'You have come here from my city of destruction, which is rather
> like Glasgow, to plead before some sort of world parliament in an
> ideal city based on Edinburgh, or London, or perhaps Paris if I can
> wangle a grant from the Scottish Arts Council to go there. Tell
> me, when you were landing this morning, did you see the Eiffel
> Tower? Or Big Ben? Or a rock with a castle on it?'
>
> 'No. Provan is very like –'
>
> 'Stop! Don't tell me.' (L, 483)

That Provan is very like Glasgow seems the natural conclusion, and one
that would fit in well with the socio-political aspect of the book, its
sense of ordinary people being used by formidable forces and learning
how to fight back. In *Lanark*, as distinct from *1982 Janine* and *Something
Leather*, socio-political thrusts come mainly through fabular and highly
imaginative scenes and settings, as if this at first sight less likely
method would be (as turned out to be the case) more powerful in the
end. No reader has been in Unthank or Provan till he reads the book.
Then he has.

The complexity of the novel, the non-straightforward course of the
narrative, the use of different levels of reality, are all very deliberate and
are related to a certain epic intent. The fact that the novel begins not in
Glasgow but in Unthank, when Thaw in his second life as Lanark is a
young man in his twenties, is modelled on the way an epic plunges *in
medias res*, and only later by means of flashbacks tells you what has gone
before. The danger of this method, for Gray, is that the reader who

opens *Lanark* for the first time is confused and disoriented at the start, and may simply give up. But the reader's struggle is intended. You are meant to want to know who Lanark is and why Unthank is the way it is, to pick up the clues here and there, and eventually in Books 1 and 2, in the middle, to be rewarded by a clear and beautifully written account of the hero as a boy and youth growing up in Glasgow and the Highlands during and after the Second World War. And the nightmarish hallucinations Duncan Thaw begins to have towards the end of that part of the book are meant to prepare you for a return to the fantasy world of Book 4.

There is also, though it is beyond the scope of this essay, a sense in which the novel need not be taken to be about Glasgow at all, that it is a sort of universal mental allegory, reminiscent of *The Pilgrim's Progress* or *The Faerie Queene*. Gray himself has said, for example, that Unthank 'is a state occupied by many people in their twenties'.[4] And the whole book shows itself, among other things, as a history of mental states and attitudes and of emotional sickness and health, searching for love, despairing, having hope.

In the future Glasgow at the end of the book, the scene is fairly apocalyptic. The mysterious, powerful, ruthless Institute which Lanark has already been through and survived — it is a mixture of scientific research centre and government establishment — has decided that Unthank is no longer viable, has become expendable, and at the end of forty days is going to be destroyed and its people used for food and fuel. There is a civil war which looks like a galactic war because Unthank is a projection of Glasgow in another dimension as well as being late twentieth-century Glasgow (where poor or unemployed people may very well feel they are being used for food and fuel). There are fires, earthquakes, much destruction, but hopeful signs also. The sky brightens, gulls cry as water floods from the sea up into the shrunken Clyde and Molendinar, and the rising sun casts extraordinarily beautiful colours over the city. Although the war is still going on, the whole cityscape, seen by Lanark from the hill of the Necropolis, is so visionary that he cannot take his eyes off it. Lanark has been reunited with his wife and family. He now has both a son and a grandson. In his published synopsis of the story Gray says of this ending: 'There is a chance of new life for the children.'[5] Lanark is told by a messenger that he will die, a natural death, the next day. He scowls at the news. 'I ought to have more love before I die. I've not had enough.' The messenger replies: 'That is everyone's complaint.' The last little paragraph is very calm and measured:

The chamberlain vanished. Lanark forgot him, propped his chin

on his hands and sat a long time watching the moving clouds. He was a slightly worried, ordinary old man but glad to see the light in the sky. (*L*, 560)

It is a wonderful conclusion which returns us, after the hero's different lives and adventures in time and space, after all the complexities of the narrative, to an ordinary old man with an ordinary mixture of feelings, anxious and content at the same time, sitting looking at the sky from a very ancient part of Glasgow.

NOTES

1. Donald Saunders, *The Glasgow Diary* (Edinburgh: Polygon, 1984).
2. Alasdair Gray, interview, *Gown Literary Supplement* (Queen's University, Belfast), January 1989, pp.13–16.
3. W.F.H. Nicolaisen, 'An Onomastic Vernacular in Scottish Literature', in Derrick McClure, ed., *Scotland and the Lowland Tongue* (Aberdeen: Aberdeen University Press, 1983).
4. Alasdair Gray, 'From the World of *Lanark*', *Scottish International*, No. 11, 1970, p.30.
5. *Ibid*.

Six

Alasdair Gray and the Condition of Scotland Question

Christopher Harvie

I

Alasdair Gray's *1982 Janine* has been available since 1987 in a German translation. Gray figured in 1990 in a far-from-uncritical documentary 'Warum Glasgow?' on the City of Culture on German television. His equal skill with the brush and pen, his political commitment and libertarian socialism may suggest parallels with Günter Grass, but a deeper sense of historical imprinting common to Scotland and Germany pervades his *œuvre*. Gray 'implags' Goethe in *Lanark*; the McLeish-Denny relationship in *1982 Janine* has its parallels with Faust and Gretchen. More profoundly, he recapitulates the tensions between enlightenment and emotion, organisation and community, which German intellectuals registered in the period between 1780–1830 partly through their acquaintance with Scottish culture (Ossian, Burns, Scott) and their reaction to the rationalism of the enlightenment.

There are also immediate political parallels. The subterranean world of the Institute, the prisons and barbed wire 'installations' of *1982 Janine*, reflect national pasts. The well-organised cultural scene of West Germany, erected on the ruins of the German-Jewish tradition, wins opulence through the inertia that affluence accumulates, though at a cost. Scotland is threatened both by economic decline and by the centralising policies of a deeply inegalitarian government which treats the Scots as a minority to be ignored and systematically disadvantaged. Both societies are at threat from the forces symbolised by the metal shells hurtling along the motorway and the politics which are calculated to keep them doing so: the overvaluing of possessions, 'mechanism' and economic individuality, the undervaluing of wholeness and sympathy. A world out of science fiction has been created under the hills of Swabia and Argyllshire with enough fissionable material to wipe out human life several times over.

II

Like Grass, with his 'voters' initiatives' for the left in West German politics, Gray has become a political symbol. His phrase 'work as if you were living in the early days of a better nation' from the cover of the Canongate edition of *Unlikely Stories, Mostly*, has become a slogan for the distinctive Scottish resistance to Thatcherism. (cp. *J*, 185) In itself, this is a contrast with the 1970s, a period when measures of national autonomy up to outright independence seemed within the grasp of the Scots. In 1977 the political journalist Neal Ascherson observed that little cultural efflorescence seemed to accompany the political activity.[1] Indeed one of the last political declarations of Hugh MacDiarmid was said to be that, if he survived to vote in the 1 March Referendum on the Scotland Act, he would vote against it. (This was quite a logical position, as he had written as early as 1925 of devolution being the completion of the Anglo-Scottish union.[2]) The act itself was flawed in construction, and the careful removal of any economic teeth made it appear irrelevant, in the 'winter of discontent', to the mounting economic problems that Scotland was facing.

Conventional wisdom in the South had it that the Scottish question was exploded in 1979; and indeed the resumption both of agitation for Home Rule and any growth in the fortunes of the Scottish National Party took two parliaments to achieve. Yet as Cairns Craig has written:

> Instead of political defeat leading to quiescence, it led directly into an explosion of cultural creativity, a creativity coming to terms with the origins of the political defeat and redefining the nation's conception of itself. The eighties have been one of the most significant decades of Scottish cultural self-definition in the past two centuries.[3]

Ambitious parallels have been drawn between Ireland after the death of Parnell in 1891 – the foundation of the Gaelic League, of the Irish Literary Theatre and in 1908 of Sinn Féin – and 1980s Scotland. W.B. Yeats's later image of Parnell visiting Jonathan Swift's dark grove, and there drinking 'bitter wisdom that enriched his blood', seems a telling comparison. Of all these cultural developments – in painting the revival of representational art in a new Glasgow School, in plays the work of John McGrath, Liz Lochhead and Iain Heggie, in television John Byrne's *Tutti Frutti* and the films of Bill Forsyth – perhaps the success of Alasdair Gray's *Lanark* in 1981 was the most vivid, particularly as Gray explicitly stated that the traumas of 1979 had knocked away a writer's block that had afflicted him for years. Perhaps his Scottish profile was further aided by the fact that his novel, although nominated for it, did *not* win the Booker Prize, which went to the slight, and now forgotten,

Offshore by Penelope Fitzgerald. One of the judges regarded it as 'too big', which must have helped.

This contemporary history gives Gray significance. More than any other writer in contemporary Scotland, he has been credited with Hugh MacDiarmid's vatic propensities; not least because of the influence of *A Drunk Man Looks at the Thistle* on *1982 Janine* (J, 343). But the problem of locating Gray in a 'Scots tradition' is that part, at least, of that tradition is its tendency to ignore talented writers and artists for most of their careers. Moreover, Gray's success has been, to a great extent, identified with something which is, for Scotland, new rather than traditional: the literary articulateness of the West of Scotland working class. In his 'Postscript' to Agnes Owens's *Gentlemen of the West* Gray has characterised the fiction that he, Owens and James Kelman have produced as something quite novel – in the sense of seeing political processes from the point of view of 'folk with low incomes'.[4] Traditionally this testimony has been devalued in favour of the values of rural and small-town Scottish life. One recollects Chris Guthrie's rebuke to the unemployed man in Grassic Gibbon's *Grey Granite*, 'My class? It was digging its living in sweat while yours lay down with a whine in the dirt', and realises that precious little distancing went into it on Gibbon's part. What Gray is doing owes something to the tradition of the Scottish Renaissance; but its driving ambition creates an approach to Scottish history which, if original, is also overdue.[5]

III

In a seminal essay of the 'hangover' period after 1979, 'The Body in the Kitbag', Cairns Craig blamed the decline of the novel in modern Scotland on Sir Walter Scott's subsuming of Scottish history within a British continuum. Through this surrender, which symbolically at least facilitated the southward drift of the Scottish intelligentsia, the great age of the realist novel of individual morality and public life – of Trollope, Dickens, George Eliot and Meredith – passed Scotland by. What was left behind was marginal, even when accomplished. Scots writers were conscious either only of highly localised environments – achieving reality through processes which withdrew them from the flow of history – or saw their world retrospectively, with childhood not a *tabula rasa* but a period of psychic completeness which subsequent experience dismantled rather than supplemented.[6]

It is possible to extend this argument, to see an economic history of print capitalism which, following Benedict Anderson's *Imagined Communities*, plots the rise of the then unprecedented 'mass-circulation' Scots novel.[7] Scott, Galt, Hogg and Ferrier create it. It runs into

economic problems, and escapes through a 'reverse take-over' of the larger, more stable but more conservative English publishing industry. The upshot is, however, that the 'serious' Scottish novel survives in the dubious status of a regional *genre*, enjoying a roughly cyclic popularity — Stevenson in the 1880s, Linklater, Gunn, Gibbon in the 1930s, Gray, Kelman, *etc.* in the 1980s — while the other Scots continue to be providers of undemanding but highly-marketable entertainment, from the Kailyarders *via* A. J. Cronin to Lucilla Andrews and Alastair MacLean. Scottish literary culture has been, in other words, a casualty of the print capitalism it helped create.

It is this fractured 'Scottish tradition' that Gray's *œuvre* engages with: the intellectual and social currents set loose in the century after 1745, and their impact on the Scottish people. To Craig the 'failure' of Scottish realism is a false presumption; the 'dissociated sensibility' which became apparent in the early nineteenth century, and whose reification was prevented by the coincidence of violent economic and technological change with religious and philosophical breakdown, print-capitalism and the southward flight of the intelligentsia, inaugurated the possibilities of a literature far more experimental, profound and compelling. Gray's strength is that, wholeheartedly, he engages both with it and — adapting Carlyle — with the 'Condition of Scotland Question'. I will start with the symptoms which Gray diagnoses (something, surely, signposted by the recurrent images of dissection, flaying, trepanning in his graphic work). Then I will examine the use he makes of the Scots literary tradition — among other 'traditions' — to attempt, if not a reification, then a centring of literature in contemporary social, economic and philosophical problems.

IV

The *leitmotiv* of Scottish experience 1745–1845 was not nationality or the democratic revolution — as elsewhere in Europe — but industrialisation and culture. Associated with technology, urban life, capitalism and the division of labour, this process was publicised and dissected by writers of imaginative genius. Take, for instance, Adam Smith's famous sketch of the pin factory in *The Wealth of Nations* (1776). At first this suggests a straight description of a 'believe it or not' sort. Seen, however, in the context of Smith's own humanist view of society, and that of actual human relationships under industrial discipline, it takes on a fabulous and a menacing quality. The little vignette which accompanies it, of the inventive lad who devised a gadget out of string which saved him the bother of opening and closing the valves of the steam engine, is even more ambiguous, as this ingenuity would put him out of a job, not

make him a second Watt.[8] The Scottish Renaissance tradition of the
1920s and 1930s averted its eyes from this, to reinvoke the epic or the
folk-tale. MacDiarmid or Neil Gunn acknowledged industrial reality
through a sort of academic *Wissenschaft* which stressed the importance of
science, but they did not attempt to engage with industry on its own
terms. This Gray does. The 'steam intellect' phenomenon has rarely
been sent up so succinctly as in 'The Crank That Made the Revolution',
in which the Samuel Smilesish monster Vague McMenamy applies
mechanisation and the division of labour to ducks (disastrously) and his
granny (profitably). The result is both funny in a *1066 and All That*
way, and also serious in identifying the disorganisation which followed
the unchecked 'rationality' of capitalist development (*US*, 37–43). 'It is
not the labour which is divided', Ruskin later commented on Smith's
fable, 'but the men.'[9] Indeed, Smith himself had an admonitory
purpose, to warn against the tedium and mindlessness of such a system
of production, but its overall impact was to unleash forces which human
agency – particularly *Scottish* human agency – was unable to control.

The link between the two is Carlyle, who apotheosised Scottish
society in his essay on Walter Scott:

> Thought, conscience, the sense that man is denizen of a Universe,
> creature of an Eternity, has penetrated to the remotest cottage, to
> the simplest heart. Beautiful and awful, the feeling of a Heavenly
> Behest, of Duty god-commanded, over-canopies all life.[10]

The same man would, a couple of decades later, write of technology, in
the shape of railways, destroying society:

> Railways have set all the towns of Britain a-dancing . . .
> confusedly waltzing, in a state of progressive dissolution, towards
> the four winds; and know not what the end of the death-dance will
> be with them, in which point of space they will be allowed to
> rebuild themselves.[11]

Carlyle never managed to achieve this reification. His own dance of
death led, via the 'Condition of England', to the deification of Prussia.
But his combination of *Schwärmerei* for a 'Scottish' idea of reality and
fatalism endured, to penetrate Stevenson's *Master of Ballantrae* (1883)
and George Douglas Brown's *The House with the Green Shutters* (1901).

Regret for a past 'wholeness' pervaded the literature of the Scottish
Renaissance. Edwin Muir characterised the journey his family made
from Orkney to Glasgow as covering 250 years of history. If we do the
appropriate sums, we start in the mid-seventeenth century. Muir was
mourning a pre-Calvinist, not a pre-industrial, society. Like Max
Weber, he saw capitalist values as inhering in religious ideology, and its
rationality toppling the solidarity of the medieval Scots community.

The utopian prospect of socialism — in its literal definition (no-place) assuming a breach with local identity — was a possible way out. It provides the background to *Poor Tom* (1930), whose central figure, Mansie Manson, has some affinities with Duncan Thaw. Manson reaches a sort of epiphany of human solidarity in a Glasgow May Day march, only to have it evaporate, leaving him even more disconsolate than before. For Muir, the recapture of Eden involved the flight from Glasgow.

Gray's social criticism does not have this Manichaean aspect, the cleft between Edenic country and purgatorial town. A mid-twentieth-century upbringing was one in which families regretted the absence, not the presence, of industry, and where the pride in craftsmanship and the impressive presence of the products — whether ships, locomotives or complex machinery — had its own cultural impact. In this, work conditioned more than class. Scotland, particularly West Central Scotland, was dominated by a skilled working class which comprised up to 60–70% of the male labour force. It had a self-consciousness in many ways distinct from the 'labour aristocracy' of England or, for that matter, of Edinburgh or the Scottish mining districts, a continuity of skills with the rural craftsmen, cottars and farm workers, and much of their fierce independence. At the same time its existence was penetrated by a transience which went deep into its psyche. The launch of a ship could mean wholesale redundancies; the ship — or locomotive — would eventually be taken out of service and scrapped, no matter how beautiful it was.

This instability also affected *place*. Glasgow's expansion in the nineteenth century was protean: the Scottish Chicago. The epoch-making buildings of one decade were torn down in the next, the people were fitted into such land as was not required for industry, railways or upper-class housing. Much of the population lived effectively an underground existence, in small tenement flats which the sun reached, at best, for only one or two hours each day. Nowadays they may live in sunlight, but several hundred feet above the ground. *Lanark*'s monstrous cities and Thaw's quest for sunlight are not too far from actuality.

This essentially unpredictable type of urban life held itself together as a community, but one which could be destructive as well as cohesive. At the end of his 'Postscript' to *Gentlemen of the West*, Gray writes that Agnes Owens's hero, Mac, takes a course — getting out — which is anti-social but necessary to his own survival:

> By the last chapter our man has been employed for several months, his only close friend has died of drink and exposure, and he has been arrested as accessory to an unusually futile crime. Heavy

drinking has so washed out his chances of a sex-life that he has never considered one, and this is lucky. In his community sex leads to children and marriage, and who would gladly bring children into such a community? It is collapsing. The only choice is, collapse with it or clear out. If he had children his decent instincts would lead him to collapse with it. So his worst habit allows him a happy ending.[12]

Society is rather like the rope that holds climbers together. It can rescue individuals, but it could, in the case of a real collapse, pull everyone down. The question of society and community in Scotland was one which attained particular salience in the 1980s. An interpretation of the Scottish enlightenment was undertaken by Conservative politicians and advisers who had an undeniable locus in one Scottish intellectual tradition (Douglas Mason, Michael Forsyth, Michael Fry, Peter Clarke); this stressed the supremacy of individual decision-making, put the family in the second line, and society nowhere.[13] With some elements of this Gray would be more in agreement than one might at first imagine.

The artist, if true to himself, will always be an individualist. Social cohesion — where the society is in process of decline — is a mixed blessing. Qualities other than community-consciousness are necessary to maintain a political entity.

In Gray's conspectus the family, too, is ambiguous. In Scotland it tends to operate like a diminished clan, as D.H. Lawrence described it in *Lady Chatterley's Lover*. The Scottish family is a peculiarly enveloping organisation: a microcosm of society rather than something stemming from sex. In *Lanark* the parents of Duncan Thaw inflict on him tortures of peculiar intensity, but one of a mixture of affection and ignorance, not alienation or hatred. 'Sympathy' — out of Adam Smith — subsists, although its consequences can be bizarre.

If society and families can kill as well as sustain, where does this leave the individual? Gray's individualist heroes tend to be failing artists and megalomaniac supermen, and the line between both is very close, a twist of the point-switch would have sent them in either direction. As Duncan Thaw's mural-painting brush with the Kirk in *Lanark* demonstrates, the calling of artist is not one which fits securely into a puritan polity. Even although Carlyle (himself much painted), quite late in his career, propagandised for a National Portrait Gallery for Scotland — something Gray has contributed to as a limner to the City of Glasgow — the Godly Commonwealth has had little use for the artist, save as portraitist, rustic moralist and recorder of the martyrdoms of the righteous. He has either got out, or painted for the cosmopolitan bourgeois and gentry.

The 'unpolitical' artist or the poet ends up, like the artisan, as the plaything of the power structure — something conveyed both in Book Two of *Lanark* and in the 'Five Letters from an Eastern Empire' (*US*, 85–133), where Bohu, the Emperor's tragic poet, is trapped into providing the rescript for the destruction of his city. The alternative to this is for the individual to shed social solidarity and go for power: which is the course taken by Kelvin Walker. Having penetrated to the centre of power, Walker finds, however, that its manipulation is merely a matter of inertia. There are no Nietzschean supermen to hand. Just as Bohu finds that his Emperor is actually a doll, passed round the bureaucrats at the heart if the power structure, Lanark discovers the 29th Lord Monboddo is a cipher, in the hands of his administrators.

V

All of this would suggest the political pessimism shown by many twentieth-century European intellectuals. In much post-Nietzschean German writing and painting there is a sense of individual powerlessness so profound as to induce despair — the fair fields of the Allgäu poisoned and threatened by the incalculabilities of human behaviour. With the collapse of the 'socialist' utopias and the accelerating dysfunctions of the market this stance is likely to become more, rather than less, widespread. There are terrible and tragic aspects to Gray, victims whose fate makes one want to cry out, injustices — as much to be found, interestingly, in the entertainments as in the 'serious' novels — and yet there is also a powerful positive drive. *Lanark* should end on a down note, with the hero's death, and yet one finishes with a feeling of having only half-undertaken a process of instruction and digestion, surfeited on the richness of the book, and ready to plunge back into it again. When Lanark, on the Necropolis, sees the floods recede and the light break over the city, there is an image of rebirth:

> Drunk with spaciousness he turned every way, gazing with wide-open mouth and eyes as light created colours, clouds, distances and solid, graspable things close at hand. (*L*, 558)

As well as the memory of Goethe's last words: 'Mehr Licht!' *1982 Janine*, despite its obsessions and perversions, ends with a distinct if tentative sense of optimism. Where does this come from?

Ordinary life, for a start, is something which requires decency and courage. This seems to be a conviction common to the Glasgow writers. 'It will be horror', says James Kelman, talking about the daily experience of ordinary people: risk, death, humiliation under authority. And yet it also contains possibilities, symbolised for Kelman's Patrick Doyle in the pipes that he tries to transform into musical instruments, by his attempts at affinity with the German poet Hölderlin. Agnes Owens's

Mac might have got his notion of getting out of the scheme by his
encounter with the German hippy:

> They are a right ignorant lot round here, but some day I will get
> away from this place. Some day I might go and see castles
> myself.[14]

The escape-reconnaisance is spatial: more importantly it is mental and
educational. Gray, as much as MacDiarmid or Grassic Gibbon, is a man
who has devoured libraries. This does not lead, as would the case in
England, into the cul-de-sac of London literary society, of 'bookmanship'
or a post at one of the universities. With Gray, there is always the sense
that ideas are being engaged with through a type of intellectual system,
not something that classifies and orders, but something that assumes a
particular purpose about existence. In this sense the ramifications of his
curiosity do not result in a heap of detail, or some sort of 'Kim game'
along T.S. Eliot lines — which has a significance only to the élite — but
a sense that culture, like religion, ought to be simultaneously ordinary
and extraordinary.

Gray is a novelist who finds politics important, but almost by
definition complex and *trügerisch*. Politics are necessary to the ordering
of the moral state; the market by itself being inadequate — indeed
denounced as such by Adam Smith himself. On the other hand the
important decisions are not made in Scotland. In a highly-centralised
state they will occur in London, where they will be closely interrelated
to other elitist institutions such as the City and the media, to whom
the lives of ordinary people may as well be taking place on another
planet. Thus Kelvin Walker's and Mungo McGrotty's voyages to
London might almost be Lanark's descent (ascent?) to Provan. There
they encounter a world of force and bureaucracy, not only of 'sympathy'
(to use Adam Smith's term) and co-operation; they divest themselves of
their human attributes, they play roles.

Against this, Gray implies a particular type of Scottish democracy,
which, as it has never existed, can only be indicated metaphorically. In
Lanark the survivors organise themselves in a co-operative way, as
'Makers, Movers and Menders', which enables them to save the city (*L*,
556). In *1982 Janine* the drama group is a democracy of sorts. McLeish
succeeds in his ambitious lighting ideas not because he is a Nietzschian
superman but because he embodies the general will of the group (*J*,
pp.328–9). Fundamental to this is the notion of sovereignty inhering in
the people, not in any individual, or political body. This is the political
theory of the Declaration of Arbroath, George Buchanan's *De Iure Regni
apud Scotos* (1579), and the Covenanters.[15] To this extent Gray truly
represents his politics as the 'Scottish Co-operative Wholesale Republic':
a political society socialist, moral and democratic.

Gray has said that the novelist, however fascinated by politics, should not become a moralist:

> It's a pity that storytellers can't be moralists. They may invent people who pass moral judgements, when these are convincing and appropriate, but if they make their inventions the text of a sermon then a sermon is all that they will write. Readers must be enticed to their own conclusions, which cannot be predicted. [16]

We are back again in the moral/aesthetic dilemma stated by George Eliot, when Frederic Harrison tried to prod her into producing positivist tracts. But it is not all that easy, for us as much as for Gray. There *is* a profoundly sermon-like quality to his books, partly dodged out of by adopting a surreal style, in which the documentary-didactic can run in harness with the story, partly by detailed appendices detailing sources and obligations.

From this, we have a 'message' which is straightforward and, in these days of triumphant marketism, 'new times' designer-socialism, and European cultural capitalism, unfashionable: a plea for small-scale co-operative socialism rather along the lines of William Morris's *News from Nowhere* (1891). Gray's drawings – though far more complex – have the formal structure and character of Walter Crane's red-flag-bearing working men and bosomy Mariannes. Nastler, indeed, tells Lanark that he had originally intended his book to be a socialist epic:

> . . . what the *Aeneid* had been to the Roman Empire my epic would be to the Scottish Cooperative Wholesale Republic, one of the many hundreds of small peaceful socialist republics which would emerge (I thought) when all the big empires and corporations crumbled. (*L*, 492–3)

Certainty is given to Thaw's and McLeish's fathers; Gray's own generation is less optimistic. But the book's resolution, if less dogmatic, is more in tune with Lanark's notion of some humanistic outcome than with the 'banal world destructions' which Nastler suggests (*L*, 497). If Lanark has an epiphany, it seems to be when he is dancing in the Assembly at Provan, and remembers his life in Unthank:

> He turned sadly away and looked at the crowded gallery where the dancing had resumed. On the faces of all these strangers he saw such familiar expressions of worry, courage, happiness, resignation, hope and failure that he felt he had known them all his life, yet they had surprising variety. Each seemed a world with its own age, climate and landscape. One was fresh and springlike, another rich, hot and summery. Some were mildly or stormily autumnal, some tragically bleak and frozen. Someone was standing by his side and her company let him admire these worlds peacefully, without wanting to conquer or enter them. (*L*, 509)

Lanark then passes through an episode of sexual delight and fantasy, to re-emerge in a naturalistic Scotland – as his own father? as God? – with a foretaste of the death that will come to him at the end of the book.

God is not a frequenter of the Scottish novel – it is too much the product of the theism of the Enlightenment – but he has lodged himself firmly as part of the historical landscape, and seems somehow as present in Gray as in Bunyan, a figure rarely absent. Something less attuned to the Scottish tradition is the sexual-feminist element – embodied in the Paraclete-figure of the Catalyst in *Lanark* (L, pp.88–92, 509). Sexual frankness was not a complete innovation in the Scotland of the 1960s in which Gray matured. There had been a fair bit of uninhibited coupling in MacDiarmid's *Drunk Man* and Grassic Gibbon, and Naomi Mitchison's *We Have Been Warned*, trying in 1935 to present the liberated Soviet woman, contains the book-stopping line, 'Take them pants off me, Scottish comrade!' But MacDiarmid's bawdry can have a distressing Langholm Rugby Club echo, and Gibbon never manages to get his lovers together without his diffusionist friends, the naked, innocent hunters 'in the dawn of time', crashing around in the nearby bushes.

> We undressed and got into bed and cuddled for an hour or two. Nobody ever had a skin which was smoother and sleeker than Denny's so it was easy for us to slide and swim all over and around and under each other, though we had sometimes to stop and disentangle the bedclothes. The palm of my hand still remembers the exact shape of her foot, a small soft globe blending into a larger squarer globe (there cannot be a square globe, yes there was) a soft globe bending into a larger squarer globe with five little crisp globes along an edge. Her body was all smooth tight soft globes (how can tight be soft? It was) soft smooth tight globes like silken dumplings blending into each other at the wrist ankle knee elbow breast thigh waist blending in lovely curving creases which a finger-tip exactly fitted. Sometimes I said, "Are you tired of this yet?" and she said, "No, not yet." (J, 209)

It is difficult to describe sexual love without sounding prurient, sentimental or in general hackneyed, but Gray seems to manage to suggest Blake's 'lineaments of satisfied desire', their mutuality and incalculability. This is something for which there is no real precedent in Scottish literature – and something, of course, which stands at the opposite pole to the 'power-sex' of McLeish's fantasies, the pabulum of most best-selling pulp fiction.

Two things follow from this. One is the symbolic role that nudity seems to play in Gray. It is only by taking off their clothes to make love that Lanark and Rima discover they both have Dragonhide. McLeish

and Janine end *1982 Janine* naked, and the book's only illustration – McLeish delicately poised *as* acrobat – is also a nude: one suggesting, in pose at least, Leonardo da Vinci's famous life studies, as well as, perhaps, William Blake's 'Damn braces, bless relaxes': this is the Dionysian body, the source of energy, pleasure, and ease.

The second implication – and the one triggered in particular by the clothes fetishism of *1982 Janine* – is Carlyle and the philosophy of clothes in *Sartor Resartus* (1833–4). In this nudity was seen as the abnegation of the 'false' society of fashion and clothing: purity, sacredness, and also vulnerability. Carlyle is a deeply subversive and radicalising element in Scotland, in practically every field but the sexual. In fact, one can make the general observation that until the 1970s women as a whole derived very little recognition of their part in Scotland's social and intellectual development, in a society dominated by men at every level, from the pulpit to the pub. Even strongly-minded figures such as Catherine Carswell, Naomi Mitchison and Willa Muir were firmly marginalised by the men of the Scottish Renaissance. Literature seems, however, to be an equal opportunity employer in the myth and the folk-tale, and Gray has drawn women into his narratives in a variety of good fairy and wicked queen roles. As John Buchan had said in 1931 that it would, the fairy-story, with its moral purposes and metaphorical methods, has staged a revival. [17]

In order to manage this, Gray has gone beyond the Scottish tradition, although, interestingly, when he has done so, he has come up either with Scots of an earlier period – Sir Thomas Urquhart, the translator of Rabelais (*US*, 137–94) – or with writers who have owed much to Scottish connections. He is only one of four remarkable English-language writers who have come from that peculiarly debatable land, the Scottish art school. Besides John Byrne, the others are Joyce Cary and John Arden, both as deeply concerned as Gray about the fictionalisation of politics and the 'condition of Britain'.

The link with Cary and Arden seems not to have been explored. Gray has read Cary, and *The Horse's Mouth* serves as a 'difplag' in *Lanark*. There are two Scots connections here: one is Stanley Spencer, whose wartime paintings of shipyard workers on the Clyde were both a documentary account of Gray's people and a liturgical celebration of them. Spencer being given to things like painting the ceilings of churches in unorthodox ways, he obviously fits into *Lanark*. The other is the Scottish post-impressionist J.D. Fergusson – a paid-up member of the Glasgow bohemia – whom Cary admitted he took as the model for Gully Jimson as the apolitical, anomic artist. Arden has written of how his idea of theatre as eucharist, a democratic social ceremony received its

first impetus from watching Sir David Lindsay's *Satyre of the Thrie Estaitis* at the Edinburgh Festival in 1948, and, like Arden, Gray has stressed – in *1982 Janine* – the importance of the play as a collective creation. More important, both Cary and Arden were radicals in the Bunyan vein, who believed in the politics of an empowered people. Ultimately Gray's nationalism stems from the fact that he sees such values as more possible in Scottish society than elsewhere; nationality is not a given good, around which the rest of politics moulds itself.

VI

Gray's ambition has been quite spectacular: in effect to write the sort of novels which the Victorian Scots ought to have done, concerned with the life and morality of a society in the course of violent and unplanned change. We now know that the literary projection of Scotland in the nineteenth century did not vanish but migrated to the 'secular sermon', the 'imaginative autobiography': attempts by an individual – Carlyle, Hugh Miller, George MacDonald, John Muir – to comprehend violent social change as it affected him or her: at once confessional and didactic. This is one strand of Gray's experience; the other is the outreach to metaphor, and thence into fantasy or grotesquerie as a means of rendering the impact of change – again something with a Scottish location – in Hogg, George MacDonald, Barrie, the modern David Lindsay. The result is something which is at once Scottish and universal, but it reaches its goal because Gray's feet remain securely on the ground he knows. Recently, talking to the Irish poet John Montague, Gray's name came up. 'I hope he never leaves Glasgow', Montague said. A prayer we all echo.

NOTES

1. In 'Devolution Diary' in *Cencrastus*, No. 22 (1986), p.10.
2. Stephen Maxwell, 'The Nationalism of Hugh MacDiarmid' in Paul H. Scott, ed., *The Age of MacDiarmid*, (Edinburgh: Mainstream, 1980), p.221; and see *Albyn, or Scotland and the Future* (London: Routledge, 1927), p.55.
3. Cairns Craig, 'Scotland Ten Years On' in *Radical Scotland*, February/ March 1989, p.9. Kenneth O. Morgan, *The People's Peace* (Oxford: Oxford University Press, 1990), regards the devolution issue as merely an 'essay in survival' by the Labour government (p.371).
4. Alasdair Gray, 'Postscript' to Agnes Owens, *Gentlemen of the West*, 1984 (Harmondsworth: Penguin, 1986), p.129.
5. Gibbon, *Grey Granite*, 1934, in *A Scots Quair*, (London: Hutchinson, 1946), p.25; and see Andrew MacPherson, 'An Angle on the Geist'

in Walter Humes and H. Paterson, eds., *Scottish Culture and Scottish Education*, (Edinburgh: John Donald, 1983), pp.216–43.

6. Cairns Craig, art. cit., *Cencrastus*, No. 1, Autumn 1979, pp.18–22.
7. Anderson, *op. cit.* (London: Verso, 1983), pp.31–2.
8. Adam Smith, *The Wealth of Nations*, 1776 (rpt. London: Dent, n.d.), pp.4–9.
9. John Ruskin, *The Stones of Venice*, Vol. 2, 1853 (London: Allen, 1906), pp.162–3.
10. 'Sir Walter Scott' in the *London and Westminster Review*, Vols. i–iv, 1837, reprinted in *Scottish and other Miscellanies* (London: Dent, n.d.), p.71.
11. Thomas Carlyle, *Latter-Day Pamphlets* (London: Chapman & Hall, 1850), pp.228–30.
12. Gray, 'Postscript', in Owens, *op. cit.*, p.141.
13. See David Graham and Peter Clarke, *The New Enlightenment* (Basingstoke: Macmillan, 1986), p.xi.
14. Owens, *op. cit.*, p.62.
15. See my essay 'The Covenanting Tradition' in Tom Gallagher and Graham Walker, eds., *Sermons and Battle-Hymns* (Edinburgh: Polygon, 1991).
16. Gray, 'Postscript', p.137.
17. John Buchan, 'The Novel and the Fairytale', English Association Pamphlet No. 79, 1931.

I would like to thank Steve Rizza for checking this chapter, and throttling a few howlers. Any that remain are my responsibility.

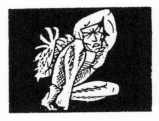

Seven

Going Down to Hell is Easy:
Lanark, Realism and The Limits of the Imagination

Cairns Craig

In the 'Epilogue' to *Lanark* (four chapters before the end of the novel), the protagonist, Lanark, confronts his 'creator' and debates with him how his [their] story should finish: meanwhile, around the borders of their conversation, another scribe is providing footnotes to the conversation, footnotes which are squeezed on to the page alongside an alphabetical list of some of the 'plagiarisms' which the novel has committed. Not for nothing does the final footnote (*L*, 499) allude to the contribution, despite the fact that their 'names have not been mentioned', of 'the compositors employed by Kingsport Press of Kingsport, Tennessee' who have had 'to typeset this bloody book'.

The gesture is significant: a book is not simply a text, it is an object, and in this case a substantial object (note 8 comments on the fact that 'a possible explanation' for the twin plots of the novel is 'that the author thinks a heavy book will make a bigger splash than two light ones' (*L*, 493)); its making is a function not merely of the genius of the author but of the production processes which connect typesetters in Tennessee with publishers in Edinburgh, readers around the English-speaking world and an author in Glasgow with tree planters, papermakers, binders, typographers, truck-drivers, bookshop assistants, librarians — a world of work that makes possible the delivery of the aesthetic 'work' the writer has created. Just as the creative effort of the author is built on the literary works which have preceded him, the transmission of that creation is built on the labour of those who make the book-as-object possible. The pleasures of the text are founded on the unspoken labour of the book producers.

That *Lanark* should emphasise its physical place within the system of production in this way points both towards the nature of the culture

from which it came and the major theme around which it is built. The most striking fact about the major literary contributions of twentieth-century Scotland is that they originate from and are focused around the experiences of working people — not necessarily working-class people, in the sense of an urban proletariat, but working people in the sense of those who sell their labour for their week-to-week survival. However much the Scottish renaissance movement of the 1920s was imbued with the spirit of European modernism — often seen as the product of a high bourgeois culture — the major Scottish writers were all from lower-class backgrounds and — whether it is the peasants of Muir's Orkney, the fishermen of Gunn's Sutherland, the industrial workers of Grassic Gibbon's Duncairn in *Grey Granite*, or the mill workers of MacDiarmid's 'The Seamless Garment' — made the experiences of the 'folk' the basis of their art.

The union of avant-garde experimentalism, folk culture and political commitment has meant that there has never been the division between serious writing and working-class writing in Scotland that has existed in English writing. As David Storey noted when receiving the Booker prize in 1978, there is in England 'the novel' and 'the working-class novel'. The latter is marginal, regional, necessarily limited and predictable in its concerns — as far, at least, as the critics and the reviewers are concerned. In Scottish culture the position is reversed: because the Scottish middle and educated classes have been so insistently anglicised, the expression of Scottishness has come to depend upon the classes which are least touched by English values: lower-class and working-class culture has thus come to be the repository of all that has been elided by the Scottish bourgeoisie's mimicry of English values.

This union of the avant-garde with folk and lower-class culture was reversed in the period after the Second World War, however, when Scottish writing came to be seen as split between the self-conscious experimental writers — who, like Muriel Spark, worked outside Scotland and with 'international' themes — and the working class writers who, in trying to document the lives of their community, remained locked within 'traditional', if not actually retrogressive, literary forms. The novelists — from George Friel to Archie Hind and Robin Jenkins in the '50s and '60s — who 'stayed at home' were those who, in their commitment to expressing working-class life, by and large worked within the accepted boundaries of a realism whose roots are in the nineteenth-century novel. So, for instance, Alan Bold accepts one of the listed plagiarisms of *Lanark*, the plagiarism of a plot in which 'heavy paternalism forces a weak-minded youth into dread of existence, hallucination, and crime' from George Douglas Brown's *The House with*

the Green Shutters of 1901, to insist that the Scottish novel has not moved forward at all in the twentieth century – its development has been nothing more than 'a long line that describes a vicious circle' (*Modern Scottish Literature*, p. 263).

The division between exiled experimentalism and immobile stay-at-homes has all the hallmarks of that 'schizophrenia' which has been for several generations the explanation for all the reputedly disabling internal contradictions and oppositions of Scottish culture. And at no time in the past fifty years has the 'schizophrenic' view of Scotland seemed to have more justification than in the aftermath of the failure of the political movement of the 1970s and the irresolute outcome of the vote in the Referendum of 1979. The importance of *Lanark* when it was first published in 1981 was that it seemed directly to confront these cultural and literary issues: with its protagonist split between the lives of two entirely separate characters it took on the burden of the self-division of the Scottish tradition; with part of the novel in an urban realist mode and part in a fantasy style, it directly faced the division of the Scottish novel into two opposing strands; and its political concerns addressed the issues of Scottish government and society in a context when the political debate seemed to have foundered. By the scale of its ambition and its apparent eccentricity, *Lanark* proclaimed the vitality and originality of a culture which, to many, seemed to be close to exhaustion, if not extinction, and was the first statement of what was to dominate Scottish writing throughout the 1980s – the effort to redefine the nature of Scottish experience and the Scottish tradition, both to account for past political failure and to begin to build a Scottish culture which would no longer be disabled by a lack of confidence in its own cultural identity.

Appropriately for a work which will almost inevitably be seen as both an end and a beginning to phases of Scottish writings, it is a novel in which beginnings and endings proliferate: the death of the hero, Duncan Thaw, at the end of Book 2, turns out, for instance, to have been preceded by his afterlife as Lanark in Book 3; his birth as Lanark (a name he takes from a photograph of the town in a railway compartment) turns out to be but the prologue not only to the birth and growth of Thaw, but to several deaths and rebirths of Lanark himself; the death of Thaw, however, is merely a rehearsal of an apocalyptic conclusion which Lanark awaits at the novel's close, though that in turn has already been prefigured in an endlessly unfinished painting produced by Thaw when he was an art student, a painting whose problematic structure we might take to be a commentary on Gray's novel itself: ' A landscape seen simultaneously from above and below and containing north, east and south can hardly be peaceful. Especially if there is a war in it.'

Lanark is a novel attempting to present its subject, the life and times of Duncan Thaw, with that kind of complexity of viewpoint. It juxtaposes a realist novel of the 'portrait of the artist as a Glaswegian' with a fantasy novel of Scotland as microcosm of the world, and links the two by having Books 1 and 2 of its narrative – the realistic sections – framed by Books 3 and 4 – the fantasy sections – so that we read Book 3 before we reach Book 1. This framing is achieved by having Lanark hear the narrative of what is or might be his own earlier life from a computer oracle in heaven – or is it hell? – so that Thaw's story is enclosed within Lanark's; while, at the same time, Lanark's voyage through a fantasy world that is part science fiction, part medieval romance is at once a commentary upon Thaw's life in history and a repetition of it that allows him to be released from the dead-end world in which he has been trapped. It is a journey which takes Thaw-Lanark not only through parodies of many other literary works – turning *Lanark* into a compendium of the modern mind – but through many different kinds of society, so that the novel is also a compendium of human histories, and of the societies that humanity has envisaged as the ends to which it aspires.

Each of the novel's four books is an archetypal journey from birth to death, from death to rebirth, with Thaw-Lanark an eternal quester after love and creativity trapped in an environment which denies him both. At each of his rebirths he must confront a monster as protean as himself – Glasgow, Scotland, the industrial-military system – all symbolised in the fantasy sections by the city of Unthank, Glasgow's apocalyptic twin. Whether in the historical or the fantasy sections the monster has him in its grip, and whatever its name or apparent nature its purpose is always the same, to keep itself alive at the expense of those who live under it, to feed itself by limiting, suppressing and, in the end, destroying them.

The contradictions of the plot are balanced in our hands as we read the novel, because the physical book we read is the product of this system just as much as the text is the product of Gray's art. In the world division of labour, people's work is used to support their own domination; trapped in a system which consumes them as they strive to sustain themselves, they become as monstrous as the system they live in. In the fantasy section this vision of Glasgow as hell turns it into a place in which people are beset by illnesses that grow mouths over their bodies or encase them in dragon hides that their dragon-claw hands tear at to chastise the humanity trapped within. In the real Glasgow, Thaw can escape the world of work and exploitation only by becoming an art student, but it is an escape which is no more satisfactory than the escape we have already seen Lanark make, in the

fantasy of Book 1, into the Institute, a place where new life is offered to the sufferers of Unthank's unkindliness as long as they are willing to live off the processed dragon-flesh of those less fortunate than themselves. In the Institute, Lanark is allowed to become human again by consuming the flesh of the unsaveable, just as Thaw is allowed to live imaginatively through his art only at the cost of immunising himself from the imaginative dereliction being imposed on the rest of humanity around him.

The 'thaw' which art brings to the iced-up world of Glasgow is as short-lived and has as little impact on the total system as the New Lanark experiement by which Robert Owen had attempted to melt the harshness of capitalism. Thaw and Lanark divide between them the possibilities of trying to transform life by art and by politics — another dualism of the modern condition sundering the aesthetic from the practical — only to discover that they live in a nightmare world in which every escape route that they take leads straight into the maw of another monstrous head on the hydra of a system in which one is either the exploiter or the exploited, in which one is almost inevitably both at the same time.

II

The conflict between realism as history-inscribed-on-the-world and a world where history has apparently been negated is dramatised in *Lanark* in the conflict between father and son. Thaw the father is a man who wants to have his own life reconnected to the dynamic of history, a dynamic which he experienced destructively in the First World War, but which he believes will have a beneficent outcome for humanity:

> "I was in it [Stobhill Hospital] myself in 1918: a shrapnel wound in the abdomen. Don't worry, I'll make sure you've plenty of books. I read a lot in Stobhill, authors I couldnae face now, Carlyle, Darwin, Marx . . . Of course I was on my back for five months." Mr. Thaw looked out of the window a while, then said, "There's a railway cutting in the grounds which goes to a kind of underground station below the clock tower. The army sent us there in trains. Would you like me to bring you Lenin's *Introduction to Dialetical Materialism?*"
> "No."
> "That's shortsighted of you, Duncan. Half the world is governed by that philosophy." (*L*, 299)

His belief is that

> ". . . modern history is just beginning. Give us another couple of centuries and we'll build a *real* civilization! Don't worry, son,

others want it beside yourself. There's not a country in the world
where folk aren't striving and searching . . ." (L, 295)
That vision, deeply linked to the whole process of industrialisation, is
the driving force of his, Thaw senior's, acceptance of present suffering
for the sake of future fulfilment, a belief by which the various 'shock-
treatments' administered to his son are justified. But that perspective
on history is countermanded by his son's experience of the industrial
city which is decaying back towards a state of nature – the canal which
carried its early industrial traffic having been transformed 'from a
channel carrying trade into the depth of the country' to 'ribbon of
wilderness allowing reeds and willows, swans and waterhens into the
heart of the city' (L, 279).

Thaw the father emerged from the wound of the First World War
with his belief in the ends of history intact; Thaw the son suffers the
post-Second World War world as a wound of history failed. Instead of
a history pressing forward towards fulfilment, Duncan can only see
history as like the Glasgow in which he is trapped: 'an infinitely
diseased worm without head or tail, beginning or end' (L, 160). Thaw
the father strives to rise above the pattern of local events to see the ends
of history – which is why in his son's vast painting of human history
God appears 'strong and omniscient, like Mr. Thaw' (p. 309). But
Thaw the Father has also been the suffering Son, which is why Duncan
copies his hands as the hands of Christ (L, 248). The redemptive schema
of omniscient Father and suffering Son fails in Duncan's case: he is
immersed in the cold bath of reality which is no baptism into new life
but only endless pain and suffering.

In the suffering of the Son the ideology of the Father is not fulfilled,
but negated: the art which charts this thankless reality conforms to
words of Vergil as quoted on p. 283:

**GOING DOWN TO HELL IS EASY: THE GLOOMY DOOR
IS OPEN NIGHT AND DAY. TURNING AROUND AND
GETTING BACK TO SUNLIGHT IS THE TASK, THE
HARD THING**

Realism goes down to hell – easily. In the failure of a historical
trajectory that will bring about a transformation of society, it cannot
show us the way back to the sunlight. More importantly, it cannot
show us why we are in hell.

When, in Chapter 33 of *Lanark*, Lanark and Rima leave the
Institute, disgusted by a place in which they can only live by eating
other human beings (who have conveniently ceased to look human,
being so fully coated in dragon-hide), they discover themselves on a
road with a yellow line which they take as guide through the twilight

mist of what is described as an 'intercalendrical zone', a place that is out of history:

> They walked into the mist guided by the yellow line on the road between them. Lanark said, "I feel like singing. Do you know any marching songs?"
> "No. This rucksack hurts my back and my hands are freezing."
> Lanark peered into the thick whiteness and sniffed the breeze. The landscape was invisible but he could smell sea air and hear waves in the distance. The road seemed to rise steeply for it became difficult to walk fast, so he was surprised to see Rima vanishing into the mist a few paces ahead. With an effort he came beside her. She didn't seem to be running, but her strides covered great distances. He caught her elbow and gasped, "How can . . . you go . . . so quickly?"
> She stopped and stared.
> "It's easy, downhill."
> "We're going uphill."
> "You're mad."
> Each stared at the others face for a sign that they were joking until Rima backed away saying fearfully, "Keep off! You're mad!" (*L*, 376–7)

The moment, as so often in *Lanark*, is both part of the surreal displacement of the fantasy world in which Lanark is lost and, at the same time, a commentary on the nature of the novel itself. The road goes uphill on one side, downhill on the other, and after disastrously trying both to travel downhill together and finding that they lose control and go tumbling off the road, Lanark and Rima find that the only way forward is one on either side of the line, arms linked, so that the uphill toil of one is counteracted by the downhill race of the other: 'The new way of walking was a strain on the linking arm but worked very well' (*L*, 378).

The image sums up the method of *Lanark* itself as a novel which works in two different directions at the same time. On one arm, on one side of the line, is the career of Duncan Thaw, born into a family struggling to attain decency in the tenements of Glasgow, a family determined to ensure that its children escape from the threatening presence of the slums into a world of opportunity, of expanded material and intellectual horizons. Thaw's struggle, the uphill struggle, is a struggle against the beneficent but materialistic expectations of his family (expectations bred out of their own awareness of deprivation); it is a struggle which is continued in his effort to be allowed to pursue his own imaginative vision art against the confining and cramping

scholasticism of the art school, whose main aim is to train him so that he can find work. Both of these are tied to his struggle to escape from his deeply inhibited sexuality, an inhibition that is artistically fecund but humanly destructive. The uphill struggle is presented in the measured realism of Books 1 and 2, with its downhill consequences in Thaw's failure to fulfil his family's expectations, his failed sexual relationships, his failed art, ending in his (perhaps) successful attempt at suicide. The downhill career is continued into Books 3 and 4, the fantasy world of the city of Unthank, of the Institute, of the World Council gathered at Provan; their ethos, in streets on which the sun never rises, in an Institute where people are driven along corridors of endless labyrinthine complexity by gusts of hot or cold air that allow them to travel in only one direction, in a city where poisons seep through the sewers and where people are trapped in "mohomes" — parked cars with the whole windscreen area as a television to stop them having to contemplate the bleakness of the world outside — is subterranean, claustrophobic; but through these 'downhill' environments Lanark is able to achieve an uphill recovery of his lost humanity.

It is by adopting these entirely different angles of approach that the quest of Thaw-Lanark is made possible, for one takes 'the high road' and one takes 'the low road' and both set out to get to Loch Lomond together in order to encompass the reality of Scotland. The road, however, takes a detour — for this, after all, is the twentieth century — to lead us through our century's two most widespread mythologies, the mythology of Hollywood in which the road with the yellow line is also Dorothy's road to Oz, with its happy resolution of reality through fantasy, and the mythology of psychology, in which the wizard at the end of the road is the good doctor Freud, renamed Ozenfant, who will plumb the fantasies of the child's — 'enfant' — psyche in order to release the adult into the Oz-world of purified control over conditioning.

When we first meet Lanark, on his arrival in Unthank, he has made his escape — though we do not know this yet — from his life as Thaw through the possible murder of a woman in a Chapter 29, called 'The Way Out', and from his own possibly successful suicide in Chapter 30, 'Surrender'; these are his gateways to the afterlife, but it is an afterlife which, if it initially seems to allow a sudden step beyond the world in which we had been trapped, rapidly turns into its re-enactment in allegoric form, enforcing the realisation that if the previous life was hell, we are not out of it. In the Unthank to which he has escaped out of Thaw's unacceptable life, and then in the Institute to which he escapes out of the horrors of Unthank, Lanark — like Dorothy in Oz — will meet disguised versions of the inhabitants of his previous existence,

encountering them in shapes in which the psychological deformities of their ordinary lives, which we can only describe metaphorically, have become literal: people whose personalities are being consumed by the repressed energy of the libido are transformed into dragons whose bodies will eventually be consumed into pure energy to provide the power for the Institute's technology. The 'fantasy' repeats in emphatic form the conditions of ordinary life as Thaw has experienced it, while at the same time – by the uphill-downhill logic of such things – illuminating the terms of that life by gesturing towards how the consumption of bodily energy which people suffer within the industrial system leads to their neuroses in the first place. For Lanark, as for the schizophrenic, as for us as readers as we are forced between the different domains of the novel, each escape into an alternative world is an escape leading only to repetition in another dimension of the very contradictions from which he sought release. This is the crucial pattern which underlies – and continually defeats – Thaw-Lanark's whole 'progress' through the novel, and which, projected outwards upon his whole society, reveals the deception of the 'progress' to which it is committed.

The 'road' on which Lanark and Rima set out is thus the road which offers a trajectory from the past towards an alternative future, but the directionality that it implies is an illusion for it brings them continually back to their starting point: the door marked

EMERGENCY EXIT 3124
NO ADMITTANCE
(L, 378)

Except that now they are on the wrong side of the door: it is locked to them and no longer offers them any escape. Their apparently forward motion has only brought them again to the same place, insisting that the force of repetition, which underlies everything in both the realistic and the fantasy sections of *Lanark*, is more powerful than the dynamics of change.

It is repetition that is Thaw's disease when he cannot leave his psychiatric ward – 'a repetitive cycle of improvement and deterioration' (L, 311), a repetition resulting from having accepted the nature of hospital life itself so that 'he has reverted to an infantile state in which suffering and being regularly fed feel actually safer than health' (L, 312). It is the condition of modern Scotland, living off the neuroses and achievements of its past. Thus as well as his life as Lanark being full of echoes of his life as Thaw – as for instance in the voices which travel along the corridors of the Institute (L, 64) – his life as Thaw is full of echoes of Scottish history, surrounding him with names like

Kenneth MacAlpin, MacBeth; James Watt is the man in charge of Thaw's artistic education as well as the builder, one hundred and fifty years previously, of the Monkland canal that Thaw tries to paint. And just as it is Hume's *Treatise*, with its mathematical clarity about the workings of the mind, which brings relief to Thaw's fevered brain when he is suffering from his first serious attacks in adolescence (*L*, 161), so it is Monboddo, eighteenth-century Scottish enlightenment theoretician, who rules over the council which is as illusorily benign in Book 4 as had been the Institute in Book 3.

The historical echo of Monboddo's name into Lanark's life is, however, accompanied by an existential repetition, since the bearer of the name is actually Ozenfant, whose wife is a woman Lanark had known as Catalyst:

> "Call her Lady Monboddo," said Ozenfant, who was standing beside her. He shook Lanark's hand briskly. "Time changes all the labels, as you yourself are proving also." (*L*, 473)

Those repetitions in the fantasy domain are a horrific-benign projection of what happens in the real world, for there repetition is not an opportunity for the same person to reappear under a changed label – it is the endless rotation of the machine to which humanity is tied, a horror explained to Thaw by his friend Coulter, when he has just joined the adult world of work:

> "Aye. Well, anyway, this business of being a *man* keeps you happy for mibby a week, then on your second Monday it hits you. To be honest the thought's been growing on you all through Sunday, but it really hits you on Monday: I've tae go on doing this, getting up at this hour, sitting in this tram in these overalls dragging on this fag, clocking on in this queue at the gate. 'Hullo, here we go again!' 'You're fuckin' right we go!' and back intae the machine shop. (*L*, 215–16)

The label-shifting of the fantasy world – the upper world – is to all appearances a means of extending one's humanity, but it is actually a fragmentation of humanity as dehumanising as the repetitions that it enforces on the worker and that turn him or her into a robot who can 'get up, dress, eat, go tae work, clock in etcetera etcetera automatically, and think about nothing but the pay packet on Friday and the booze-up last Saturday (*L*, 216). Thaw-Lanark's life is torn between the large scale repetitions of the fantasy world and the micro-repetitions of the worker's world; the novel involves continual shifts of location and of personnel, but concealed within this process of constant movement there is a pattern of repetitions which makes all movement an illusion.

This, perhaps, is the explanation for the novel being littered with

cross-references to other works of literature: at a formal level the novel is acknowledging that it too is trapped within a system of repetitions from which it cannot escape. And thus when the road which apparently carries them from past into future leads them back to where they started from, when they eventually escape the intercalendrical zone back into Unthank, it may no longer be the Unthank they left, it may be the changed Glasgow that Thaw never lived to see, but beneath its changes it remains the same, thankless as ever, for it is still a place from which people need emergency exits if their humanity is to survive. The paradox of the sign which offers an emergency exit but no admittance points, however, to the essential feature which links together all the emergency exits that people create for themselves in the world of *Lanark*: that they must be emergency exits for themselves, and they must be closed against everyone else. They must not be exits through which everyone can pass; for they exist to allow the few to escape from universal disaster.

That is why we enter the novel through the Elite cafe: the Elite is a world which locks the emergency exits upon everyone but those already inside; in the Elite we learn that the Nietzschean drive towards domination is the only means of maintaining one's personality in an uncreative world. Sludden, who rules over this world as Ozenphant rules over the Institute, insists that 'moments of vivid excitement are what make life worth living, moments when a man feels exalted and masterful'; work and love, he adds belong 'in the same category' since 'both are ways of mastering other people' [5–6]. Power is the escape route of the Sluddens of Unthank, because Unthank is a city locked in a world of power relations that leave it powerless to overcome the forces that are planning its destruction. But power is an emergency exit which shuts the door on the bulk of humanity: those whose bleak misery is the source of the desire for the power, the desire to escape their condition, are also a consequence of its imposition.

Mastery becomes self-lacerating; this is the lesson of the reality that Duncan Thaw has already lived through, the Glasgow which teaches him that:

> Hell was the one truth and pain the one fact which nullified all others. Sufficient health was like thin ice on an infinite sea of pain. Love, work, art, science and law were dangerous games played on the ice; all homes and cities were built on it. The ice was frail. (*L*, 160)

To 'thaw' the ice is not necessarily to save the world; it may only sink in the quagmire that is produced; the Thaw family in the historical Glasgow fail to melt the harsh reality which encases them. In such a situation, if you think you are escaping from hell, then going down to

hell is easy, especially if, when you first arrive, it seems as though it might possibly be heaven. For Lanark, the Institute is potential heaven because there he is allowed to recover in Rima the *Marjory* whom Thaw had lost in Glasgow; but it is a heaven which, like Sludden's ideology of love as mastery, can only exist by immuring the rest of humanity in hell; it is an Oz where those who are released from the physical and psychological damage inflicted on them by Unthank live only at the expense of those who cannot be released; a 'thaw' which only lets us see the perma-frost beneath the surface.

At the many gateways and boundary-points of Lanark the self-enclosed Oz-worlds that we create in order not to see hell are being broken open: Oz is not an escape from hell, it is the condition which makes hell inevitable. That is why it is easy to get down to hell: we are already in the midst of it; that is why it is so difficult to get back to the sunlight, because we must get back without merely encasing ourselves in an Oz-world where the light is an illusion, turned inwards upon ourselves and intensifying hell — and the desire to escape to Oz — for others. Having escaped to Oz, Lanark will have to return, to go down to hell yet again, to encounter the ice — 'You're wearing thin sandals and you're standing on ice. I'm sorry, Rima, I've led you onto a frozen lake' (*L*, 394) — to try to become the thaw that he has failed to be in Thaw's life. The knowledge that Lanark brings back from the Institute is thus knowledge of the marriage of heaven and hell, of the universal logic of uphill-downhill, of the world held in place by the linked arm across the fearful yellow line: the escape routes of heaven are all versions of the Elite cafe mentality in which personal salvation is bought at the expense of everyone else's damnation; whether it is the bohemian elite who have released themselves from ordinary morality but are parasitic on others' work and suffering, or the business elite who have secured their material circumstances on the back of others' body-destroying labour, or the religious elite who secure themselves by damning the rest — all walk in light only because of the darkness they impose on the rest of the world.

The ultimate temptation of the artist, of course, as, indeed, of the critic, is to imagine that in the imaginative environment of art one has encountered reality, that one has circumscribed it and understood it. That too is an Oz, though it is inscribed in the whole tradition of romantic aesthetics that art, that the imagination, is the ultimate truth-teller. The artist is the hero not because in him, unlike the rest of us, work is play, but because he is our guide into unacknowledged truth. But in Thaw Gray has turned on its head the myth of the artist which lurks behind many of the great works of early twentieth-century

modernism: the Stephen Dedalus who dreams of the artist as God, the Paul Morel who denies the virtues and the self-destructiveness of his father's labour as a miner, the Yeats who can claim his inspiration from the powers that shape the world. Glasgow may demand its imaginative fulfilment in art, but Thaw's art — because it is *his* Oz — is life-negating: it is an imagination sustaining itself by such an effort of concentration, by such an effort of exclusion of the outside world, that it demands the death rather than the rebirth of the world to which it seeks to bring its vitality.

Thus, in a nightmare, Thaw dreams the consequences of his art, when it is forced to operate — like his relationship with Marjory — as an escape route from his impoverished life:

> He was standing on the golf course of Alexandra Park shortly after dawn, listening to a lark in the grey air overhead. The song stopped and the bird's corpse thumped onto the turf at his feet. He walked downhill through a litter of sparrows and blackbirds on the paths to the gate. On Alexandra Parade a worker's tram, apparently empty, groaned past the traffic lights. He watched the lights change from red and amber to green, then to green and amber, and then go out. The tramcar came to a halt.
>
> Not everything died at once for the lowlier plants put on final spurts of abnormal growth. Ivy sprouted up the Scott monument in George Square and reached the lightning conductor on the poet's head; then the leaves fell off and the column was encased in a net of bone-white bone-hard fibre. Moss carpeted the pavements, then crumbled to powder under his feet as he walked alone through the city. He was happy. He looked in the windows of pornography shops without wondering if anyone saw him, and rode a bicycle through the halls of the art galleries and bumped down the front steps, singing. He set up easels in public places and painted huge canvases of buildings and dead trees. When a painting was completed he left it confronting the reality it depicted. (*L*, 266–7)

This is the end-point of realism: fixing life in the *rigor mortis* of death in order to be able to make inevitable the power of art to imitate life. How, *Lanark* asks, can imagination save us if imagination is drawn into the power structures of the world of exploitation, imposes death on the world in order that it can live? The very imagination through which Gray constructs his novel is implicated in that destructive process of mastery: the novel must challenge the source of its own creativity if it is not to become just another play in the power structures and the escape routes by which the world entraps us.

The paradox upon which *Lanark* is based, therefore, is that its hero, Thaw, must be deprived of the escape route of imagination, of art, if he is to recover his humanity; but he does so only through the medium of the novel's own imaginative vitality, through Gray's construction of a fantasy completion for Thaw's life. That fantasy world is both, therefore, a compensation for the world that Thaw has suffered, a sublimatory domain in which he will win the woman he could not win in life; but, at the same time, it is also a critique of the escape routes of fantasy which live off the hell of ordinary experience without transforming it; it is a place in which Thaw will be reborn − the wrong way round as he arrives down the birth canal from the grave-mouth in the Necropolis − not as the fulfilled artist who represents the best of human creativity, but as an ordinary human being with no escape route to the elite, but as a human being whose ordinariness is only possible because of the imaginative escape route provided by Gray's fantasy projection that is *Lanark* itself.

III

'*Einmal ist keinmal*. What happens but once might as well not have happened at all.' The words of Nietzsche, rendered hauntingly into his novel *The Unbearable Lightness of Being* by Milan Kundera[1] point to the dilemma that Gray has charted in *Lanark*. Thaw-Lanark live in a society which has lost its historical significance, has entered into a kind of historical entropy in which there is no longer any forward momentum. Denied an end towards which life is directed, and a transcendence (into art, for instance) by which we can escape from it − how are we to survive? *Lanark* is haunted by the possibility of a different way of seeing the universe:

> The darkness outside the window paled and soft pink came into the sky behind the pinnacles of the dingy little church. Drummond shot up the window to let in a cool draught. From grey rooftops on the left rose the mock Gothic spire of the university, then the Kilpatrick hills, patched with woodlands and with the clear distant top of Ben Lomond behind the eastward slope. Thaw thought it queer that a man on that summit, surrounded by the highlands and overlooking deep lochs, might see with a telescope this kitchen window, a speck of light in a low haze to the south.
> (L, 275)

The double perspective, of the view from the kitchen window, and the view from the mountain top, from within the trudge of history and from a perspective that is outside of it, is the foundation of the generic

doubling of the novel. Neither perspective will suffice by itself — only
the dialectical interaction of the two will allow us to live with the
unendurable weight of a history that we still have to believe may go
somewhere.

And it is such a doubleness that he tries to incorporate into his
paintings: 'a perspective showing the locks from below when looked at
from left to right and from above when seen from right to left; he
painted them as they would appear to a giant lying on his side, with
eyes more than a hundred feet apart and tilted at an angle of 45 degrees'
(L, 279). He can never complete his canvases because they have to show
both the God's eye point of view and, at the same time, an alternative
perspective in which we confront 'someone whose bewildered face
looked straight at the viewers, making them feel part of the multitude
too' (L, 280).

We must be inside and outside at the same time: we must live in
history and yet with the consciousness of being outside it. It is that
desire for the impossible union that creates the double identity of Thaw-
Lanark, for Lanark lives out Thaw's art, as Thaw, after his death, is
allowed to live on through Lanark's life. In Book 3 — the first book we
encounter in the novel — Lanark experiences life from within a
framework whose elements are the subconscious obsessions of Thaw
junior; whereas in Book 4, he pursues the fantasies of Thaw senior's
conscious desire for an ordered and rational world. In Book 3, Lanark
is cleansed of the Oz-world of the art that Thaw has surrounded himself
with and rediscovers himself as a human being able to form a creative
(and procreative) relationship with someone else; in Book 4, he
discovers the hollowness of the controlling perspective that his father
sought, and, in the end (almost), he encounters and denies the God-
artist of the novel who would claim complete control over his life (and,
incidentally, who would claim the false God of Knox as the total
explanation of the perversions of Thaw-Lanark's life):

> "Suddenly the sea floods the city, pouring down through the
> mouths into the corridors of council and institute and short-
> circuiting everything. (That sounds confusing; I haven't worked
> out the details yet.) Anyway, your eyes finally close upon the
> sight of John Knox's statue — symbol of the tyranny of the mind,
> symbol of that protracted male erection which can yield to death
> but not to tenderness — toppling with its column into the waves,
> which then roll on as they have rolled for . . . a very great period.
> How's that for an ending?"
> "Bloody rotten," said Lanark . . .

The conjuror's mouth and eyes opened wide and his face grew red. He began speaking in a shrill whisper which swelled to a bellow: ". . . As for my ending's being banal, wait till you're inside it. I warn you, my whole imagination has a carefully reined-back catastrophist tendency; you have no conception of the damage my descriptive powers will wreak when I loose them on a theme like THE END."

"What happens to Sandy?" said Lanark coldly.

"Who's Sandy?"

"My son."

The conjuror stared and said, "You have no son."

"I have a son called Alexander who was born in the cathedral."
(*L*, 497–8)

The God-author who has put his creation to such stress and can offer only disaster as an end – is overthrown by the freedom which Lanark has attained, the humanity he has acquired and been able to pass on. If Thaw the father could offer nothing to ameliorate present suffering for his son, God the spiritual father of Lanark's world can only threaten destruction for his offspring; but Lanark defies his creator with the creation of a son, and so enables himself to reunite the father and the son – Thaw senior and junior – who had been sundered in and by history.

The imaginary – Lanark – has thus redeemed the real – Thaw – and in so doing acquired for itself a reality which even its creator would not have claimed. Thaw could not make his art come alive, but through Lanark he is not only allowed to live on – in a world where his artifice has become reality – but in that world to fulfil the sexual creativity that he was always defeated by in his life.

The redemptive moment comes in a scene which fuses the alternative perspectives of the double vision, linking Thaw's life directly to Lanark's. As a child, Thaw had refused to wear climbing boots that his father had bought for him; he had gone climbing none the less, and had met at the top of the mountain a minister who had told him how his father's notion of education

". . . embraces everything but the purpose of life and the fate of man. Do you believe in the Almighty?'

Thaw said boldly, "I don't know, but I don't believe in Hell." The minister laughed again. "When you have more knowledge of life you will mibby find Hell more believable . . . I was six years a student of divinity [in Glasgow]. It made Hell very real to me."
(*L*, 143–4)

The denier of his father's authority was busy and unconsciously making

a hell for himself; his later incarnation, Lanark, in despair at failing to save Unthank, to save the city from hell, recalls or imagines going climbing with his son Alexander:

> He was wondering sadly about Alexander's life with Rima when the path became a ladder of sandy toeholes kicked in the steepening turf. From here the summit seemed a great green dome, and staring up at it Lanark saw an amazing sight. Up the left-hand curve, silhouetted against the sky, a small human figure was quickly climbing. Lanark sighed with pleasure, halted and looked away into the blue. He said, "Thank you!" and for a moment glimpsed the ghost of a man scribbling in a bed littered with papers. Lanark smiled and said, "No, old Nastler, it isn't you I thank, but the cause of the ground which grew us all. I have never given you much thought, Mr. cause . . . and on the whole I have found your world bearable rather than good. But in spite of me and the sensible path, Sandy is reaching the summit all by himself in the sunlight . . . I am so content that I don't care when contentment ends. I don't care what absurdity, failure, death I am moving toward. Even when your world has lapsed into black nothing, it will have made sense because Sandy once enjoyed it in the sunlight. I am not speaking for mankind. If the poorest orphan in creation has reason to curse you, then everything high and decent in you should go to Hell. Yes! Go to Hell, go to Hell, go to Hell as often as there are victims in your universe. But I am not a victim. This is my best moment.
> (L, 515)

In that one moment the apparently endless repetitions in which Thaw and Lanark are caught up become redemptive, because the figure Lanark sees climbing the hill is both Thaw as a child and his own son: Alexander provides the 'sandy' toeholes by which Lanark is able to recover his childhood as Thaw, and allows Thaw to achieve the fatherhood (through Lanark) that he was denied in his own life. Thaw and Lanark, son and father, reality and imagination, history and the historyless are momentarily fused together: the watcher is both on the hilltop looking down and in the valley looking up. Out of continual defeat, out of a continual fall into yet another hell, comes a kind of success, for by the end of the novel Lanark is no longer a striver after a place in the elite, a creator of hells for others to live in; he is neither a striver after the ultimate ends of history nor after the imagination leaping to transcend the actual: he is one of us, between heaven and hell, a survivor of the tyranny of our historical imaginations, waiting the end — 'a slightly worried, ordinary old man but glad to see the light

in the sky' (*L*, 560) – who leaves us the weight of a large book in our hands, an object both inside and outside the economic system that makes it possible and negates its values at one and the same time.

NOTES

1. Milan Kundera, *The Unbearable Lightness of Being*, tr. Michael Henry Heim (London: Faber & Faber, 1984), p. 223.

 Eight

Black Arts: *1982 Janine* and *Something Leather*

S.J. Boyd

'Be true! Be true! Show freely to the world, if not your worst, yet
some trait by which the worst may be inferred' – Hawthorne, *The
Scarlet Letter*.

The publication of *Something Leather* confirms beyond doubt what was
already strongly suggested by *1982 Janine*: Scotland's greatest living
literary light is a pornographer. That this should be the case is massively
ironic but with a certain subtle propriety to it. For the most famous
figure in Scottish literature is, after all, a voyeur. Tam o' Shanter is a
Peeping Tom. A drunken binge gets Tam to a box-seat at the orgiastic
danse macabre but he fails to become one of the participants. His
enthusiasm for (watching) striptease is recalled by our colossus of the
first half of the present century, Hugh MacDiarmid, in *A Drunk Man
Looks at the Thistle*: 'Cutty, gin you've mair to strip, / Aff wi't, lass –
and let it rip!'[1] MacDiarmid's poem, the 'blatant sexuality' of which
'came as a severe shock to contemporary taste and mores' in Scotland
in 1926, is acknowledged by Alasdair Gray as one of the sources of
1982 Janine (J, 343).[2] A brief examination of some points of similarity
between the two texts may help in constructing an explanation of Gray's
turn 'to debauchery and dirt'.[3]

Gray's own acknowledgement of debt to MacDiarmid's masterpiece
refers only to 'the matter of Scotland refracted through alcoholic reverie'
(J, 343), but it is not diffficult to see that there's more to it than that.
There is, for example, the matter of the sado-masochistic nature of the
alcoholic reverist:

Masoch and Sade
Turned into ane
Havoc ha'e made
O' my a'e brain.[4]

Those lines might be the motto of Gray's Jock McLeish, whose fascination with sado-masochism needs no example. Related to the masochism are the bouts of violent self-disgust, as in the poem MacDiarmid borrows from Zinaida Hippius where the Drunk Man characterises his own soul as 'A shameless thing, for ilka vileness able' (in the transvalued values of pornography, incidentally, these would be terms of praise), or in Jock McLeish's admirably terse paragraph, 'I am shit' (J, 129).[5] This nadir of self-esteem follows immediately after the classic expression of inebriate Scots boastfulness: 'Here's tae us, wha's like us? Damn few, and they're a' deid' (J, 129). The juxtaposition suggests the manic-depressive extremes of the (suppositious) Scots character, an aspect of the national schizophrenia that manifests itself in literature as the 'Caledonian Antisyzygy', perhaps the central idea around which *A Drunk Man Looks at the Thistle* is constructed. (Even the braggart's toast above has a double-edge to it with its hidden suggestion of queerness and morbidity.) Gray's Jock, who has *the* Scots forename, is a thoroughgoing Jekyll and Hyde, being outwardly respectable and by day a protector of the privacy and security of others while secretly an alcoholic and by night an invader in fantasy of others' privacy, an inward immoralist. His book of confessions is one which Gregory Smith or Hugh MacDiarmid would have recognised as profoundly antisyzygous, a work where 'real life and romance', 'things holy and things profane', are all a-jostle, where the drunken Jock's waking dreams are a strange mixture of the paradisaical and the infernal.[6] As MacDiarmid puts it, 'Whisky mak's Heaven or Hell and whiles mells baith'.[7]

It was, as remarked above, the frank treatment of sexuality in MacDiarmid's poem which his contemporaries found so shocking. It was something of a shocker that a Scot should 'talk dirty' at all. For the Jekyll side has rather had the upper hand. To Jock McLeish Scotland is still a deeply unsexy place. 'We are all timid and frigid here', he reflects, and remembers a 'singles club' in Motherwell, 'where I was too nervous to speak to anyone' (J, 35). It's hard not to be amused at the very notion of a 'singles club' in Motherwell and the image of such a club where people are too inhibited to talk to one another is a splendidly comic emblem of poor old repressed Scotland. In Jock's little world glamour is *elsewhere*: 'Seen from Selkirk America is a land of endless pornographic possibility' (J, 17). The repressive atmosphere of Scotland no doubt helps explain Jock's retreat into voyeuristic fantasy. MacDiarmid's poem is explicitly an attempt to kick against such repression, to free the wild profane Scot from the stranglehold of 'the douce travesty', the canny respectable Scot. For MacDiarmid this process is a matter of enabling the 'true Scot' to triumph over the 'false': 'In other words, the

slogan of a Scottish literary revival must be the Nietzschean "Become what you are".[8] In both MacDiarmid's poem and Gray's novel whisky unleashes the Dionysian in the Scots character: *in aqua vitae veritas*. It is, to borrow a phrase from Dostoevsky's *Notes from Underground* (another work cited by Gray as influential upon *1982 Janine* (*J*, 343), 'the filthy truth' about Jock which is revealed.[9] A very filthy truth indeed. For Jock is not simply, like the Drunk Man, an enthusiast for the erotic. He is a consumer of the second-worst kind of pornography (I had thought to write 'the worst', but recent revelations in the media of the indescribable evil of child-pornography made me think again), that which proffers images of violence against women and rapacity for titillation, and is himself a creator of some very nasty pornographic fantasies. From all sorts of contemporary political and moral standpoints, Jock is not at all far from the lowest of the low.

Within his fictive world, however, Jock tends to keep this truth to himself. Locked up in his nondescript little hotel-room, fantasising about glamorous dreamworlds, he is surely a signal example of *failure* to become what he is, to realise or express that hidden self (and, one is tempted to say, just as well!). The book, however, allows the reader a voyeur's access to someone else's hotel room, the pornographer's privilege. Jock is, indeed, like a player in one of his own imaginary films, starting off 'worried and trying not to show it', as Janine is introduced to the novel (*J*, 12), and ending up 'tearwet' like so many of his imaginary victims (*J*, 340). Pornography can be regarded as a kind of documentary which reveals truths about ourselves which have generally been kept hidden: one of Jock's fantasy locales bears on its gates the name 'FORENSIC RESEARCH ASSOCIATION' (*J*, 20). The novel uses pornography as a means of researching the truth about Jock, however unpalatable. MacDiarmid's Drunk Man commands himself to stick his pig's snout into the truth, even if it is his own vomit he has to lap up.[10] Nietzsche in *Ecce Homo* similarly advocates the fearless exploration of forbidden territory:

> *Nitimur in vetitum* [We strive after the forbidden]: in this sign my philosophy will one day conquer, for what has hitherto been forbidden on principle has never been anything but the truth.[11]

It is our own 'vomit' we've hidden or outlawed, but *1982 Janine* puts us metaphorically and even literally ('Some scum still sticks, scrape loose with fingers' (*J*, 186)) in touch with such *verus vomitus*.

There is another respect in which Jock's situation resembles that of Janine, Superb and his other creations. He *is* a creation too: he is a product of Alasdair Gray's fantasy. And so, of course, are they. Gray does not keep his fantasies to himself. His writings are in general

marked by a bizarre kind of confessionalism, a determination to reveal, if not his worst, yet some trait by which the worst may be inferred. Thus in *Lanark* the 'Index of Plagiarisms' records that the novel's author is 'unhealthily obsessed by all of Dr. Freud's psycho-sexual treatises' (*L*, 488). In the *Saltire Self-Portrait* Gray tells us virtually nothing of his autobiography. It is a remarkable testament of shyness, yet in its very first paragraph he chooses to reveal to the world the fact that his genitalia are small (*SSP*, 1). *Ecce Homo!* It is a truth to which few men would care to admit. This courageous drive to reveal the truth about himself seems to characterise Gray's novels, which form one vast *Apologia pro Vita Sua*. The two with which this essay is concerned might be gathered under the subtitle *Confessio Amantis*.

Among the snippets of criticism chosen by Gray to round off the 1985 Penguin edition of *1982 Janine* is the following, written by George Melly:

> If Alasdair Gray were a pornographer he would be rather a good one. He is not a pornographer, however. His power to titillate is betrayed by humour and pathos, the worst enemies of true porn.

This is a wily piece of excuse-making, but it rather ignores the fact that a book may be funny or touching at one moment and thoroughly pornographic at the next, which is the case here. One might argue that the book's humour arises in part out of our sense that Jock's fantasies are parodies or pastiches of pornography, but it would be as well to take note of the wise words of Susan Sontag on this sort of matter: '*Candy* may be funny, but it's still pornography. For pornography isn't a form that can parody itself.'[12] Melly is, of course, correct in suggesting that Gray is no *mere* pornographer. It is pretty clear that *1982 Janine* is, among other things, some kind of allegory of the state of Scotland at a particular point in history, but it is a *pornographic* allegory.

Melly suggests that Gray might make a *good* pornographer. This chapter will deal largely with the question of whether he *is* a good pornographer, but the question must first be asked whether his character Jock McLeish is or is not a good pornographer. The question has an aesthetic and a moral aspect and the aesthetic will be considered first.

In a certain obvious respect the success or failure of a work of pornography is a matter of personal taste, or personal gut-reaction. One is either titillated or one is not and the degree to which one is titillated is a simple measure of the success or excellence of the pornography in question. However, it may well be that there are certain narrative strategies which, *ceteris paribus*, are more likely than others to achieve such success. Jock McLeish seems to have some grasp of the nature of

such strategies and some skill in constructing them. This statement applies equally, of course, to Alasdair Gray: even if it is all a parody, one must have a good working knowledge of whatever it is one wishes to parody. Jock tells himself little stories, but the stories read not like novelistic narratives but like screenplays of films or a running commentary upon or verbalisation of the images on a cinema screen. This is generally achieved by the use of a continuous present (which is also a feature of *Something Leather*) and a concentration upon externals, upon what the eye or the camera sees. That the fantasies are cinematic becomes at points quite explicit, with Jock's characters watching a pornographic film for which Jock supplies details of shots, costume, sound-effects, music and titles (*J*, 87–8). This indicates a grasp of the notion that, to risk an aphorism, *all porn constantly aspires to the condition of movies*. Literature is not the ideal medium for pornography. Words can create images, but they also get in the way of them, forcing us to build a picture bit by bit and in so doing losing all the immediacy and coherence of an image:

> But Janine is not happy about the white silk blouse shaped by the way it hangs from her I must *not* think about clothes before I've imagined Janine herself. (*J*, 13–14)

Jock wants to see a blouse hanging in a certain way around a particular woman's shoulders. He wants a cinematic image, but he struggles to create it with words which advertise their inadequacy to the task. And yet, *faute de mieux*, words are useful to Jock's strategy in his particular situation. Because all the endless word-spinning he goes in for, the very time-consuming and roundabout nature of verbal descriptions, *delays* him on the way to his inevitable goal, which is a sad detumescence. Pornographic fantasies make the world seem a thrillingly attractive place to Jock, keep his mind off his dreadful inner anxieties, make life seem worth going on with, but only as long as they continue to fail in their apparent aim. So Jock wisely devises plot-strategies which shy away from getting down to the really nitty gritty. It is in careful setting of the scene that the real skill lies.

Jock is, at times, pleased enough with his own skill in this business: 'I ought to be a film director. I can imagine exactly what I want' (*J*, 87). He can imagine well enough what *he* wants, but perhaps this is not enough to make him a *good* pornographer. There is a certain *sameness* to his pornographic plots and this sameness in the material is carried on into *Something Leather*, a fact which might lead one to ponder again the question of the degree of distance existing between Jock McLeish and his creator.

There remains the moral aspect of the question of the good

pornographer. With regard to Alasdair Gray the question will be considered in discussing *Something Leather*. But the question of what sort of moral judgement to pass on Jock McLeish is a ticklish one. Gray clearly wishes to set us this sort of challenge. Dostoevsky's tortured soul in *Notes from Underground* insists in the book's stunning opening sentence on being sick and wicked. By contrast, at the outset of Chapter 4 Jock McLeish states: 'I AM NOT A BAD MAN, I AM A GOOD MAN' (*J*, 57). And yet the book is dominated by the man's pornographic fantasies of sadism and rape. There seems to be potential for a broadly feminist reading of the text which would take the sadistic and rapacious aspects of Jock's fantasies as indicative of the essence of all pornography, pornography being a form of rape, a cruel expression of male power over women. Jock is thoroughly warped and wicked, but a representative of general male swinishness. Apart from the inherent vapidity and incoherence of the general argument, there are a number of problems with this interpretation. For one thing, in an interview in *Bête Noire* Gray clearly resists the feministic blandishments of the interviewer:

> Alan and the Oedipal confrontations with Hislop provide the background against which you can build a pornographic seeming book that isn't finally pornographic, but more an expose [*sic*] of corrupted male sexuality.
>
> Oh it does a bit, aye, but the thing is, I quite enjoyed writing the sadistic nasty bits (laughing) and well I cannot say (adopts lofty tone), 'I happened to write this for purely sociological reasons.' I rather enjoyed it for its own sake. [13]

Gray's comments regarding *Something Leather*, as we shall see, run along similar lines and have a similar tendency to render the feminist reading problematic, if not untenable. It is quite clear that Gray, like Jock, enjoys his fantasies.

Moreover, the problem with generalising arguments based on Jock's fantasies is that the fantasies are very specifically Jock's and the book is designed to show how they are shaped by his own life and his own situation. And though Jock indulges in fantasies of doing things to women which are indubitably wicked, he is *not*, in real life, a rapist. He is able to provide worthwhile evidence in support of his claim to be a good man:

> I contribute to Oxfam, the Salvation Army and Cancer Research although I do not expect to benefit from these organisations. On crowded trains and buses I offer my seat to cripples and poorly dressed old women. I have never struck a man, woman or child in my life, never lost my temper, never raised my voice. (*J*, 57)

How many of us can say as much? Jock wants 'to keep fantasy and

reality firmly separate' (J, 41) and has succeeded at least to the degree that he has not given his sadistic and rapacious tendencies any expression in real life. He has not, in any obvious way, harmed anyone along the lines of his fantasies. Even his sodomising of Denny was accidental and mutually pleasurable (J, 106).

Jock *has* acted badly, has caused great harm, notably to poor Denny, his overall treatment of whom he describes as 'very ordinary and very terrible' (J, 230). His misdemeanours have not been inspired by or in keeping with his extravagant fantasies. They have been those of an ordinary, normal, respectable man and the world of ordinary, normal, respectable people is shown in this book to be completely hideous. Thus, Jock describes Helen and himself in their marriage as 'killing each other quietly, gently, in the respectable Scottish way' (J, 33). The perfectly respectable exciseman describes to Jock how he enjoyed, while serving in HM Forces in Palestine, machine-gunning an entire family, grandparents, three or four children and all (J, 148). Helen's father, a monster of self-righteous Scots respectability, forces Jock and the supposedly pregnant Helen into wedlock, but this had not been his real hope: Jock finds out years later that he 'had discovered a safe but expensive abortionist he would have sent her to if I had been willing to pay' (J, 296). The canny man! He favours infanticide to save face but baulks at the expense. Our respectable, normal, decent world rests on foundations as brutal as anything in Jock's fantasies, but *real*. A smart man 'knows that anyone with five pounds in an account has inadvertently invested half of it in practices which would make him vomit if he could see them' (J, 137). In the light of all this, it is difficult to maintain the view that Jock's pornography brands him as among the lowest of the low. His fantasies *do* represent the filthy truth about politics and society, about 'a world ruled by shameless greed and cowardice' (J, 176) where 'the winners shaft the losers, the strong shaft the weak, the rich shaft the poor' (J, 121), but this is not specifically a revelation of the nature of *gender* politics. Perhaps it is *not at all* a matter of gender politics. The last sentence quoted above goes on: '. . . accusations of sex-discrimination are irrelevant. Most men are poor weak losers. Many women are not.' After all, in this book, at least according to Jock, women rape men and use them as whores.

There is a more specific aspect of politics to which the book addresses itself and that is the politics of Scotland. Gray states, after all, that the novel deals with 'the matter of Scotland' (J, 343). Needless to say, Scotland is identified as the hapless victim of rapacious powers:

> . . . clearly Scotland has been fucked. I mean that word in the vulgar sense of *misused to give satisfaction or advantage to another*. (J, 136)

This notion seems to be detectable also in *Something Leather*, where Senga and Donalda's firm could be seen as an emblem of working-class Glasgow prostituting itself for the entertainment of cultivated English bitches. Wicked Jock McLeish, like so many gifted or well-born Scots down the years, has sided, for his own advantage, with the exploiters. Jock's biggest victim in real life, the girl he betrayed horribly because his brush with the glamorous Anglicised world of the theatre had made him think her horribly common, bears the name Denny, an improbable name for a Glaswegian girl but also the name of a rather run-down and sad-looking wee place, a town located bang in the middle of central Scotland. 14

Such an association is highly speculative, yet all of Gray's works show an interest in topography, an abiding interest to which the final words of *Lanark* bear testimony (*L*, 560). So it is perhaps appropriate to speculate a little on the significance of Jock's awakening to a new day in *Greenock*. The novel asks us to think about the matter: 'This is Greenock, why?' (*J*, 315). Greenock is an ugly man-made mess on the edge of sublime natural beauty. A place of deprivation, it is just across the Clyde from the glorious sea-lochs of the southern Highlands, scarred (as Gray's cover-illustration to *Lanark* shows) by the presence of the secure installations of foreign powers and their ships of mega-death. 15 It is a bit like Jock, for beneath all the mess of twisted fantasies there is beauty too in Jock's soul. The etymology of the name Greenock suggests that it is a sunny place. One wonders whether this might be some sort of Celtic joke, but the Celts were used to even wetter places. When Jock looks for the first time beyond the walls of his bedroom, he finds the Greenock weather in typically glum form: 'Gently pull curtains. Dawngrey sky, dawngrey sea, grey mountains between them' (*J*, 314–15). This view contrasts strongly with the sunny American world of Jock's fantasies and Jock has earlier specifically associated Scotland's lack of glamour with its cloudiness (*J*, 71). Yet this ordinary vision of Greenock is beautiful and refreshing, especially after the claustrophobia of Jock's room, in its sense of space and resurgent life. Jock must learn to love again this beauty of the ordinary. The voice of God tells Jock:

> listen i
> am light
> air
> daily
> bread
> common
> human
> warmth

 ordinary
 ground
 (*J*, 180)
It is salvation to love these things. There is a part of Jock's soul which
does love these things. One of the worst aspects of his fantasies is that
they distract his mind from such things, yet in a way they testify to
the strength of his love for them. For it becomes clear that his fantasies
are designed to prevent his mind turning to a consideration of his own
life and in particular his treatment of the thoroughly common, human,
warm, ordinary, earthy girl that was Denny. Jock loved Denny and he
cannot bear to think of what he did to his love. For several decades Jock
has not wept, but in the novel's final pages he lets the tears flow — as weel
he micht efter sic a nicht — for his lost friend Alan, for his parents, above all
for Denny. Gray contrives a wonderfully moving effect by dissolving the
seemingly endless flow of words in Jock's mind into inarticulate exclama-
tions of 'Ach', at once a jolt of grief and a stubborn Scots dismissal of such
shows of emotion. The wide-open white spaces on the page which the
typography suddenly creates suggest perhaps the inner silence, the
cessation of the distracting babble within, which allows Jock to
commune with his deepest feelings, his deepest griefs. This silence is,
indeed, in terms of the book's rhetoric, the croon o' a'. Jock images his
highly satisfactory lovemaking with Denny in terms of 'homecoming'
(*J*, 36) and it is clear that in general his alienation from home and roots
is something which he feels deeply. It is perhaps worthy of note in this
context that, waking up in Greenock, Jock at the end of the book is a
little nearer his original home, in northern Ayrshire, than his speculations
as to his whereabouts (Peebles or Selkirk) at the outset of the book
would have led him (and us) to believe.

Jock plans a new day, a new life of reform: 'I will not squander myself
in fantasies' (*J*, 340). But he backslides at once into fantasies of Janine.
He still loves Janine and could say, at this point, with Ernest Dowson:

> But I was desolate and sick of an old passion,
> When I awoke and found the dawn was gray:
> I have been faithful to thee, Cynara! in my fashion. [16]

At the close of the book Janine is changed too. She is more self-
assertive, but asserts herself by more than usually enthusiastic *stripping*
(*J*, 341). Jock's fantasy world must not be seen in a *wholly* negative
way. It expresses a Dionysian energy and creativity which Scotland is
seen to lack. In *A Drunk Man Looks at the Thistle* MacDiarmid translates
a poem by Alexander Blok which contains a couple of lines which might
well characterise the *chiaroscuro* of Jock's soul:

I ha'e dark secrets' turns and twists,
A sun is gi'en to me to haud . . .[17]

But in MacDiarmid's poem the sun is associated with whisky and the Dionysian.

It seems proper at this point to acknowledge that the foregoing account of *1982 Janine* does very little justice to the magnificent complexity and subtlety of the novel, in particular to the ways in which Jock's worlds of fantasy and memory interlock. It is a novel which would benefit from a lengthy *Reader's Guide*. The same cannot with any confidence be said of *Something Leather*, though the two novels seem to be close relatives in many respects. Jock describes his prototypical fantasy as one in which a 'woman is corrupted into enjoying her bondage and trapping others into it' (*J*, 193), which is not too far from being a blueprint for *Something Leather*. Perhaps the most significant difference between the two works lies in the fact that *Something Leather* lacks a Jock McLeish, lacks a central consciousness to mediate, as it were, between its pornographic material and the reader. There is no Jock here to take the blame and the pornography cannot be explained away conveniently as an exposé of 'corrupted male sexuality'. Nor is it clear that we are to regard the pornographic material in *Something Leather* as fantastic. Indeed, we are given pretty plain instructions otherwise, since the 'Epilogue' to the book states that the stories of its women's lives are told 'without fantasy' (*SL*, 248). Yet in what is, by Gray's own testimony, the core of the new novel, we find ourselves in a world that is highly reminiscent of a McLeish fantasy, a world of bondage, sado-masochism and rape. The fetishistic interest in costume is markedly similar in the two books, right down to those vital little details of unfastened skirt-buttons and the effect on the gluteal muscles of high-heeled shoes:

> It would be too tight if most of the studs were not unfastened but a few top ones are fastened to hide an arse made proud by her high-heeled shoes. (*SL*, 13)

In this otherwise factual verbal description of a photograph discovered by the book's heroine, June Tain, the impressionistic word 'proud' is the lively one. What might ordinarily be an object of shame is made 'proud' in the world of the pornographic picture. Proud may mean imposing or splendid, thus worthy of honour, again rather an inversion of conventional values. It carries suggestions of haughtiness, arrogance, perhaps a desire to dominate. Yet pride also comes before a fall and one may be tempted to humble or humiliate the haughty. And pride is the first of all sins and fount of all the many, many others. All of these

aspects of the word 'proud' seem relevant to June's psychology and
situation as she looks at the picture. It's a lot of mileage out of a
monosyllable and perhaps thus a little verbal compensation for the
absence of an image.

This kind of fantasy-world can be traced back into *Lanark*, where the
adolescent Duncan Thaw indulges in some daydreams about a girl called
June Haig:

> She wore white shorts and shirt but high-heeled shoes instead of
> climbing boots, and he raped her at great length with complicated
> mental and physical humiliations. (*L*, 179)

From June Haig to June Tain is but a step. This pornographer's mind,
it seems, returns time and again to the same old fantasies (like a dog
to its own vomit, one is tempted to say). 'I don't hurt people but',
claims Jock McLeish (*J*, 43), though the claim may be qualified if we
read that final 'but' in its English sense rather than in its Glaswegian
usage, and Jock does just fantasise. After all, even Stylite saints were
tempted by impure visions. But Alasdair Gray *publishes* his fantasies.
He is disarmingly honest about this: 'June's story had a pornographic
content. Such fancies come easily to me' (*SL*, 247). This is following
Hawthorne's advice with a vengeance!

According to the 'Epilogue', *Something Leather* has its origins in the
suggestion made (by a woman) to Alasdair Gray that he might consider
writing a book 'about a woman'. Gray confessed that he felt inadequate
to the task since he could not imagine how a woman felt when she was
alone (*SL*, 232). Inspiration arrived, however, from the voyeuristic
pleasure of seeing a woman in an outrageous leather suit at Queen St
Station and from accompanying a female friend on a clothes-shopping
expedition (*SL*, 231). He had discovered, and it was a voyeur's insight,
how women felt when they were alone: they felt *exhibitionistic*. They
enjoyed the thrill of tarting themselves up in sexy clothes. Whatever
the veracity of this insight, and it is perhaps worthy of mention in this
context that Europe's only sex-shop for women is given over very largely
to articles of clothing, it is abundantly clear that the notion was all very
thrilling for Alasdair Gray:

> While writing the first chapter of this book I enjoyed a prolonged,
> cold-blooded sexual thrill of a sort common among some writers
> and all lizards. (*SL*, 234)

Writing down whatever turns you on is as good a recipe as any for
literary pornography and the first chapter of *Something Leather* certainly
reads like pornography. Again, with the use of continuous present, it
is like the verbalising of a film. It charts the initiation of an apparently
'straight' ordinary woman into an underworld of lesbian and sado-

masochistic pyrotechnics. That the sex should be lesbian has its
advantages. One might argue, with prudential considerations in mind,
that keeping men out of it is to be recommended, since if there are no
males on the scene there is no one for male readers to seek to emulate.
Voyeurism is the closest any man can get to lesbianism. This serves to
commend it as subject matter for less prudential reasons: one could
argue, for example, as does Leo Bersani, that 'women are penetrated
most profoundly by men when men can watch them experiencing a
pleasure from which men are absent'.[18] June is seduced into all this
partly by her discovery of two indecent photographs of women dressed
in bondage-gear in Senga's catalogue of leatherwear. The idea that
women should themselves be aroused by pornography (or by the
thought of being involved in its production) is no doubt a comforting
one for the voyeur: it's the 'I like looking at you' / 'You like showing
(or looking at yourself)' idea again. It is much the same when Donalda
comes to visit June:

> With a white silk blouse she is wearing exactly the high-heeled
> shoes and leather skirt she wore in the photograph, and to prove
> it she lifts both hands to shoulder-height and turns round till she
> faces June again, having shown the rear fastening more than half
> undone . . . (*SL*, 18)

Donalda recreates the original photograph and behaves towards June as
if June were the camera.

Thus far, however, there is little enough to worry anyone of a liberal-
minded disposition. The book makes a case for seeing pornography, and
the kind of untrammelled Dionysian behaviour it habitually represents,
in a positive light. It offers a holiday from the humdrum, a period of
R & R from the pressure of conventional morality. As Donalda says:

> '. . . We all have wicked dreams, don't we? And unless we bring
> one of our wicked dreams just a wee bit to life we live like zombies
> – the living dead – slaves like my Mammy, right? . . .' (*SL*, 20)

It can glamorise ordinary people, exalt the humble. Thus Donalda is
'more interesting, more enticingly beautiful in the photograph' than in
reality (*SL*, 13) and it might be taken to be the overall burden of June's
experiences in the book. It offers admittance to an enchanted world, a
prelapsarian world which shame has not yet entered: Senga, the
ringmistress of the sexual circus, is, according to Donalda, 'a fairy
godmother who makes dreams come true' (*SL*, 20), a child's-eye
redemptrix. The religious vocabulary is not accidental: the chance
encounter with Harry gives the male character called Dad something
like a mystical experience:

> She stimulated my heart and gave me the freedom of the universe

last night. I felt able to swim over, under, inside every woman in the world, able to love and own the whole as completely as well-loved babies own it after a good meal. (*SL*, 200)

Gray's own way of coping with asthma attacks (i.e. *à la* Duncan Thaw) may have led to the association in his mind of sexual fantasy and freedom from mortality, another goal of the mystic.[19] Gray is not alone in making this kind of blasphemous association. Susan Sontag remarks that pornography 'encompasses experiences in which a person can feel he is losing his "self"'.[20] Leo Bersani remarks also on the 'experiences of omnipotence' in fantasy (as experienced above by Dad), but shows that there is a less rosy side to this:

> The paradoxical nature of uncompromised desire is that it is simultaneously the experience of a lack and the experience of omnipotence: we yearn for what we don't have in fantasies which provide us with ideal (both perfect and unsubstantial) possessions of what we don't have.[21]

Anyway, all is comparatively innocuous until, at the end of Chapter 1, Donalda handcuffs June and calls in her accomplices . . .

At this point the book delves deep into the past lives of its pornographic players, in the case of Harry tracing her life-story from the womb. This is, in itself, deeply *un*pornographic, since pornography has little enough interest in the psychology or backgrounds of its characters. June, looking at the photos in Senga's album in Chapter 1, is 'confused by having her mind read' by Senga (*SL*, 15), but it's an easy trick to read minds in pornography since they are all one-track. This anchoring of the characters to some kind of realistic world may be ill-advised, however. Perhaps it's best to keep this sort of material at the level of sheer fantasy. Making the women part of a believable world may be dangerous, especially in view of what they get up to later in this book. The Senga and Donalda chapters of this middle section of the work are, in any case, sad stuff, a shameless rehash of sorry kitchen-sink dramas penned years back by Gray. Indeed, an appropriate sub-title for the whole book might be 'Cauld Kail on Heat!' The Harry sections are at least original and have the qualified advantage of being almost completely incredible. The bizarre story of Harry's schooldays seems to be some sort of parable, whose meaning is perhaps that the whole damn world is just one big story of coercion and exploitation, frank or subtle, open or covert. For example, the liberal headmistress stops Hjördis spanking Harry (which was certainly not what Harry wished) but does this by means of the most ferocious threats against Hjördis (*SL*, 44).

The tangled web of chapters and lives comes together in the climactic

chapter entitled 'Class Party', which begins where Chapter 1 had left off with June handcuffed by Donalda. This chapter describes the rape of June by Senga, Harry and Donalda. It is not, of course, technically a rape, since under Scots and English law women cannot rape one another, but the narrative itself refers to them as rapists (*SL*, 224). At any rate, against her will and in spite of her protestations, June is chained, beaten, caressed, photographed in stupendously compromising positions, robbed of her possessions, shorn of her hair and tattooed all over her body and face with images of wasps. It's not the kind of thing you can dismiss with a giggle next day. When June does wake up on the Monday after, she feels, at first, understandably 'robbed of something essential to life and dignity' (*SL*, 223). Still, not to worry, the rapists left her a present, a leather suit like the one Gray had seen worn at Queen St, *and* the will to wear it. For the effect of the rape has been, albeit belatedly, to awaken the Dionysian in June or, to put it in more demotic terms, to make her extremely randy and absolutely shameless. 'New June' is the title of the chapter, suggesting that the experience has been like one of religious rebirth, suggesting also a combination of great heat and freshness. The only problem for the born-again June is how to satisfy the voracious sexual hunger that has been awakened in her. This is not a problem for long though, as Harry phones to declare her love, begging to be allowed to see June again, offering money, and Senga sends a large sum of money in a letter declaring her love and offering some apology. (The letter *is* oddly moving. Again Gray uses inarticulacy in a masterly way to betoken sincerity and strength of feeling.) So June has lovers who'll conform to her particular 'kinks' and she can get large sums of money thrown in. The idea of prostituting herself does not trouble her one whit. She feels 'free, happy' (*SL*, 225). She has found what she was looking for and the story ends with her saying yes to a life now spiced with richest expectation. *Incipit vita nova!*

It's a blissfully happy ending and the blythe attitude is carried on into the final section, 'Critic-fuel: An Epilogue', where Gray outlines the genesis of the book. He describes wondering how 'a modest, conventional woman' might be changed by being 'forced' to dress as does June at the close: 'For the better, I thought, if she had health and vitality' (*SL*, 235). We have already seen the nature of the *forcing*. Gray admits, very candidly, to experiencing a 'wicked thrill' in imagining this (*SL*, 235). The word 'wicked' is, indeed, one which appears quite a lot in the text and it's not really clear what force it should be given, naughty or evil? It seems, to judge by a recent article in *The Observer*, to be some sort of code-word for women who are into lesbian sado-

masochism. [22] Indeed, this article provides evidence that there *are* women who might react as does June to her initiation, that there are women who share the tastes of Harry and Senga and who go to clubs to watch live pornographic displays that are tailored to suit those tastes. In sooth, to quote one of the greatest voyeuristic poems in the language, such things have been![23] *But*, the suggestion, which seems clearly to be present in *Something Leather*, that forcibly chaining, beating, indecently assaulting, depilating and tattooing a woman might be *doing her a favour* is surely outrageous and dangerous. Publishing detailed pornographic fantasies which carry this suggestion is perhaps wicked in the strong sense and such writings might with propriety be described as the product of a black art.

NOTES

1. Hugh MacDiarmid, *A Drunk Man Looks at the Thistle*, Annotated Edition, edited by Kenneth Buthlay (Edinburgh: Scottish Academic Press, 1987), p. 68 (ll.839–40).
2. *Ibid.*, p. xxxviii.
3. *Ibid.*, p. 108 (l.1421).
4. *Ibid.*, p. 42 (ll.513–16).
5. *Ibid.*, p. 30 (l.353).
6. *Ibid.*, p. xxiii.
7. *Ibid.*, p. 80 (l.986).
8. *Ibid.*, p. xxxi.
9. Fyodor Dostoevsky, *Notes from Underground* and *The Double*, tr. Jessie Coulson (Harmondsworth: Penguin, 1972), p. 102.
10. MacDiarmid, *op. cit.*, pp. 12–14 (ll.121–8).
11. Friedrich Nietzsche, *Ecce Homo*, tr. R. J. Hollingdale (Harmondsworth: Penguin, 1979), pp. 34–5 ('Foreword', p. 3).
12. Susan Sontag, *Styles of Radical Will* (London: Secker & Warburg, 1969), p. 51 ('The Pornographic Imagination').
13. *Bête Noire* 5, Spring 1988, p. 19.
14. I intend no disrespect to the good people of Denny. I spent my childhood in a similar sort of place and remember it with great affection.
15. I have no wish to offend the people of Greenock, but I am sure no one could dispute the claim that in that area there is a poignant contrast between the gifts of nature and the efforts of man.
16. *Poetry of the Nineties*, edited by R.K.R. Thornton (Harmondsworth: Penguin, 1970), p. 159 ('Non sum qualis eram bonae sub regno Cynarae', ll.10–12).
17. *Ibid.*, p. 20 (ll.209–10).
18. Leo Bersani, *A Future for Astyanax* (New York: Columbia University Press, 1984), p. 297.

19. See *Bête Noire* 5, p. 24.

20. Sontag, *op. cit.*, p. 59.

21. Bersani, *op. cit.*, p. 286–7.

22. *The Observer*, 5 August 1990, p. 31 ('A whip away from plain old vanilla').

23. John Keats, *Poetical Works*, edited by H.W. Garrod (London: Oxford University Press, 1956), p. 197 ('The Eve of St. Agnes', st. IX).

Nine

How the Laws of Fiction Lie:
A Reading of Gray's Shorter Stories

Anne Varty

All of Alasdair Gray's shorter fictions are 'unlikely', and unlikely for several reasons. The title of his first collection, *Unlikely Stories, Mostly* (1983), liberates the author from the burden of conventional narration. Yet, by its very reasonableness, it traps the reader into the expectation of something more conventional. The title is understated, self-consciously modest; it hesitates about its opening statement in a tease over the comma, only to collapse into weaker confirmation with 'mostly'. 'A likely story!' is the experienced reader's response: Gray is telling fairy-tales, even in his title, but it is not simply in content that these narratives are fantastic. They are more deeply innovative, or experimental, in their form.

'The Problem' (first published 1983) may serve as an initial paradigm for what makes these tales 'unlikely' (*US*, 8–10). The story is generated by a pun, by the sheer contingency that the words 'sunspots' and 'spots' (pimples) can be superimposed to give us a sun with spots. There is no necessary connection between their meanings, there is only the imaginative relation created by the author's language. The pun, the primary, but significantly arbitrary, linguistic act, is the first cause of the story, and like most first causes it is without explanation or justification. There is actually no causal relation between the pun and the story; we begin with a pun and end with an explanation for why the sun might shine only once a fortnight in Scotland. The author's conjuring is in making us believe that certain effects (the story) do follow from the cause. We trust the narrative while simultaneously we are made aware that we should not. Like Hume, Gray is a sceptic about causal relations and his readers will learn to share that scepticism.

From the primary linguistic act there follows the anthropomorphism

of the sun. Perhaps because a beautiful woman with spots breaks more social stereotypes than a man with spots and is, therefore, a more interesting phenomenon, Gray alters the grammatical and mythological gender of the sun from masculine to feminine: 'The Greeks were wrong about the sun; she is definitely a woman. I know her well' he begins (*US*, 8). But perhaps he does this because he wants to display a fundamental authorial chauvinism: language and the world it creates are his domain and entirely at his disposal. We look to the pronouncement of Sir Thomas Urquhart in 'Logopandocy' (1983) for confirmation of this. His ancestry, he declares, goes 'back to Adam surnamed the Protoplast, who was quintessence of that red earth created in time, of nothing, by the word of TRIUN JEHOVUS . . .'. Urquhart is contemptuous of those who seek evidence: this, he comments 'will be doubted by pedant sciolasts and fidimplicatary gownsmen who can neither admit the eductions of informed inspiration, nor comprehend the congruency of the syllabic with the Sibylene' (*US*, 141). Adam was empowered to name the creatures of the earth as he chose; Urquhart grants himself this ancestral privilege, as he shapes (in a typographically literal way) the linguistic reflection of his environment at will. We must meet Gray's work on its own terms if we are not to be left as baffled 'sciolasts'. We must also accept that his authorial chauvinism rarely permits the creation of an autonomous subject; the author keeps close reign on his creations.

Gray describes himself as a 'maker of imagined objects' (*SSP*, 4). His fictional artefacts display an internal logic. As we recognise the incongruence between his artefacts and those in the world we think we inhabit, and as we recognise that it is only the pattern-seeking mind of the artificer which has ordered materials (language and what it represents) into the shape of fiction, so we are made aware that our orthodox sense of logic and order may be similarly, if not equally, factitious. We come to share his chauvinism. And we enjoy it, because this technique of departure from the norm, utterly dependent as it is on what it most deserts, is fundamentally comic.

'The Problem' develops as a confessional monologue by the man whose mistress is the sun, and it includes an account of their most recent conversation. Both the speaker and his reported interlocutor play stereotypical roles. The man wants nothing more than to bask complacently in the presence of his mistress whom he takes a little bit for granted. She may be a rare visitor, but she is a regular one. She, however, demands attention. She is vain, coquettish, jealous and seeking consolation for her spots:

> I realized she was talking to me in a more insistent tone, so I

occasionally said, "Yes" and "Mhm". At last she said, "You aren't
listening."

"Yes I am —" (I made an effort of memory) "— you were talking
about your spots."

"What can I do about them?"

"Honestly, Sun, I don't think they're important."

"Not important? *Not important?* Oh, it's easy for you to talk like
that. You don't have to live with them."

I almost groaned aloud. Whenever someone makes me perfectly
happy they go on to turn themselves into a problem. I gathered my
energies to tackle the problem. (*US*, 9).

At least the speaker, like the author behind him, does not pretend
that his chauvinism (both male and authorial) is easy to maintain. And
yet the reader is made complicit with this stance because of the intrinsic
absurdity of the conversation. The dialogue is not just contingently
absurd (a petulant woman who must be humoured is safe quarry for
ridicule) but absolutely absurd: we are witnessing, after all, dispute
between not just any animate and inanimate object, but between a man
and the sun. She is certainly impossible. Both our emotional and our
rational sympathies are with the man who finds his situation problematic,
hence our assent to the double chauvinism.

The emotional tension between the couple is socially conventional.
The role-playing is so stereotypical that the speaker does not even
bother to relay the full dialogue:

And she would have left without another word if I had not jumped
up and begged and pleaded and told her a lot of lies. I said a great
deal had been discovered about sunspots since Galileo's day, they
were an electromagnetic phenomenon and probably curable. (*US*,
10)

By drawing attention to the routine nature of their interaction in
these terms ('told her a lot of lies'), Gray turns the predictability of the
scenario into a comment on the conventional nature of narrative itself.
And we, complicit with the man who is lying to his mistress, also
accept that the author is lying to us. Henry James's dictum 'To tell a
story is to tell a lie' is now as much a cliché about narration as Gray's
scenario is a social cliché. But the content of the sentence about the
curability of sunspots is not clichéd.

The speaker's final flattery is a pseudo-scientific explanation, holding
out hope where really there is none. The Sun is placated, but the reader
is alerted to the duplicitous use of science. Gray's imagination toys
repeatedly with the apparent fixtures of our understanding of the
natural world and we may remember Nietzsche's warning:

Physics too is only an interpretation and arrangement of the world (according to our own requirements, if I may say so!) and *not* an explanation of the world . . .[1]

Gray has a fine sense of our capacity to confuse description with explanation and his imagination luxuriates in the creation of possible worlds which expose assumptions we make about our own. The speaker in 'The Problem' is motivated to offer a scientific solution to the Sun simply because he wants to see her again in serene circumstances. She wants to believe the explanation because she wants to be rid of her spots. The reader, like the Sun, is pleased by the solution, but pleased not because of its explanatory value or truthfulness. Instead we enjoy the shape this gives to the fable. Our pleasure is aesthetic. We realise that the satisfaction we take in explanations from other domains may be motivated by a similar aestheticism and therefore by factors other than their truthfulness. Explanations are seen as more strictly relative to our already existing horizons.

Gray's challenge to convention extends even to the westerner's habit of reading from left to right. The pair of stories 'A Likely Story in a Nonmarital Setting' and 'A Likely Story in a Domestic Setting' illustrate this (*US*, 272–3). Each story consists of a picture and five lines of dialogue. The pictures are identical, but one is the mirror image of the other. A man stands with his arms around a woman and they face one another. In the 'Nonmarital Setting' the man stands on the left, in the 'Domestic Setting' the woman stands on the left. There are no textual indicators in the lines below to tell who says what to whom. Our habit of reading pictures as well as text from left to right combines with our social conditioning to make us believe, initially, that in the 'Nonmarital' setting it is the man who says 'Listen, you owe me an explanation . . .', and in the 'Domestic' setting the woman who says 'Fuck who you like but . . .'. But why should this be? If instead we read the pictures from right to left, reversing the order of the speakers, we confront a role-reversal in the power relations which is equally plausible.

The frontispiece to 'Five Letters from an Eastern Empire' contrasts western with oriental reading conventions as each word in the title is printed vertically making Scrabble nonsense (apart from the almost coincidental 'FLEE' and 'ROARE', not inappropriate for the story) if we read normally (*US*, 85). The reader should mistrust this tale from the beginning. Gray's uninhibited view of conventions leads him to deploy an extraordinary variety in the form his stories take: the journal, the mythopoeic history, epistolary form, TV script, dramatic monologue, and occasionally even the third-person narrative. This variety is com-

mensurate with the pluralist vision of the world Gray seeks to offer. He is most expert at finding first-person perspectives to invest his subversive stories with sincerity.

Gray's integration of picture with text is a further way of simulating authenticity. 'The Crank that Made the Revolution', offering 'quips, and cranks, and wanton wiles' in plenty, exhibits this technique (*US*, 37–43). Again, this story teases linguistically by inviting us to consider simultaneously a man, Vague McMenamy, and his invention, the crankshaft, under the same appellation 'crank'. But the former consideration is implicit, not made explicit until the last sentence of the story. The story jests with the reader's sense of propriety by fusing the man and the object of his creation. The congruity, and therefore the implicit incongruity, between animate and inaminate objects, provides the source of the humour which riddles the tale. But the innovative feature of the text is the way it is coupled with illustration. It is a 'scientific' text, a kind of *Dictionary of National Biography* account of Vague McMenamy, his family and his achievements. Pictures, purporting to illustrate his historical and geographical contexts and his inventions, accompany the story. They are in the styles of eighteenth-century encyclopaedia woodcuts and nineteenth-century engravings. Both are styles which, historically, were used to inform rather than to decorate. Just as the story presents a description as though it were an explanation, so the illustrations are decorative but masquerade as information. They tease with what they withhold.

The most self-conscious example carries the comment:

> An engraving by Shanks in Glasgow People's Palace Local History
> Museum. It amply demonstrates the decadence of the medium before the
> advent of Bewick. It is impossible to tell whether, it portrays Provost Coats
> or McMenamy's Granny. (*US*, 42)

The picture pretends to be a reproduction, it draws attention to its medium, but it does not illustrate pre-Bewick '*decadence*' (this is a logically inappropriate word anyway since a medium cannot decay until it has flourished and Bewick developed new wood-engraving techniques in the late eighteenth century); rather it illustrates Gray's own illustrative decadence. He has designed a face which could indeed be male or female, but this is the fault of the subject not the medium. The reader is more tempted to see the face as that of McMenamy's Granny simply because she is more important to the story, and the fact that McMenamy apparently had no parents but only a Granny might then be 'explained' by the old lady's crusty androgeneity. But this is sentimentality on the reader's part; we catch ourselves fixing facts that do not exist. The picture is indeed more about itself than about the text, its collocation

with which seems almost gratuitous. But it engages the imagination as the text does, by offering an ambiguous subject which acts as a catalyst to produce self-aware and self-defying ignorance.

The six illustrations in encyclopaedia style also disguise decoration as information and two of them are irrelevant to the narrative altogether. The style is appropriate for the historical setting of the story; McMenamy appears to have worked during the 1720s (the map depicting the McMenamy hovel in 1739 is a 'forgery' since it was burned down in 1727) and the first edition of the *Encylopaedia Britannica* was published in 1768, in instalments until 1771, edited from Edinburgh by Smellie. Gray's pictures are presented in pairs, each pair showing nature before and after McMenamy's intervention. Barthes has argued how such pairings work for the genuine Encyclopaedia. They display:

> Precisely a human relation, the relation of the omnipotent praxis of man, which out of nothing can make everything.[2]

Gray's encyclopaedic paradigm is in the centre of the plate, showing, left, 'Unimproved duck, after the watercolour by Peter Scott' (even here, in the case of the definite article 'the watercolour' we see Gray's love of ludic precision); and, right, 'McMenamy's Improved Duck' (*US*, 40). The first picture shows us what we already know, *i.e.* what a duck looks like. It flaps in an ungainly but cheeky way across a (the) sunset, displaying a (the) webbed foot. Nature here is man's classified property, unthreatening, and, with the adjective 'unimproved' suggesting improvability, it is not only tame but also distinctly second-rate in relation to man. The 'Improved Duck' depicts a static profile of a duck's head extending meekly from a wooden boat-shaped container with a propeller where the webbed foot should be. The background is empty. There is a sterility about this drawing which strips the duck of its duckhood and leaves the nature of the improvement utterly obscure. It represents the absurd triumph of McMenamy's tidy-minded pragmatism which had been offended by the fact that the bird does three things badly instead of one thing well.

The destructiveness of man's intervention in nature is comically portrayed in the next pair of pictures at the foot of the page: '*Above*: McMenamy's Improved Duck Tandem .0005 seconds after launching'; '*Below*: McMenamy's Improved Duck Tandem .05 seconds after launching. (The ducks, though not yet drowned, have been killed by the shock.).' The frenetic motion and visual buffoonery of the first picture contrast with the rigid stasis and mock gravity of the second. The precision of each description, the redundant repetitions, the righteousness of 'Improved', and the exact timing, mock not just the uselessness of the invention but also its self-indulgent wastefulness. It is not just

a dead duck, but seventeen dead ducks. And as both the narrative and the picture draw attention to the likeness between this invention and the submarine ('Without the seventeen heads and necks sticking up through holes in the hull one would have mistaken it for a modern submarine') there is an underlying comment about our modern war machinery (*US*, 39).

While a Nietzschean view of science liberates Gray's formal imagination, the world he presents is often one where scientific explanation is put to politically corrupt service and inhibits freedom. In this way Gray illustrates the destructive nature of monolithic explanation and demonstrates the political implications of imaginative atrophy. For example, in *McGrotty & Ludmilla* (1990), the wicked Uncle, Sir Arthur Shots, persuades McGrotty to steal the Harbinger Report by providing a linguistic excuse:

"But that's *stealing!*" said McGrotty.

Shots chuckled in a friendly way. He said, "I am surprised, Mungo, to hear you employ such an unscientific word. You will not be '*stealing*' the document in question. You will simply be transferring it from one office to another as cautiously as possible."

(*ML*, 48)

Strictly speaking, Shots uses the word 'unscientific' correctly. The idea that McGrotty is stealing the Report does not suit the world view that Shots needs McGrotty to hold. So Shots provides an alternative, workable, hypothesis which will make events go as he wishes.

The 'Axletree' stories exemplify corrupt use of denotative language and scientific explanation, even in the title. The emperor who dreams of the project to build a structure to reach the sky dies with the announcement:

"Do not call it a tower! Towers are notorious for falling down. Tell the fools you are building a connection between two absolutely dependable things. Call it an axletree." (*US*, 82).

As the race to reach the top gets more hectic both the material and the political structures which permit the enterprise get more fragile and the narrator warns: 'And the word *tower* was never spoken, because towers were still notorious for sometimes falling down.' (*US*, 242). At last it is the poet of the community who dares to use languages with exactitude:

". . . the world could become a splendid garden where *many* plants will grow besides this damned, prickly . . . cactus of a poisoned and poisoning TOWER."

"Strike that word from the minutes!" said the president swiftly.

(*US*, 259)

The Axletree narrative, presented in the collection as two episodes separated by three substantial tales, is based on the Biblical account of the building of the tower of Babel and is, Gray states, indebted to Kafka's 'The City Coat of Arms' (*US*, 275). It therefore has competitive and divisive uses of languages deeply embedded in its theme. Indeed, it begins 'I write for those who know my language. If you possess that divine knowledge do not die without teaching it to someone else' (*US*, 67). It ends with the narrator, the only one from Axletree civilisation to survive the purging deluge, describing how his children in the new nomadic community 'refuse to learn . . . the language of the axletree' (*US*, 269). It is the language of duplicity, yet out of this stories are born: 'Did you visit the sun too? Did you stand on it, Dad? Was it hot?' (*US*, 269). The loss of the axletree language is also the end of the story, though the language, like the story, promises to regenerate. But this is the essence of the archetypal story in *Genesis* about the rise and fall of political structures, which Kafka recast so tersely and which Gray 'embellishes'. The axletree language itself is not iniquitous; indeed plurality of meaning is necessary to our moral growth and discrimination. But we must recognise that plurality and harness it, as the poet does, for good not evil.

The multivalency of language parallels that of the natural world. This is illustrated in the story by the scientist who discovers that the sky is a membrane which can be pierced with fire. He offers various explanations for the observed phenomena, and gets the reply from the director:

> "I am a religious man . . . You have given us three little toy pictures of the universe, and told us to believe in the safest one, and asked permission to test it. The fact that you need to test it shows your ignorance. Your test may destroy something essential and beautiful which you did not make and cannot replace. Mankind has taken the whole of human history to reach this height. Why should we not pause for a couple of years and consider the situation carefully?"
>
> "Because of the co-ops!" cried the commander of the armed forces. (*US*, 256–7)

The rejoinder is deliberately bathetic. Man himself in this story is a creature of anti-climax, foolish enough to pit petty political struggles against almighty and elemental forces, which he believes he can exploit for commercial gain.

The one irreducible feature which this story presents is sensuous physical experience. It ranges from intense pleasure to intense pain. The narrator's defiant act of touching the sky translates wonderment and

awe into physical terms with a sudden flurry in the narrative of marvellous colour adjectives (*US*, 251–2). Pain accompanies the destruction of the sky membrane (*US*, 262, 265–6). The happy medium of simple pleasurable existence is presented when the narrator returns to earth with the president for the duration of the experiment: 'The president removed his shoes and walked barefoot on the warm soil. He said "I like the feel of this. It's nourishing." ' (*US*, 264).

It is an earthly consolation, which makes a virtue out of mortality, in a realm where even the gods are at the command of dictators: 'Keep the official religion a kind of *cavity* which other religions can hope to fill if they grow big enough', instructed the first emperor (*US*, 82). This view of religion as a manipulative construct, intrinsically vacuous, on a par with scientific and political explanations, accords with Gray's own view of religious practice:

> . . . those who pray are consciously strengthening wishes which (whether selfish or not) are already very strong in them, and which decide the nature of the god they invoke. (*SSP*, 13)

The 'Axletree' stories present us directly with religious belief as an extension of human desire. Even the 'religious director' says 'I used to wish I lived in the age of faith . . .' (*US*, 260) and the president uses 'god' as a kind of ventriloquist's doll:

> *President to control*: RAPIDLY CONVENED HEAVENLY PAR-
> LIAMENT ORDERS YOU TO STOP. FOREMAN OF WORK
> DECLARES GOD WANTS YOU TO STOP . . . PLEASE STOP.
> (*US*, 267)

A more sophisticated vision of religion is presented in *The Fall of Kelvin Walker* (1985). The worldly-wise Jake uses faith as wall decoration, with his painted equation 'GOD = LOVE = MONEY = SHIT' (*FKW*, 22). He views religion as a matter of mood and relativity. But Kelvin wrestles with more orthodox Christian faith, despite his Nietzschean intoxication. He endures, rejects and eventually, as a fallen adult, accepts the Calvinist God of his father. *En route* to his final orthodox position he excites himself and the nation with vatic utterance:

> Kelvin stood still, frowned at his shoes, beamed at the ceiling and cried,
> ". . . and believe comma, once and for all comma, in Belief itself capital 'b' for Belief exclamation mark end of article."
>
> "Beautiful words, Mr Walker!" said Mrs Hendon, "really beautiful."
> "No! Mrs Hendon", said Kelvin severely, "not beautiful, but true, which is better . . ." (*FKW*, 118).

To 'Believe in Belief' may sound like tired rhetoric, offering nothing

less vacuous than the '*cavity*' of the 'Axletree'. But it is reminiscent of another great Scottish scourge, Thomas Carlyle, who warned the nation in 1829 with the words:

> The truth is, men have lost their belief in the Invisible, and believe, and hope, and work only in the Visible, . . . Worship, indeed, in any sense, is not recognised among us, or is mechanically explained into Fear of pain, or Hope of pleasure. Our true Deity is Mechanism.[3]

While Gray does not advocate, as Carlyle does, a regeneration of religious faith, he does, with Carlyle, plead for restored trust in the Invisible. The cumulative effect of his stories is to engender, in however whimsical or eccentric a fashion, confidence in an experimental and questioning imagination as a means to survival in the modern world.

'Five Letters from an Eastern Empire' (1979), developing Kafka's 'The Great Wall of China', casts fresh light on the nature of oppressive political regimes (*US*, 275). The narrative strategy is highly sophisticated in its manipulation of the reader. Four of the five letters are written by Bohu, the emperor's tragic poet, to his parents in the 'old capital' from whom he has been separated since early youth. The reader is therefore placed in the position of Bohu's mother and father. Indeed, the reader is even the progenitor of Bohu in his translated state in the new empire for it is the reader who makes a complete picture out of the vivid detail provided both wittingly and unwittingly by Bohu. It is the reader, for instance, and not Bohu, who understands that the description of his entry to the new capital is the account of a birth:

> My entourage helped me to my knees and I crawled in after the janitor. This was the worst part of the journey. We had to crawl a great distance, mostly uphill . . . The floor was carpeted with bristly stuff which pierced my kneebands and scratched the palms of my hands. After twenty minutes it was hard not to sob with pain and exhaustion . . . (*US*, 90)

Bohu confesses his need for readers, and gives ambiguous assurance about the trustworthiness of the text: 'Don't be afraid to read it . . . And the postman who re-writes letters before fixing them to the pigeons always leaves out dangerous bits' (*US*, 96). However, we have no sense of a censored text, for what follows is full of 'dangerous bits' including the extraordinary but predictable revelation that the almighty emperor revered as a god is literally a puppet manipulated by the 'headmasters' or ministers of the regime. The reader therefore trusts the narrative, just as the writer trusts that he is read.

The spontaneity and insouciance of the epistolary style are captivating,

as are the minute details of the fully realised realm which Bohu inhabits. The empire, as he says, is architectually 'like a chessboard' (*US*, 87), and life there governed by a 'new etiquette' that is as astonishing as it is repressive. The reader, while marvelling at this world, marvels also at Bohu's passivity in the face of it. He seems to question nothing about the manifest injustice of the government. Yet the reader, in recognising injustice where Bohu merely relates fact, is constantly questioning and enjoys the illusion of rebellion.

The reader is placed literally *in loco parentis* when Bohu is told that his subject matter must be the recent destruction of the old capital and its inhabitants. Paradoxically, he continues to address his parents:

> My main thought was that you, mother, you, father, do not exist now and all my childhood is flat cinders. This thought is such pain that I got up and stumbled round the screens to make sure of it. (*US*, 114–15)

The screens depict the razing of the old capital, and incidents from Bohu's childhood. His final revolt comes when Tohu, the comic poet of whom he was hitherto scornful, is butchered for writing a bad poem on the same subject. Bohu requests and is granted permission to die. He is taken by his entourage who must share his death on an exhilarating excursion into freedom, experiencing at last a rich life of social and sensual license. At the end of this he writes the poem 'To the Emperor's Injustice' and concludes his last letter 'I lie down to sleep in perfect satisfaction' (*US*, 128).

The reader is saddened but also satisfied. Bohu has been educated out of his passivity and a pernicious regime has been denounced. The fifth letter provides alarming education and humiliation for the complacent reader. It is 'A CRITICAL APPRECIATION OF THE POEM BY THE LATE TRAGEDIAN BOHU ENTITLED *THE EMPEROR'S INJUSTICE* DELIVERED TO THE IMPERIAL COLLEGE OF HEAD-MASTERS, NEW PALACE UNIVERSITY' and it is dictated by Gigadib, Headmaster of Modern and Classical Literature on Day 1 of the New Calendar (*US*, 130, 133). We learn that Bohu's grief at his parents' death, and his poem about the massacre, were in vain for he was the victim of false beliefs engineered to make him write the poem which the government needed. The last paragraph of the story reads:

> To sum up, *THE EMPEROR'S INJUSTICE* will delight our friends, depress our enemies, and fill middling people with nameless awe. The only change required is the elimination of the first syllable in the last word of the title. I advise that the poem be sent today to every village, town and city in the land. At the same time Fieldmarshal Ko should be ordered to destroy the old

capital. When the poem appears over doors of public buildings the readers will read of an event which is occurring simultaneously. In this way the literary and military sides of the attack will reinforce each other with unusual thoroughness. Fieldmarshal Ko should take special care that the poet's parents do not escape the general massacre, as a rumour to that effect will lessen the poignancy of the official biography, which I will complete in the coming year. (*US*, 132–3)

We are toppled from our role as progenitors and judges. The reader has been no less a victim of false belief than Bohu. We, naïvely trusting the narrative, entertaining all the emotions and ideas evoked by the story, have been no less passive than he. It is small consolation to remember Bishop Blougram's words to Gigadibs:

I am much, you are nothing; you would be all,
I would be merely much: you beat me there.[4]

Yet we had been warned already in 'The Problem' that the author would trick us. It is rare, however, that the duplicitous craft of the story-teller is linked so intimately with the craft of state politics. And it is the recognition that necessary passivity (*i.e.* trust) in relation to the art-work may mirror the manipulations of political propaganda which makes this story so disturbingly powerful. What remains irreducible after the initial shock that our experience in reading the story may have been entirely sentimental is a sense of the virtue of decent, humane values. We are invited to share with Gray what he 'still mainly' believes, 'that original decency is as old as original sin and essentially stronger' (*SSP*, 13).

NOTES

1. Friedrich Nietzsche, *Beyond Good and Evil: Prelude to a Philosophy of the Future*, tr. R. J. Hollingdale (1973; rpt. Harmondsworth: Penguin, 1981), p. 26.
2. Roland Barthes, 'The Plates of the Encyclopaedia', *Selected Writings*, ed. Susan Sontag (London: Fontana, 1983), p. 228.
3. Thomas Carlyle, 'Signs of the Times', *Critical and Miscellaneous Essays*, Vol. II (London: Chapman: Chapman & Hall, 1872), p. 245. The essay was first published in the *Edinburgh Review*, No. 98, in 1829.
4. Robert Browning, 'Bishop Blougram's Apology', ll.84–5.

The Necessity of Dragons: Alasdair Gray's Poetry[1]

Thom Nairn

Alasdair Gray's poetry is the least considered component of an eclectic, multi-genre body of closely interrelated works. This is a consequence of various factors, not least the almost intimidating dominance of the novel *Lanark*, 'Alasdair Gray' and *Lanark* having become virtually synonymous. It is also significant that while some of his poetry appeared as far back as 1962 (in *Lines Review*) what Gray regards as the final context for his poetry to date, the completed work, *Old Negatives*, was only published by Cape in 1989 so that a broad spectrum of the poetry in what the author regards as a finished form has only been readily available for a fairly short period.[2] Gray's poetry can be an awkward area to approach, leading into a web of intriguing dichotomies. While the poetry gathered in *Old Negatives* can be seen as integral to an overview of Gray's work as a whole, it can also emerge as in many respects subtly or dramatically different. That 'difference' as well as the ways in which the poetry relates to the broader context of Gray's works reveals 'the kind of poetry he wants'.

In an interview with Sean Figgis and Andrew McAllister for the magazine *Bête Noire* Gray has spoken admiringly of Walt Disney's flair in 'collapsing a lot of things into a very quick period of time'.[3] This in turn is akin to many of Gray's own inclinations (though he is perfectly capable of reversing the process): from the convolutions of *Lanark*, where time is shattered and compressed on diverse strata, to the daunting and detailed crush of images in his illustrations, on to *Old Negatives* in which the '4 Verse Sequences' included are closely hinged around Gray's life and work from 1952 effectively to the present (clinically, the last sequence 'To Lyric Light' is dated '1977–83'). Thirty-odd years of life (and poetry) are condensed into sixty-seven

pages of poems and perspectives, at once wildly oblique and disconcertingly frank.

The poetry itself is like little else in modern Scottish verse. Taken in isolation it can seem skeletal and minimalist:

> I am new born.
>
> I want to suck sweet and sing
> and eat and laugh and run and
> fuck and feel secure and own my own home
> and receive the recognition due to a man in my position
> and not have nobody to care for me
> and not be lonely
> and die.
>
> <div align="right">('Wanting', <i>ON</i>, 58)</div>

For all the sparseness, though, this eight-line poem can grow very large. It vividly encapsulates pervasive (male) fears and desires as well as broader human insecurities: the poem seems at once disarmingly forthright yet still gently self-mocking. Meanwhile the mimetic syntax and typography along with the agglomeration of 'and' conjunctions uncomfortably accentuate the nature of the process as well as the relentless rapidity of the movement to the inescapable conclusion. Tenuous Scottish connections might be found with the works of Ian Hamilton Finlay, Edwin Morgan or Tom Leonard but it is more tempting to see this as an echo in miniature of Gray's own tactics elsewhere. In *1982 Janine* for instance, Jock McLeish's blackout is prefigured in haywire typography followed by blank pages as Gray leads us through dislocation to sickness to disconnection.[4]

'Wanting', though, is not representative of the collection as a whole. Possibly none of the poems here is capable of that, but at another extreme, you could sample 'Bare Bloodhymn':

> GOD IS A BLEAK FACT IN A BOOK OF STONES
> A COLD VOICE IN A ROOM OF IRON CLOCKS
> A FROZEN HOOF THAT CLATTERS ON MY BONES.
>
> <div align="right">(<i>ON</i>, 26)</div>

If seeming very different from 'Wanting', such strange rhyming poems are not unusual in this collection. The bleakness of 'Bare Bloodhymn', though, connects with that of 'Wanting' but its growling capitalisation and its sense of the cold resonance of de Chirico's landscapes steps off into darker, surrealistic zones devoid of the human frailty and the grim, tongue-in-cheek humour that lightens 'Wanting'. If you like to examine the differentiation between 'sparse' and 'stark' this is one place to dig in. Still, it is important here to note that these poems are drawn from opposite ends of the book, 'Wanting' from the last sequence, 'Bare Bloodhymn' from the first.

The impact of *Old Negatives* is cumulative rather than demonstrable from component fragments. Dichotomies loom. While there is a distinctive homogeneity there is also a traceable movement and development, suggested by the two citations above, from an opaque allusive symbolism to a greater directness and lucidity. This is a whole business-process of congealing, of recontextualisation: a sequence will suggest a context for the succeeding sequence while at the same time recontextualising the preceding sequence. So perceptions and readings are shunted around. By the time you reach the fourth sequence it is time to go back to the first with distinctively altered expectations and perspectives.[5]

In this respect once more, *Old Negatives* provide a minimal echo of the interrelated block techniques employed in the four books of *Lanark*. This is an escalating process of mutual elucidation of the nature of Gray, Gray's view of Gray and the nature of the world, its peoples and arts. There is a temptation to see this poetry as the flying sparks and splinters thrown off in the building of other works. It is suggestive for instance that the poem 'Wanting', related to *1982 Janine* above, belongs to the 'To Lyric Light' sequence, dated 1977–83, while *Janine* was published in 1984, indicating a clear suggestion of overlap in periods of composition.

Such cross-referencing, though, cuts in much deeper. It is illustrative of homogeneity in *Old Negatives* and provides bonding materials linking Gray's work in different genres. Anyone with even a slight knowledge of Gray's fiction will find much in the poetry that is familiar: God, Death, and Sex, sequences of itemisation, the endemic subterraneanism characteristic of so much of the work. Rejection, isolation, the absence, difficulties or failures in communication, blood, images of the void, eyes, mouths, sunrise, darknesses, wounds, wombs, and, centrally, the proliferation of dragons and dragon armour.

In *Lanark* the characters Rima and Lanark discover they are both developing 'dragonhide', a common condition among the population of Unthank which threatens to, and in many cases does, envelop the entire body. These encrustations represent a physical manifestation or materialisation of the accumulated deformities, the emotional and psychological dislocations, precipitated by attempting to survive in a corrupt and corrupting society which is itself deformed. Dragon armour also illustrates in vivid physical terms the alienation, the disconnections, which can affect an individual in such a society. Paradoxically it can also serve to signal the insulation sometimes perceived as necessary to survive. Again, a physical manifestation of barriers an individual may calculate (mistakenly) as protective. 'Like nations losing unjust wars

they convert more and more of themselves into armour when they should surrender or retreat' (*L*, 68).

However, while a major concern in *Lanark* is laying bare the socio-political realities which engineer this condition, *Old Negatives* deals primarily with the wounds gathered in direct personal terms. There are many indications of how dragons grow in *Old Negatives*, how barriers arise as thick skins develop from painful failures:

> There is no excuse for this and can be none.
> Soft pricks won't be stiffened by verbal alloy.
> But the man resorts to words out of old habit.
> The woman has only rage for what she did not enjoy.
>
> ('Mishap' *ON*, 47)

A further correlation with *Lanark* is apparent as the eponymous Duncan Thaw, not surprisingly, looms in the weave. The poem 'Announcement' draws on other sources of damage contributing to the growth of 'ribs of dragon armour' (*ON*, 34) while providing a compact illustration of how what I have called 'Itemisation' is manifest in the poetry:

> 'When wounds did not hurt those who inflicted them
> 'I was born in a city built over the desolate garden.
> 'The fall was an obscure event involving grandparents.
> 'I looked back without loss to an uncushioned womb,'
> said Thaw,
>
> rolling the syllables over and under his tongue.
>
> (*ON*, 41)

While I have been discussing *Old Negatives* largely in terms of its cross-reference to other work, it is straightforward enough to invert the process. The itemisation above is virtually a key to Gray's development of a codified terminology for himself, whether in purely linguistic terms in the fiction or in the more immediate, visual terms of paintings or illustrations. The condensed time-span covered in *Old Negatives* lays bare at once how these symbols have accrued and evolved so that in one way you can use the book as a guide to the other works.

Paradoxically, while the poetry illustrates a stylistic refinement, it simultaneously indicates a consistency of vision and technique – two points that can be uncomfortable to reconcile. The central movement of these sequences is from the bleak shadow of 'In A Cold Room' to a (flickering) sense of light and alleviation in the concluding 'To Lyric Light'. The difference and the consistency can be illustrated by taking a look at a further example of Gray's use of itemisation. In the opening sequence, from 1952 TO 1957, we find:

> What is there for me when the morning comes?

A kitten scrabbling cold gnawed rabbit bones
among the tinkling cinders of a hearth,
desolate wisdom got avoiding the known good,
a tramcar moaning down an empty street,
a memory that fingers old regrets.

('Predicting', *ON*, 14)

Then, if we move on to the third sequence of 1961–71 this can be
balanced and contrasted with these lines:

In a room a man sits pondering a debt he cannot pay.
A small boy plays with bricks beside the man's feet.
Nearby a woman mends a shirt, smoking a cigarette.
A clock ticks. A cat sleeps by the fire.
There is noise of brawling from the street.

('Both Perspectives', *ON*, 50)

The movement, on the positive side, is from complete isolation to a
kind of contact, though the reserve is still there. For Gray people are
invariably seen as glancing off one another, failing to connect and
remaining 'two feeling hearts in towers of rocking bone', ('Married',
ON, 46). In the extract above worry malingers in the substrata; man,
woman and child (and cat) inhabit separate, private worlds, only just
keeping off the threat of the outside environment, the 'noise of brawling
from the street'. A disconcerting aura of insecurity pervades.

If there is a sense of movement toward a kind of light and optimism
set beside a consistently bleak world view, there is also a third
dimension here. From the sometimes quietly frantic insistence on
'communication' suggested by the poem 'Predicting', with its 'Beat'
resonance, bohemian scenario and 'honesty' of expression, there is a
relentless metamorphic drive through to the last poem, 'End':[6]

THE GRAVE COLOURS OF EARTH
BRIGHTEN TOWARD
AN
OPEN BOOK
OF
LIGHT UNSTAINED
BY
WORD

(*ON*, 67)

In the book this poem is colour-coded, moving from black in the
opening line, through maroon, mauve, blue, green, yellow, orange to
an almost invisible grey 'WORD'. So there is a move into silence taking
place as well, a signing-off paralleling Gray's usual 'GOODBYE'. This
can begin to seem like parody of the postmodern lurch into silence (the

one that more or less swallowed Beckett), a contentious quagmire to which so much of Gray's work can be related. Though it is dealt with in much more detail elsewhere in the present volume, it is worth taking a tangent here to see what Gray has to say on this, specifically with regard to his poetry, on which he has spoken (or been asked) very little over the years.

In an interview for *Verse* magazine Elizabeth Donaldson asked: 'Are you still writing poetry Alasdair?' Gray responded:

> I only do it when suffering a strong feeling of personal loss and I haven't had that for quite a while. With any luck I won't have it again.[7]

On one level this is probably quite simply 'true' but it also efficiently circumvents discussion of other aspects of his poetry. A closer examination of Donaldson's interview reveals a web of contradictions (check for yourself) which grows more alarming if you begin to cross-refer from one interview to another. Basically, as in all the other arts practised by Gray, everything is landmined or subverted; he delights in an anarchic derailing of expectations and, given his sometimes prickly elusiveness along with a capacity to seize control, the 'interview' could easily be added to his catalogue of accomplished mercurial fictions. Bearing this in mind we can look at a few related remarks and aspects which begin to suggest some of the ways in which the poetry can be seen to differ from the main thrust of Gray's work.

In certain respects the poetry sits most comfortably alongside Gray's achievement as a visual artist rather than with the more obvious (and perhaps too habitual) correlative of the fiction. Ironically this is primarily because painting and poetry occupy the polar extremes of his work, and impact via essentially different aesthetic routes. In his illustrations his use of symbolism can be incredibly dense but the visual immediacy and explicitness of the symbolism (the phallic lance through the heart prefiguring the 'Inge Sørensen' sequence, *ON*, 43) allows for immediate response and interpretation without hazarding the mazes of circumnavigation, counterpointing, distancing, parody of parody, set up in the fictions.

In a similar way, then, the poetry can be much more bare. The forms are sparse and explicit. We are *taught* to tune into symbols in poetry to a much greater degree than in prose – though such barriers and distinctions are increasingly breaking down. There is much less experimental highjinks in the poetry. While a work like *Janine* can be sifted and mined for 'meanings' and retains an ambiguity as well as its distance from 'Alasdair Gray', the poetry can be brutally, disarmingly

or alarmingly frank and autobiographical. If all the complexities of sex
and sexuality feature as dominant concerns in much of Gray's work,
from *Janine* to its prevalence in *Something Leather*, we tend to interpret
through a diversity of shields, masks and filters sixteen removes from
Gray. In the poetry sexual issues are similarly to the fore but stripped
of their distance, their fictional context.

> But love is not just knowledge and tenderness,
> a sympathy of brain and heart,
> it must be felt hard in the lower part.
> Rotten with sympathy, love is a mistake between us two
> because you make as little heat in me
> as I can make in you.
>
> ('Mistaken', *ON*, 16)

There is a directness, realism and insight as well as a self-awareness here
that is scarcely if ever laid so openly on the table in the fiction where
'self-awareness' is normally employed to inflict aesthetic anarchy.
Similarly in a poem like 'Loneliness' which employs elaborate analogy,
the 'message', the precariousness of human relationships and the
centrality of sex to their sustenance, is no less lucidly dealt with:

> From the soul's proper loneliness love and affection seem
> part substance and part dream
> held in the mouth in the same way the snake carries its eggs
> if gripped too hard they break,
> leaving a few grains of dust
> and a heart crippled by its weight of lust.
>
> (*ON*, 15)

While the vestigial utilisation of the Thaw persona as well as the
acknowledged superimposition of sequential structure (see note 2) are
among the techniques providing a veneer of aesthetic distance it is a
thin one which is frequently breached, pinpointing a central difference,
characteristic of the poetry as of no other area of his work.

Gray has said he does not differentiate between poetry and prose but
such a claim sits uneasily with his working practice.[8] In his interview
with *Bête Noire* he says:

> The Alan character was based on an artist I knew, called Alan
> Fletcher. In fact that's the closest portrait of Alan I've done. I've
> got him as Aiken Drummond in *Lanark* and in *The Fall of Kelvin
> Walker* the character of Jake is a slightly watered down version of
> him. The original Alan Fletcher is now dead. He was a very fine
> painter, not a failed one in any way. His sculpture was very fine
> indeed.[9]

Such shielding, enwrapping and remoulding, however, does not find a
correlative in the poetry:

He will not occur much to us again
unless in the thin way thoughts occur
who was wild and solid and broke doors in
and had women and clay his hands knew how to touch.

Now what we love in him deprives us of him.
Jokes, height, fox-grin, great irony and nose
will not occur much to us again.
They have been put in a box to rot.

Night air took the heat from his brain
as he lay with cracked head under a wall.
Metal and stones stay shapeless because he is dead.
His clay crumbles. His women mate elsewhere.
He will not occur much to us again.

('Lamenting Alan Fletcher', *ON*, 38)

This enters entirely different zones from the swathings of artifice, the wilful dislocations of the prose work, just as it is far from some of the vaguely de-humanised if highly personalised mythologies and symbolisms of his illustrations. But if this is stripped bare of circumnavigation a lot of the poem's power lies in carefully crafted technique: its strange balance of warm appreciation with the almost ruthlessly accurate dealings with the facts. The substantial is juxtaposed with the vaporous – a juxtaposition melding to yield the full impact, the physical fragility of the human body brought home against the ruggedness of the man's nature; 'Night air took the heat from his brain / as he lay with cracked head under a wall.'

Poetry such as this shares equal space with some of the wilder regions of *Old Negatives* discussed above. Finally, the coherence of the book lies in their fusion, the diverse tangents gradually building up a dense latticework of superimposition within which poem upon poem gradually produces a fully developed picture, a gradually expanding network of implication and cross-reference working out in both directions from whichever point of the book you care to project from. Just as Lanark illuminates Thaw, so Thaw illuminates Lanark. Something of the nature of this process can be suggested by considering the poem 'UNCEILINGED BLOOD' in relation to the poem on Alan Fletcher:

THEN LIFE APPEARED, A CANCER OF THE CLAY:
SOME MOLECULES CHANCE SHUFFLED
 INTO SENSE
WHICH WRIGGLED OUT INTO THE LIGHT OF DAY:
A KNOT OF FIBRE TWITCHING IN THE FIRMAMENT
WITH NO PROVISION FOR ITS GOVERNMENT.

(*ON*, 21)

Here the random, chaotic and haphazard nature of our situation is dominant. So too the futility, something against which much of Gray's work struggles while exploring escape routes or methods of understanding. But the latent absurdity of our being, set in a context at once cosmic, biological and blunt, echoes aspects of the Fletcher poem's 'They have been put in a box to rot', highlighting the strangeness of some of our ways of dealing with realities. The more you dwell on the idea, the more peculiar coffins can begin to seem. But both of these fragments are integral. There is the cold, barren, the ephemeral, there is isolation and loneliness: but there can be a warmth too in knowing a person like Fletcher who can pass on and share something of the fullness of his spirit.

As the component parts of *Old Negatives* begin to congeal it becomes easier for the reader to project out on to the broader scale of Gray's works. Each of his different genres lends its own unique possibilities in exploring a complete Gray, a whole vision of self and its place, its workings. Nothing is final in Gray's work. He keeps changing, crossing over barriers and gathering further generic strains into the weave, so the evolutions will continue. The differences as well as the unities looked at here each answer to specific requirements thrown up by Gray's needs for the overall body of work. The subtle interrelationships of that work ensure virtually anything you conclude can be countered by reference to another component of his output.

I suggested earlier for instance that in terms of visual arts Gray's illustrations can seem dehumanised, stark, mythologised scenarios. But if we move a little further into that area a painting such as *Cowcaddens,* 1950 offers immediate contradiction.[10] The perspectives may be wild and deviant, virtually surrealistic, but this painting is heavily peopled and shows an empathy in its representations and a comprehension of the realities of life in the city, however sinister these may seem. Attempting to get to the bottom of Gray can be an intriguing and worthwhile pastime but eventually the conclusion must be, as Rima has it: 'Names are nothing but collars men tie round your neck to drag you where they like' (*L*, 73). As far as genre is concerned, Gray slips the noose and takes us where *he* likes; we can juggle with 'names' till we're blue in the face.

Finally Gray's are arts that might just help us along the way to a place where Dragons are no longer necessary. Ironically the arts of Alasdair Gray could be considered as the embodiment of an armour of his own, paradoxically confronting realities instead of retreating from, or being engulfed by, them. In this respect Gray's poetry with regard to the overall context of his works provides the most explicit exploration

of how Dragons happen and what we need to be able to step out of them.

NOTES

1. The title of this chapter is taken from Gray's poem 'Announcement', (*ON*, 41).

2. Gray has said of the first half of *Old Negatives*:
 > There used to be twice as many poems from that period going back to the age of sixteen but I cut out more and more of them the older I got. They were too conspicuously juvenile.

 Alasdair Gray talking with Elizabeth C. Donaldson. *Verse*, 1, 1, 1984, p. 31.

 These remarks indicate the finality Gray attributes to the context provided by *Old Negatives*. This editing also suggests the extent to which the completed construction has been carefully considered and its structuring overlaid.

3. *Bête Noire*, No. 5, Spring 1988, p: 26. (The interview is dated 6 February 1988.)
 'Disney, Walt' is also cited in *Lanark*'s 'Index of Plagiarisms', (*L*, 487–8).

4. See 1982 *Janine*, pp. 177–90.

5. I have written tentatively of some of the ideas here in *Chapman*, No. 60, Spring 1990, pp. 96–7.

6. As far as the Beats are concerned there are no Blockplags, Implags or Difplags for these writers. There is the satiric portrait of 'The Elite' crowd in *Lanark* which perhaps suggests the extent of influence, or absence of it, from that quarter.

7. *Verse*, No. 1, 1984, p. 34.

8. *Ibid.*, p. 34.

9. *Bête Noire*, No. 5, Spring 1988, p. 28.

10. *The anthology Noise and Smoky Breath* edited by Hamish Whyte (Glasgow: Third Eye Centre, 1983) features Gray's *Cowcaddens, 1950* as its concluding illustration. The painting was completed in 1964.

Eleven

Gray the Dramatist

David Hutchison

The publication of *Lanark* in 1981 established Alasdair Gray's position among writers of contemporary fiction, and his subsequent work has consolidated that position. Yet for some twelve years before *Lanark* appeared he had been known not only as a painter but also as a dramatist working mainly, though not exclusively, in radio and television. But he had not achieved in drama the position of eminence he was to reach in prose fiction; rather he was regarded as an interesting but minor playwright, pursuing his own concerns outside the mainstream of Scottish drama. Since *Lanark*, a stage play dating from earlier in his career, *McGrotty and Ludmilla*, has been given a full professional production, and a television play, *Story of a Recluse*, based on an unfinished fragment of an R. L. Stevenson short story, has been transmitted by BBC Television, but Gray's success as a novelist does not appear to have led to any significant development of his career as a playwright. However, with the same economy that characterised his marketing of dramatic material, he has used two of his earlier plays — *The Fall of Kelvin Walker* and *McGrotty and Ludmilla* — as the bases for novels.

Scotland has never been the best of countries in which to seek to be a playwright. There are sound historical and economic reasons why this is the case. Presbyterian hostility to drama after 1560 is generally credited with destroying what little theatrical activity existed in Scotland, and the Union of the Crowns, by removing the patronage of the court, set the seal on its demise. It was not uncommon for attempts to open playhouses in Scotland in the eighteenth century to be met by the wrath of clerically inspired mobs, and only in the nineteenth century did theatres begin to establish themselves in cities and towns

throughout the country. Theatre had become acceptable, and in at least some of its manifestations, perfectly respectable. But Scotland is a small country compared with its southern neighbour, so the theatrical base has never been a very substantial one. Since the last war there has been a steady growth in the number of state-subsidised companies, in the business of providing a wide range of drama, but the actual total of enterprises involved remains modest. As for the attitudes of these companies towards indigenous drama, these have varied with the cultural climate and economic circumstance, the latter often having its effect on the former.

There have been times of real commitment to Scottish writing: the inter-war period was one such era, though unfortunately the companies concerned were mostly amateur and had a view of what constituted Scottish drama which was excessively sympathetic to the historical and the rural. The 1950s were also a good period for the Scottish dramatist, with the Gateway in Edinburgh and the Citizens' in Glasgow presenting a wide range of plays, and displaying a fairly constant commitment to the development of an indigenous tradition. But the 1960s were a bad period, with the directors of many companies protesting that they would love to do Scottish plays if only good ones would propel themselves, ready made, through their letter boxes. The facts that good plays grow out of bad plays and that the price of achievement is a sea of mediocrity seemed to have eluded most of these gentlemen – and in these days they were all men. The easy option was to exploit the common language and mount plays chosen from the classical English repertoire, or, if new plays were required, some contemporary success from the Royal Court or elsewhere.

It became clear in the early 1970s that the general cultural climate was changing in Scotland. The rise in political nationalism, fuelled by the limping prosperity of Great Britain, and then by the discovery of the oil which was to keep the British show on the road, led to a cultural nationalism, which was – paradoxically – financed by the increased UK arts funding initiated by Jenny Lee in the 1964–70 Labour Governments and pursued by both the Conservative and Labour governments of the 1970s. So in that period virtually every Scottish theatre felt obliged to present new Scottish work, and even the most disappointed of Scottish playwrights would have had to admit that any half decent play would get a performance somewhere, if not at the Traverse – under Chris Parr's directorship from 1975 – or at the Lyceum – where Bill Bryden was associate director from 1971 to 1975 – somewhere else, whether in one of the other well-established reps, like Dundee or Pitlochry, or under the auspices of more ephemeral companies such as Edinburgh's Pool

Lunchtime Theatre or the Stage Company Scotland – an offshoot of the magazine *Scottish Theatre* – both of which flourished in the early 1970s. The establishment of the Scottish Society of Playwrights in 1974 was a further indication of the growing strength of Scottish drama.

The débâcle of the 1979 Devolution Referendum, the subsequent fall of the Callaghan government and the advent of Thatcherism led to a period of cultural retrenchment, when the reduction in public funding combined with the loss of national self-confidence resulted in a lessening of the pace of growth of Scottish drama. However, it became clear in the second half of the 1980s that the theatre had not plunged back into a 1960s-style desert, and while the widespread commitment to the development of Scottish dramatic writing was no longer there – Pitlochry, for example, has not presented a single new Scottish play since 1980 – there were enough companies around with the necessary enthusiasm to ensure that Scottish dramatists still had some outlets for their work, although constraints in cast size and settings were a serious limiting factor on the scope of their writing.

The moral that any dramatic writer has had to take from this chequered history is that he cannot rely totally on the theatre in his native land if he wishes to make a living. If he is extremely fortunate, he might find his plays entering the English and international repertoires, and a few writers have had such good fortune – though usually in a very patchy way. The more sensible course is to write for radio and television. Throughout the last twenty years both markets have been important for the Scottish dramatist. Radio has offered the widest opportunities in respect of the kinds of play that can be written. In 1978, in anticipation of devolution, Radio Scotland became an opt-in rather than an opt-out service, that is to say it became responsible for the bulk of its own programming. But before that time and since, much of the output of its drama department has been commissioned by Radio Four or Radio Three for UK transmission – indeed there have been times when all of its work has been produced on that basis. At other times there have been opt-out productions, which may or may not have subsequently been sold to the UK networks. What this has meant is that, in theory at least, a Scottish dramatist could range from the experimental to the middle brow; in practice, the Scottish produced output has been lighter at the end of the range than the general run of UK network drama. In addition to the BBC output, Radio Clyde has regularly presented some drama productions of a mainstream nature.

Television drama in Scotland has come from the BBC and Scottish Television. For a time in the 1980s STV mounted a series of half-hour plays, but the bulk of its output has been in the series and serial

formats. *High Living* gave way to *Garnock Way* which in turn gave way to *Take the High Road*, the company's most successful serial to date. *Take the High Road* offers steady work to a number of writers, who, if they are comfortable with the constraints of the genre, can make a tolerable living. The *Taggart* detective serials, which have secured peak time UK exposure, provide work for one writer, Glenn Chandler. BBC Scotland has made thrillers, adaptations of Scottish fiction, occasional original serials like John Byrne's *Tutti Frutti* and single plays, all for network transmission, although there was a time when opt-out drama was produced, but that ceased to be financially viable as budgets became constrained in the 1980s. Channel 4 has made a limited contribution in the field of Scottish drama.

Alasdair Gray has sought to place his work in all three markets — theatre, radio and television — and he has not limited himself to Scottish markets. When he began, as has been indicated, the Scottish theatre was not in a very receptive mood, so it is not surprising to find that his early work appeared on radio and television.[1] *The Fall of Kelvin Walker* was transmitted in 1968 on BBC2 in a single play strand called Theatre 625, while *Quiet People* was transmitted by Radio Scotland the same year, to be followed in 1969 by *Dialogue* and in 1971 by *The Night Off*. All three were directed by Stewart Conn, Scotland's senior radio drama producer, with whom Gray has enjoyed a fruitful relationship. Gray benefited from the establishment of new theatre companies interested in staging indigenous drama in the early 1970s. So *Dialogue* was presented by the Stage Company Scotland in 1971 and *Kelvin Walker* by the same company in 1972. The Pool Lunchtime Theatre presented *The Loss of the Golden Silence* in 1973 and the play was subsequently broadcast on radio in 1974. *Agnes Belfrage* was originally submitted to an English Radio 4 drama producer in the 1960s, but not used. Subsequently it was televised by Granada Television in 1972, then given a workshop theatrical performance by the Scottish Society of Playwrights in 1975. The same Radio 4 producer was responsible for the broadcast of *McGrotty and Ludmilla* in 1975.

In the mid 1970s, at a time when the opportunities for Scottish playwrights were better than they had ever been, Gray's dramatic ouput began to dwindle. At the beginning of the decade, as can be seen from the preceding paragraph, he was very busy, with work appearing regularly in radio, television and theatre — and in addition he was writing for Scottish schools TV. But at a time when other writers were benefiting from the heightened cultural awareness which preceded the Devolution referendum, Gray went strangely quiet. One can only speculate as to what the reasons were. The most obvious explanation

might seem to be the fact that his agent, Frances Head, who had been responsible for selling his plays, died in 1977. Furthermore he was presumably by this time hard at work on *Lanark*. But it may be the case that as far as the theatre was concerned, Gray at this time found himself out of sympathy with the dominant mode of proletarian naturalism. Perhaps he also felt that as a dramatist he had written himself out. Subsequent events would tend to confirm this interpretation. One of his radio plays, *McGrotty and Ludmilla*, has reappeared as a stage play, and that play and *The Fall of Kelvin Walker* have been used to create novels, while some of his shorter pieces have been reworked in *Something Leather* — Gray is nothing if not economical with material — but there has been little new dramatic work. However, a radio play, *Near the Driver*, although turned down by the BBC, was subsequently broadcast by WDR in Cologne in 1983 and a television play, *Story of a Recluse*, was transmitted in 1988. Perhaps Gray is turning again to drama, invigorated by his success as a novelist.

As a dramatist, Alasdair Gray is less given to experiment than he is in his fiction. Most of his work is naturalistic in form and there is nothing to compare with the interpenetration of the real and the imagined to be found in *Lanark* or the exploration of narrative identity in *Janine*.

However, Gray is clearly impatient with the limitations of naturalism. So in *The Loss of the Golden Silence*, for example, there is a Pinteresque quality to the dialogue and the characters are initially devoid of names. He frequently employs surnames with rather obvious descriptive qualities — McGrotty and Sludden, for example, make their first appearance in *The Night Off*. There are too in Gray's dramas, elements which break clearly with the rules of naturalism: in *Near the Driver* the train in which the action is set ends cruising above the Wash at over two hundred kilometres per hour — the top speed of British Rail's 125! — and heading for a collision; in *The Story of a Recluse* the author himself intervenes at several points in the narrative.

In *Janine* and other work Gray explores the erotic in a more explicit way than has been traditionally the case in Scottish fiction. There is nothing in his drama which approaches the frankness of Jock McLeish's imaginings. However, sexual relationships are the focus of several of his plays. In *Dialogue*, for example, a rather sad commercial traveller — shades of McLeish — who has just been divorced tries to establish a relationship with a student physiotherapist, but things fall apart when he confuses her with his ex-wife. In *Agnes Belfrage* the central character is a mature student, mother of a fifteen-year-old boy, who moves in with Eric, one of her lecturers. Eric is rather an odd fellow who is

obsessed by the model of a city on another planet which he has constructed. The affair does not last and Agnes goes off to pastures new.

It has to be said that neither of these plays works very well: the characters are indistinct and the dialogue is stilted. Much more effective is the straightforward little piece of naturalism, *Quiet People*, in which a respectable retired couple let a room and find themselves playing unwilling host to a dubious scrap merchant, his wife and child and his drunken brother-in-law.

Mitchel:	I'd like a private word with you, Mr Brown.
Brown:	It's alright Tom. Come right in. He's not here just now.
Mitchel:	I've come about your brother-in-law.
Brown:	I was expecting this wasn't I, Ruby?
Mitchel:	I'm afraid he'll have to leave.
Brown:	And there's nobody more glad than I am to hear you say these words, Tom. I don't know how you've stood him so long. Frankly we're sick of him, aren't we, Ruby?
Mrs Brown:	Quite right. I'm his sister, Mr Mitchel, and he's my brother, but I'm not ashamed to say I'm ashamed to say it, and you can tell him to clear out any time you like.
Brown:	And the sooner the better.
Mitchel:	But . . . I mean . . . why should *I* ask him to leave?
Brown:	Well I think he'd take it more *kindly* from you, Tom. He's a big strong man, even if he has put on a lot of weight and he used to be a professional wrestler, and after all you're quite old. If he cut up rough, the law would be on your side, and Jimmy isn't a fool.
Mitchel:	Let's get this straight! You invite your brother-in-law to stay the night — he stays a fortnight — you're afraid to ask him to leave and you expect me to do it! I'll be *damned* if I'll do it!
Brown:	But Tom . . .

Mitchel: Stop Tomming me! Your brother-in-law can
 stay here till doomsday for all I care. Goodnight!

Gray's comic talent is clear in this piece, as it is in *The Night Off* in
which a rather worn school teacher gets involved in a pub one Friday
night with an expatriate Scottish photographer, Hector McRimmon.
McRimmon claims to be big in London and explains that he is on a
mission to record the old Glasgow before it is knocked down. The
teacher foolishly agrees to take McRimmon to his grandparents'
authentic single end so that pictures can be taken. The action
culminates in an undignified scrap at a wedding anniversary party in
which the teacher smashes McRimmon's camera. The play ends sadly
with the teacher at home with his wife, bemoaning his lot. The interest
of the piece is in the character of McRimmon. He is a repulsive example
of the puffed-up Scotsman who claims to have made it, but in reality
does not amount to very much — he is not a particularly good
photographer, his seeming knowledge of the world of the intellect is
very shaky — he confuses Walt Whitman and J.B. Priestley, Nietzsche
and Wittgenstein — and he is an inveterate sponger. Yet Gray allows
him his moment of self-justification.

Teacher: Hand that film over, Hector.

McRimmon: I get it. You're jealous. You're jealous like all
 the others! You cannae see someone achieve
 something without wanting to throw your own
 miserable wee spanner in the works! Your
 trouble is you've got a third rate mind . . .
 (the Teacher loses his temper and speaks
 out in a bold rather huge voice)

Teacher: You're a liar, McRimmon! A liar and a bully,
 a boaster, a phoney and a failure! What could
 be more third rate than you, you, you drunken
 idiot!
 (There is silence, all the party noises
 ceasing, then McRimmon speaks quietly
 with unexpected dignity)

McRimmon: You're wrong, I may be a failure and a
 drunkard, and maybe other things, but I am
 not third-rate. Second-rate, yes, all right, but
 not third-rate. At least I've tried to get out of
 the rut. I've failed. Fine. But you haven't even
 tried.

Similar characters are at the centre of two of Gray's other plays, *The Fall of Kelvin Walker* and *McGrotty and Ludmilla*.

The television version of *Kelvin Walker* was marred by the use of English actors in the Scottish roles – Corin Redgrave played Kelvin, for example. Apparently when Gray complained about this the producer, feeling that he could make some recompense by casting a Scotsman as Kelvin's father, looked through his casting directory, and chose an actor with a 'Mac' surname – this individual turned out to be an Ulsterman! The dialogue of the television script – and the subsequent stage version – is substantially preserved in the novel. The action begins in the London coffee bar in which Kelvin, a refugee from the town of Glaik, where he had difficulty in finding companions with whom he could discuss Nietzsche, strikes up his relationship with Jill. From there Kelvin progresses through several unsuccessful interviews to which he only gains access by claiming that he is Hector McKellar, a fellow son of Glaik who is a successful BBC journalist. Eventually he is taken up by McKellar, is given his own television show and gets carried away with the power that comes with it. Nemesis arrives in the shape of his father – a Free Presbyterian Session Clerk. Mr Walker reminds Kelvin that he has stolen money and jewellery from his parents in order to finance the trip to London, opines that he is 'a hollow shell stuffed with nothing but self conceit and driven onward by the wings of pride' and orders him home.

Gray regarded this ending as very weak and in the novel it is McKellar himself who instigates Kelvin's downfall by engineering a confrontation between Kelvin and his father live on television.

Although the play is set in the London of the 1960s – 'Swinging London' – it is not really an exploration of the city at that time. Jill and her artist boyfriend Jake, from whose clutches Kelvin seeks to extricate her, are hippies of the kind to be found then, but the real focus of the play is on Kelvin and his drive to succeed. We are told on the fly leaf of one of the stage versions – and in the novel – that what we are watching is an episode from the youth of the 283rd Moderator of the United Seceders Free Presbyterian Church of Scotland. What Gray is caricaturing in this play is the ruthless desire to succeed which Presbyterianism can arouse in people. In his combination of determination and hypocrisy Kelvin Walker reminds one of George Douglas Brown's Gourlay and J. MacDougall Hay's Gillespie. But Kelvin is a more humorous figure and less fearsome than either Gourlay or Gillespie. He is, however, driven by the same impulse to success.

Caricature is also the method of *McGrotty and Ludmilla*; indeed the play is described by its author as 'a political pantomime'. Mungo McGrotty, a not very bright Scottish civil servant, is taken up in

London by Sir Arthur Shots as part of a plot revolving round the Harbinger Report, the contents of which, if publicly unveiled, would apparently devastate the nation. In the event Mungo becomes involved with Ludmilla, a cabinet minister's daughter, turns the tables on Shots' attempts to use him, and at the end of the play is answering – or rather evading – a question as a front bench spokesman in the House of Commons. The play is to some extent a modern version of *Aladdin and his Wonderful Lamp*, and in a display of self-reflexive inter-textuality, Gray has *Janine*'s Jock McLeish become involved as a young man with a student production of the play on the Edinburgh Festival Fringe. McLeish, attending his first rehearsal, notes the pantomimic elements and comments that the play 'had no doubt been written with satirical intent, but I saw nothing funny in it' (*J*, 220). That is a harsh judgement and the play, aided by McLeish's lighting effects, is a success, although 'the writer' remains a gloomy and critical figure! But *McGrotty* does not work as well as a piece of drama as does *Kelvin Walker*. The characters are one-dimensional, and the shafts of wit about political opportunism do not develop into a coherent comic vision. The novel version, in which the action is updated to the 1980s and Mungo becomes Prime Minister, is much more effective, because the dialogue is framed by Gray's narrative persona, and that persona offers a sustained ironic commentary which the dialogue by itself does not carry.

The most enjoyable of Gray's plays is his most recent piece, *The Story of a Recluse*. The play begins with the unseen Gordon Jackson as the voice of the hero, Jamie Kirkwood, now in old age, looking back on his youth, and this leads the viewer into the narrative, which on screen is composed of black and white images of Edinburgh's New Town. Suddenly the author appears, that is the author Alasdair Gray, not the original author, R.L. Stevenson, and Gray explains that he has finished Stevenson's four page fragment as he thinks Stevenson would have wished, and dramatised it into the bargain. We then cut to Gray on location in Edinburgh with the supposed television crew and the supposed producer, played by Bill Paterson, and a frenetic director, played by David Hayman. (RLS himself appears only to be elbowed aside before he utters a word.) However we do not see the real producer, Tom Kinninmont, nor the real director, Alastair Reid. It is clear that what we are being offered is a postmodernist narrative in which the ideas of truth and authenticity are in question. The basic 'story' concerns the involvement of Jamie Kirkwood, son of a minister, and a medical student, with the sultry foreign lady who is the consort of the proprietor of a gambling den. While there is scope in such a situation for an exploration of the relationship between Presbyterianism and the

evils it prescribes, in the respectable Edinburgh of the late nineteenth century, Gray opts instead to play games with the viewer's narrative expectations. We are offered two endings: in one Jamie wins the right to see more of 'Miss O'Sullivan'; in the other it is revealed that the proprietor of the gambling den, Manton Jamieson, played by Stewart Granger, is married to the lady, and Jamie is accused of cheating at cards, then unceremoniously bundled on to the street. As the credits roll, an argument breaks out among Gray, the 'producer' and the 'director' about having a new beginning, which we then see. In this version, to the accompaniment of melodramatic music, Jamieson is murdered by his wife, as the 'producer' protests that he would not have hired Stewart Granger if he was going to be killed off so quickly. And there the play stops, with the credits giving the names of the real producer and director.

In an earlier version of the script none of the narrative disjunctures is to be found, although, as in the television version, there are two alternative endings, with Jamie as an old man explaining to his housekeeper that the circumstances which led to his present hermit-like existence derive from the second 'true' ending. It is not clear why the television version differs so markedly from the earlier script, but it is a much more stimulating play which results. Nothing very profound is said about Presbyterianism, but the notion that dramatic fiction is essentially a construction − no matter how 'real' it might seem − is skilfully and amusingly foregrounded.

Alasdair Gray the dramatist is not Alasdair Gray the novelist. It might be argued that the uncertain world in which the Scottish playwright has to operate made it difficult for him to develop as he might have done, and that when the situation improved in the mid 1970s for Scottish dramatists, it was too late for Gray who was then moving on to prose fiction. That could be true, but a more likely explanation is that the novel form offers him a far better opportunity to deploy his particular literary talent, and to develop his distinctive narrative voice.

NOTES

1. I should like to thank BBC Scotland and the National Library of Scotland for their assistance to me in my research. Full details of production/transmission dates can be found in Bruce Charlton's checklists at the end of this book.

Twelve

Checklists and Unpublished Materials by Alasdair Gray

Bruce Charlton

1. Checklist of Principal Works by Alasdair Gray

This is by no means a bibliography of Gray's writings, but it does itemise his major works, supplying the date of composition (if known), and the date of publication, broadcast, or performance, along with other relevant details.

1965 — *The History Maker*. Play. Not performed.

1968 — *The Fall of Kelvin Walker*. Play. BBC television. Written 1964.
— *Quiet People*. Play. BBC Radio Scotland.

1969 — *Dialogue*. Play. BBC Radio.

1970 — *Honesty*. Play. Scottish BBC Schools.
— *Thomas Muir of Huntershill*. Play. BBC Radio Scotland.

1971 — *The Night Off*. Play. BBC Radio Scotland. Written for TV 1966.
— *The Strathaven Revolution*. Play. Written 1971–2. Not performed.

1972 — *Agnes Belfrage / Cholchis / Triangles*. Play. Granada Television. Written 1969.
— *Martin*. Play. Scottish BBC Schools. Written 1971.
— *Today and Yesterday*. Documentary plays. BBC Scotland, educational television.

1973 — *The Man who knew about Electricity*. Play. BBC TV.
— *Sam Lang and Miss Watson*. Play. Not performed.
— *James Watt*. Play. Not performed.
— *Homeward Bound / The Homecoming*. Play. Performed at the Pool Lunchtime Theatre, Edinburgh.

1974 — *The Loss of the Golden Silence*. Play. BBC Radio Scotland. Written 1973.
— *In the Boiler Room*. Play. Not performed.

1975 — *McGrotty and Ludmilla*. Play. BBC Radio. Written 1973. Stage version done at Tron Theatre, Glasgow, 1986.

1976 — *The Golden Key*. Radio verse play adapted from the story by George MacDonald — written to be set to music by Wilma Purser. Not performed.

1977 — *The Gadfly*. Play. Granada TV.
— *The Rumpus Room*. Opera libretto. Not performed.

1979 — *Comedy of the White Dog*. Short story. Glasgow: Glasgow Print Studio Press. First version 1956.

1981 — *Lanark*. Novel. Edinburgh: Canongate.

1982 — *Education*. Short story. *The Glasgow Magazine*. Winter 1982–3, 7–9.
— *Tickly Mince*. Revue. With Tom Leonard and Liz Lochhead. Tron Theatre Glasgow and The Pleasance, Edinburgh.

1983 — *Unlikely Stories, Mostly*. Short stories. Edinburgh: Canongate. 'The Star', 1951. 'The Spread of Ian Nicol', 1955. 'The Cause of some Recent Changes', 1956. 'The Comedy of the White Dog', 1956. 'The Start of the Axletree', 1960 (first paragraph and plan, otherwise 1978). 'The Crank that Made the Revolution' (*Scottish Field*), 1971. 'The Great Bear Cult', 1971. 'Logopandocy', 1977. 'Five Letters from an Eastern Empire', and 'The End of The Axletree', 1978. 'Prometheus', 1980.
— *Near the Driver*. Play. West Deutscher Rundfunk (in German translation). Written 1976. Published *Chapman* 1987, No. 50, 87–99.
— *A Modest Proposal for Byepassing a Predicament*. Essay. *Chapman*, 1983, No. 35/36, 43–6.
— *The Pie of Damocles*. Revue. With Liz Lochhead, Tom Leonard and Jim Kelman, Tron Theatre, Glasgow and The Pleasance, Edinburgh.

1984 — *1982 Janine*. Novel. London: Jonathan Cape. Written 1979–83.
— Entries (and illustrations) in *The Glasgow Diary* by Donald Saunders. Edinburgh: Polygon Books.

1985 — *The Fall of Kelvin Walker* Novella. Edinburgh: Canongate.
— *Lean Tales*. Short pieces. (with James Kelman and Agnes Owens). London: Jonathan Cape. 'A Report to the Trustees', 1959. 'The Answer', 1960. 'A Small Thistle', 1973. 'Portrait of a Painter', 1973. 'The Story of a Recluse', 1973 (as brief treatment for TV — a completion of the fragment). 'Portrait of a Playwright', from a radio broadcast 1979. 'The Grumbler', 1983. ('A Small Thistle', 'The Domino Game' and 'Money' were added for the 1987 Sphere paperback.)

1986 — *Henry Prince*. Play. (Written as *Beloved* in 1975.) Granada Television. The author was given as Martin Green since Gray had his name removed from the script.
— *Five Scottish Artists*. Introduction to exhibition catalogue (November 1986). Gartocharn: Famedram Publishers.
— *Afterword* to *Gentlemen of the West* by Agnes Owens. Essay, London: Penguin.

1987 — *The Story of a Recluse*. Play. BBC2 Television. Written 1959.

- *Near the Driver: A Play for Radio. Chapman* Nos. 50–1, ('written 1976 . . . I think it the best play I have written for radio' – author's note).

1988 – *Saltire Self-Portrait.* Autobiographical essay and interview. Edinburgh: The Saltire Society.
 – *A Preface to The Anthology of Prefaces plus Three Critical Commentaries.* Essay. *Edinburgh* Review 1988, No. 78/79.

1989 – *Old Negatives.* Poems. London: Jonathan Cape. Earliest from 1952.

1990 – *McGrotty and Ludmilla.* Novella. Glasgow: Dog and Bone Press.
 – *Something Leather.* Novel. London: Jonathan Cape. (Chapters 3,4,5,6,7 and 9 are reworked from short plays listed above.)

1991 – *Everything Leading to the First English.* Essay. *Chapman* 1991, No. 63, 1–13 ('this is an extract from the introduction to Alasdair Gray's *Anthology of Prefaces* to be published in due course by Canongate, although with the introduction in a slightly different form').

2. a) Transcripts of Some Interviews with Alasdair Gray

This is not a list of all Gray's interviews, but it does include the major interviews which appear most useful to readers of his work.

Carol Anderson and Glenda Norquay, 'An Interview with Alasdair Gray', *Cencrastus*, No. 13 (1983), pp.6–10.

Elizabeth C. Donaldson, 'Alasdair Gray Talking', *Verse*, No. 1 (1984), pp.30–5.

Kathy Acker, 'Alasdair Gray Interviewed', *Edinburgh Review*, No. 74 (1986), pp.83–90.

Alasdair Gray, *Saltire Self Portrait* (Edinburgh: Saltire Society, 1988) contains autobiography as well as interview with Christopher Swan and Frank Delaney.

Jennie Renton, 'Alasdair Gray Interviewed', *Scottish Book Collector*, No. 7 (1988), pp.2–5. Particularly good on childhood literary influences.

Sean Figgis and Andrew McAllister, 'Alasdair Gray Interview', *Bête Noire*, No. 5 (1988), pp.17–44. The most comprehensive interview available.

Alasdair Gray points out that since several of these interviews were tape recorded, rather than written, the omission of a crucial *negative* from the printed transcript has sometimes entirely reversed his intended meaning.

2. b) Secondary Reading

This is not a complete list of secondary reading, but it includes published material which readers may find particularly useful.

Bruce Charlton, 'The World Must Become Quite Another: Politics in the Novels of Alasdair Gray', *Cencrastus* No. 31, Autumn 1988, pp.39–41.

Douglas Gifford, 'Private Confession and Public Satire in the Fiction of Alasdair Gray', *Chapman* Nos. 50–1, Spring 1987, pp.101–16.

Alison Lee, *Realism and Power: Postmodern British Fiction* (London: Routledge, 1990).

Dorothy Porter, 'Imagining a City', *Chapman* No. 63, Spring 1991, pp.42–50.

Ian Spring, *Phantom Village: The Myth of the New Glasgow* (Edinburgh: Polygon, 1991).

Beat Witschi, *Glasgow Urban Writing and Postmodernism: A Study of Alasdair Gray's Fiction*, Scottish Studies, Vol. 12 (Frankfurt/Main, Bern, New York: Peter Lang, 1991).

3. Material from the Alasdair Gray archive in the National Library of Scotland

Introduction

When I was given permission to inspect and list the archive material in the National Library of Scotland it was an ideal opportunity to make this information available to interested readers. The archive is still being added to and has not been fully sorted, and these limitations, combined with the constraints of time, have meant that this bibliography is not absolutely comprehensive. However, it will serve a useful purpose until the collection of archive material is completed and a final catalogue can be prepared.

The autobiographical diaries and notebooks which date back to Gray's childhood are not available for public viewing at present, and may not be released for this purpose until after the author's death. Each notebook has a detailed description of its contents on the cover, in Alasdair Gray's own words. I have been allowed to transcribe these comments, which together form a skeletal biography of the author from the age of 10 years up to about 49. The notebook comments also contain a wealth of information relating to the writing of the various published works, including the long and tortuous evolution of *Lanark*. We can see in these notebooks, albeit through the distorting viewpoint of retrospect and in a partial form, some fascinating glimpses of the transformation of experience into achieved literary art.

The archive makes it clear that Alasdair Gray is a more prolific writer than is apparent from his published books. In particular there are numerous plays for stage, radio and television; an amount of poetry and several essays and short stories either unpublished or printed in small magazines. Most of this material is not at present generally available, but can be seen in the National Library

where photocopies can be produced by arrangement. I hope this catalogue will alert interested parties to the full range of Gray's achievement, and may help some of the unpublished or unperformed works reach the light of public attention.

The archive material in The National Library of Scotland which relates to Alasdair Gray is stored in carboard filing boxes. Inside these boxes are card envelopes and folders containing manuscripts and typescripts, and in some cases there are magazines, papers and books loose in the box. Alasdair Gray has sorted much of this material and listed it on the boxes and card folders, with a variety of comments. I have checked the contents of the boxes against his descriptions and transcribed the comments, regularising punctuation and spelling, and expanding abbreviations. Where I identified inaccuracies or mistakes, I corrected them (although I did not correct what was written on the boxes or folders of the collection, considering this to be beyond my rights of access). If material was unlisted, I have added a description. The comments have been retained either for their interest (which word I have interpreted liberally) or for their informational content, but the chronologies and reminiscences cannot always be checked against objective data, and may be subject to the distorting effects of memory. Nevertheless, they seem worth noting as the only source of information available at the present time.

Further information was available on a set of file cards which Alasdair Gray had compiled for his own reference. These contain miscellaneous biographical information and descriptions relating to many of the items in the National Library of Scotland. I have added extra information from this card file to the list of accessions: specifically to descriptions of the contents of the notebooks where the cards contain information not recorded on the notebook covers. The straightforwardly biographical material (much of it relating to the author's relatives and ancestors, and to dates of paintings and exhibitions) which could not be integrated into the catalogue, but which nevertheless may be of interest or scholarly value, I have simply transcribed in chronological order.

By this method I have compiled a list of the Alasdair Gray archive material extensively annotated with the author's own words. All comments (except the purely descriptive listing of contents which I have added where necessary) are by Gray unless identified as editorial by enclosure within square brackets. Most of the material was dated by Gray. This was checked for consistency against items of established provenance where possible. Many further pieces were fitted with dates using the diary notebooks and other internal evidence. I have cross-referenced the main accessions of material for published books with the location of relevant items in other parts of the archive. This has been indicated by the prefix XR, the accession number followed by a decimal point, then the box number, and further information if appropriate (e.g. notebook number or dates on a folder). Numbered folders (e.g. in Accession 9247) have been so marked by the author. Unsorted files have not been cross-referenced as the collection is still being added to and Gray has not yet put these items into order, or dated them. Neither has material relating to the composition of *Lanark* been cross-referenced as this would have included hundreds of notebook references over three decades.

The overall aim has been to produce an annotated catalogue for tracing the development and chronology of Alasdair Gray's writing, and for linking this

with biographical information. Therefore the editorial apparatus has been kept as unobtrusive as possible. I have included anything in the way of biographical or anecdotal material that might conceivably be useful, or that I found to be interesting in some way. I feel that in this, the first volume of Alasdair Gray scholarship, it is better to have too much than too little. Though there is thus a random quality not entirely dispelled, by the cross-referencing, yet I hope the reader may be at least partially compensated by the unexpected delight of coming upon snippets of human interest in the midst of this catalogue.

Abbreviations used in this section

Folder: Any folder, envelope or other cover for loose papers.

MS: Manuscript, handwritten material (or copy thereof).

NB: Notebook

p: Page

pp: Pages

TS: Typescript (or copy thereof).

XR: Cross-referenced to the following accession.

[]: Editorial insertions.

Accession 8799
Box 1

1982 Janine
[XR 9417.1 NB 38,46,53,59,60,61; 9417.2 NB 46]

Typescript sent to the publisher.
Typescript with MS annotations for the printer.
Page proofs with corrections.

Folder: *1982 Janine* page proofs.

Folder: 1] Photocopy of the final version of *1982 Janine* with the author's and editor's final annotations as communicated to the typesetter before the first proofs were pulled.

 2] Jonathan Cape catalogue for spring and summer 1984, with advert for the April publication of the above book and self-portrait of the author.

 3] A letter from a reader of *1982 Janine* which was later (in edited form) incorporated in the advertisement at the end of the Penguin version published in 1984.

Folder: Completed typescript with hand corrections as sent to the publisher.

Accession 8799
Box 2

1982 Janine MS of Chapters 1–11. [XR 8799.1]

A Short And Curious History: An Anthology of Prefaces MS drafts for the preface to this.

Folder: 1] Chapter 1, pp.1–16. MS and TS early drafts entitled *If This Is Selkirk, This Is Thursday, Janine.* Pornographic fantasy story in MS with chapters entitled *A bored housewife, ripe for pleasure, goes to get it but runs into trouble with a denim skirt* and *Audition.* MS and TS of blurb to novel.
 2] MS of preface to *A Short And Curious History.*

Folder: Chapters 2–3, pp.17–44, & 17–101. MS & TS drafts.

Folder: Chapters 4–7, pp. 45–101, MS & TS drafts.

Folder: Chapters 8 & 9, pp.102–32. MS & TS drafts.

Folder: Chapters 10 & 11, pp.133–70. MS & TS drafts.

Folder: 1] MS & TS of stories entitled *A Fragment* or *If This Is Selkirk, This is Thursday, Janine.* Described as the first pages of a 175,000 word novel.
 2] TS of Chapter 11 with MS alterations.

Folder: TSs of Chapter 11, some with MS alterations.

Accession 8799
Box 3

1. *1982 Janine* MS of Chapter 12 & 13. [XR 8799.1].
2. Miscellaneous material.

Folder: Chapter 12, pp.170–99. MS & TS.

Folder: Chapter 12, pp.250–69. MS.

Folder: 1] Chapter 13, pp. 270–92. MS & TS including final pages of novel marked with letters instead of numbers.
 2] MS fragment of a review of Kurt Vonnegut's novel *Deadeye Dick.*

Folder: 1] Chapter 11. MS & TS.
 2] Poem/song entitled *A Pianist: A Piano Solo.*

Loose Pages: 1] *1982 Janine* contents page.
 2] *Old Negatives*, blurb. [XR 8799.9]
 3] *The Grumbler*, MS [XR 8799.5]
 4] Letter to Tina Reid, draft MS, undated.
 5] Letter to Stephanie, draft MS, Jan 1981.
 6] Letter to Stephanie, draft MS 18.7.1981.
 7] Letter from Jane Hill (Jonathan Cape) undated.
 8] *The Fall of Kelvin Walker*, MS Chapter 9+ [XR 8799.8]
 9] *A Short And Curious History* MS of preface. [XR 8799.2]
 10] *Lean Tales*, MS of *Translation, Authority & Humanity* [XR 8799.5]
 11] *Doing It Very Well*, MS of song.

Accession 8799
Box 4

Unlikely Stories, Mostly.

> *The Start Of The Axletree*
> *The End Of The Axletree*
> *Prometheus*
> *Five Letters From An Eastern Empire*

Folder: 1] Origins of *The Start Of The Axletree*, MS of the start of a story called *The Tower*, 1960. [XR 9417.1. NB 34 & 59]

2] List of contents for a proposed anthology of short stories, circa 1977

3] *The Start Of The Axletree*, early MS versions, 1977–8.

4] *The Start Of The Axletree*, TS drafts, 1978, entitled *An Outline Of The Origins Of The Axletree, The Emperor's Dream* and *The Axletree*; the last version published in *Collins Scottish Short Stories 1979*. Review of this volume by Chris Small from *The Glasgow Herald.*

5] *The End Of The Axletree*, TS drafts. 1979–81.

6] *Prometheus* [XR 9417.1 NB 1,60]

7] *Five Letters From An Eastern Empire*. MS & TS drafts from the author's time as writer-in-residence at Glasgow University, 1977–9.

Accession 8799
Box 5

Lean Tales

Folder: *Portrait Of A Playwright*, here entitled *The Vital Witness*. Photocopy of a MS of a documentary radio play, broadcast by BBC Scotland in 1979, which became the basis of an article of that name in *Chapman* magazine.

Folder: *The Vital Witness* MS.

Folder: *Portrait Of A Playwright*. Coverless copy of a feminist edition of *Chapman* magazine containing *The Vital Witness*, to which some MS additions by the author have been added to make this an essay for *Lean Tales*.

Folder: *Portrait Of A Playwright*. TS with MS corrections, and final TS as sent to Jonathan Cape.

Folder: *A Small Thistle* [not in Cape hardback edition of *Lean Tales*]. Various versions, starting with the extract from the *Glasgow West End News*, late May 1973, as reprinted in the catalogue of the author's retrospective exhibition at the Collins Gallery, Strathclyde University, in 1974, with MS alterations adapting them for *A Glasgow Diary* which was published by Polygon in 1984. Plus 6 pages of MS.

Folder: *A Small Thistle*. Five TSs, some of them devised for the *Glasgow Diary*, with the last completed for the Sphere paperback edition of *Lean Tales*, 1987.

Folder: 1] *The Domino Game* and *Money*, Two stories not in the Cape hardback but added to the Sphere paperback. MS & TS drafts.

2] Five letters from Harriet Gilbert, literary editor of *The New Statesman*, about these stories (17 JUN–24 Oct) with MS draft of author's reply to a lost letter from Ms Gilbert.

Folder: TS versions with MS corrections and retypings of *Decision, Authority, Translation, Humanity, Ending, Postscript* and *Autobiography* (this last subsequently removed from *Lean Tales* and used to introduce the fourth sequence of the poems in *Old Negatives*).

Folder: Final TS versions of all Alasdair Gray's stories in this apart from *A Report To The Trustees*.

Folder: *A Report To The Trustees*, MS version, transcribed from the original MS report written April 1959, and intended for *Unlikely Stories, Mostly* but subsequently relegated to *Lean Tales*. [XR 8799.5; 9417.1 NB 28,3037; 9417.2 NB 29; 9417.3 1955–6 folder]

Folder: *A Report To The Trustees*, TS draft.

Folder: *The Story Of A Recluse*, MS sheets. [XR 9247.4 folder 32, 9417.1, 9417.5, TD 2227.3]

Folder: 1] *The Story of A Recluse*, final TS as sent to Cape.

2] Volume XVI of the Tusitala edition of Robert Louis Stevenson's works (*Weir of Hermiston, some unfinished stories*) with MS additions to *The Story Of a Recluse*.

Folder: 1] *The Answer*. Faded photocopy with MS first page and MS clarifications.

2] Exercise book containing the original version of this story completed in Milan where the author went with Mrs Fletcher to arrange for her son Alan's gravestone. Inscribed Milan, Pensione Breva, Wednesday 17.8.60 [XR 9417.2 NB37]

3] BBC script of *The Answer* recorded 6.10.1970.

Folder: *The Grumbler*. Written 1983 circa *The Pie Of Damocles* rehearsals. [Revue written with Liz Lochhead, Tom Leonard, Jim Kelman]

Folder: *Portrait of a Painter* material. TS of an article intended for the *Glasgow Herald* in 1973 but never published, called *A New Way For Scottish Art*, later used as the basis for the introduction to the *Lean Tales* piece.

Folder: *Portrait Of A Painter*. MS version of the *Alasdair Taylor* article published in the *Scottish International* magazine, Oct/Nov 1973, only the last half of which was used – the half which described the painter (the first half described his context: the state of painting in 20th century Scotland). Plus MS of another version of roughly the same year, on lined foolscap sheets with gum-paper overlay corrections.

Folder: *Scottish International* magazine as described above, with article *Alasdair Taylor*.

Folder: *Portrait Of A Painter*. Three TS versions of this with extensive deletions and additions in MS, Marked chronologically A B C. Final TS version as sent to Cape, marked D.

Accession 8799
Box 6

The Fall of Kelvin Walker: Novel version and *A Book At Bedtime*.

Folder: Corrected page proofs of King Penguin novel returned to Ann Donleavy on 8 Jan 1986. With drafts of a pressurising letter, and copies of some others, which eloquently reveal our author's obsession with his text and changes to it: however trifling.

Folder: Paste-up of abridgement for BBC Radio 4, *A Book At Bedtime*. Plus BBC TS recorded by Bill Paterson 19.6.1986.

Folder: Penguin edition, final revised page corrections for Feb 1986.

Folder: Photocopies of newspaper reviews of the novel.

Accession 8799
Box 7

Unlikely Stories, Mostly: Early versions including some published in small magazines. Plus MS of *Logopandocy*.

Folder: 1] *Logopandocy*. MS version. [XR 9417.1 NB 47]
 2] Lining papers. MS.
 3] Draft of table of contents.
 4] *A Report To The Trustees*, MS and TS drafts. Not used in *Unlikely Stories, Mostly* but appeared in *Lean Tales*. [XR 8799.6]
 5] *Education*, a short story not published in book form, but appeared in *Glasgow Magazine*, Winter 1982/1983, No. 1, pp.7–9. [Xr 9417.5]

Folder: *The Spread Of Ian Nicol*. TS. [XR 9417.3 folder 1955–6]

Folder: *The Comedy Of The White Dog*, TS. [XR 9417.2 NB23A, started 1956]

Folder: *The Star*. MS version in coverless jotter and six TS sheets. [XR 9417.3 Juvenile writing: circa 1951]

Folder: *The Great Bear Cult*, MS draft. Started between Sep 1971 and Sep 1972, [XR 9417.1 NB 53]

Folder: *The Problem*. MS of this story on two sheets, one of them a yellow paged typed letter from a CND organisation. Plus a sketch for the illustration.

Folder: *An Explanation Of Recent Geographical Changes*, early TS versions of the story included in *US* as *The Cause Of Some Recent Changes*. [XR 9417.2 NB 20; 9417.3 Folder 1956–1957]

Folder: *An Explanation Of Recent Geographical Changes*, *An Answer* and *The Spread Of Ian Nicol*. TS versions with MS additions, bound with sellotape and gum paper into one book.

Loose: 1] *The Crank That Made The Revolution*, TS. Dad typed this.
 2] *GUM* [Glasgow University Magazine], volume 81, *The Comedy Of*

The White Dog, pp.3–9. [undated]
 3] *GUM*, volume 81, *The Spread Of Ian Nicol*, p.4. [undated]
 4] *The Comedy Of The White Dog.* Pamphlet. Print Studio Press, Glasgow, 1979.
 5] *1982*, volume 1, No. 1. Cover by Gray & *The Origin Of The Axletree*, pp.22–5.
 6] *The Fiction Magazine* Vol. 4, No.1, 1985. Cover by Gray & *The Grumbler* pp.11–12. [XR 8799.5]
 7] *Scottish International* No.8, 1969. *The Comedy Of The White Dog.*

Accession 8799
Box 1

The Fall Of Kelvin Walker, Novel Version. [XR 8799.6; 9247.1; 9417.1 NB 26,31,32,43,45,47,53,56; 9417.2 NB 44; 9417.3 Folders 1956–1957 & Post art school – pre Inge]

Notebook: MS version of novel made from the first TV version [written 1964] as a pot boiler following the rejection of Book 1 of *Thaw* [eventually Book 1 of *Lanark*] as a novel in its own right, by Curtis Brown. In the back of the notebook is the start of *Thaw*–Part 2, which became the start of Book 2 in *Lanark*.

Folder: Stencil copy of MS written circa 1966: but not sent to a publisher.

Folder: Stencil copy of circa 1966 version (in notebook) with odd carbon copies of pages of circa 1968 revision, and various sheets of MS notes relating to the final 1984 version.

Folder: Penultimate version, made from carbon copied pages of two earlier versions, circa 1966 and 1968, thickly corrected in MS with MS links and additions and instructions to the typist: this being the basis of the Canongate hardback version, circa 1984.

Folder: Final TS as sent to Canongate, with final MS corrections, circa 1984.

Accession 8799
Box 9

Verse Sequences: Folders containing attempts at a verse autobiography.
 1] *A Prologue In Four Parts*, 1957
 2] *Thirty Poems*, early 1967
 3] *Thirty Poems*, late 1967
 4] *25 Poems*, 20.2.1969
 5] *25 Poems*, 19.7.1969
 6] *30 Negatives*, 1973
 7] *Early Negatives/Late Negatives/Unlove Poems.*
 8] *Old Negatives*, 22.2.1979
 9] *Old Negatives*, 17.8.1979
 10] *Old Negatives*, 21.9.1979
 11] *Old Negatives*, 1981

12] *Old Negatives*, 25.7.1984

[XR 9517.1 NB 9,18,26,27,28,32,33,34,37,38,42,43,45,47; 9417.2 NB 25A,44; 9417.3 Early verse 1951]

Folder: Parts of verse sequences 1953–1957, MS & TS with marginal sketched illustrations.

Folder: *A Prologue In Four Parts*, 1957. TS with MS additions, sewn together on a machine. Dating from last year at Art School: with dedicatory poem to Bob Kitts.

 1] Night Walk Through Streets
 2] Veronica
 3] In A Cold Room
 4] Under The Helmet

Folder: *Thirty Poems*, early 1967. TS starting with dedicatory poem to Alan Fletcher. Dated 1953–1967.

Folder: *Thirty Poems*, late 1967. TS edited by hand into 25 poems. The original dating is 1949–1967.

Folder: *25 Poems*, 20.2.1969. Two copies made out of an edited earlier sequence, corrected by hand and with MS of a poem added at the end: though this is not a new poem as it dates from the Autumn of 1967.

Folder: *25 Poems*, 14.7.1969. Sewn TS.

Folder: *30 Negatives*, revised up to 1973. TS x2.

Folder: Parts of a new verse sequence in MS circa 1977 called *Unlove Poems*, plus a MS revision of all earlier poems, divided into two lots: *Fifteen Old Negatives/Early Negatives* and *Seventeen Negatives/Late Negatives*, and dated 30.7.1977.

Folder: *Old Negatives*, 22.2.1979. TS & MS corrections.

Folder: *Old Negatives*, 17.8.1979. TS & MS with MS corrections.

Folder: *Old Negatives*, 21.9.1979. TS.

Folder: *Verses*, 1981. 4 sequences, TS revised in MS with additions.
 Veronica 1952–1957
 Carole and Alan 1957–1962
 Inge 1962–1971
 Janet 1977–1981
The author decided not to title the four sequences from the people referred to in them, because only Inge truly presided over all the poems in the section named after her.

Folder: *Old Negatives*, 25.7.1984. TS bound with plastic strip. With one final change made to poem 22 on 16 April 1987 after talking to Ruth Fainlight who disliked 'toys', a word I had always felt a bit guilty about, but could see no alternative to till she and I discussed it.

Accession 9247
Box 1

Plays:

> *The History Maker*
> *The Fall of Kelvin Walker*
> *Quiet People*
> *Mavis Watson* / *Triangles* / *Cholchis* / *Agnes Belfrage* / *Agnes Watson* / *Mavis Belfrage*

Folder: 1] *The History Maker*, all this material dates from a few months in 1965. [XR 9417.1 NB 21,47; 9417.2 NB 46]

1. MS material for the following.
2. TS of battle opening, as the play was originally conceived (very expensive).
3. TS of a domestic opening of the play (cheaper). Two treatments.

Folder: 2] *The Fall of Kelvin Walker*, written 1964, transmitted 21.4.1968 by Theatre 625, BBC 2. TV script. I recall about a year's delay in transmission, through the originally scheduled date being shifted to make way for unexpected news about the Concorde aircraft.

The weak ending of the play in this first form was made weaker still by having an Ulsterman called McBride play the father (the Englishman who chose the actors knew I wanted Scots actors in the Scottish parts, and having got English actors for Kelvin Walker and Hector McKellar, and not knowing any Scottish actors personally, chose someone with a 'Mc' in their name from a cast list without first hearing him).

Folder: 3] *The Fall of Kelvin Walker*, staged 16–21 May 1972. 2nd stage version, and the first (and last) to have a professional production. (The first performance was a version acted by Glasgow Art School drama group in the Mackintosh lecture theatre in ?1969.)

The Stage Company, Scotland, staged it in the McRobert centre, Stirling.

Kelvin	— James Gillan (stage name later Chris Connor)
Jill	— Isobel Nesbitt
Jake	— Ron Bain
Mrs Hendon}	?
Mary Cranmer}	?
Everybody Else	— Robert Trotter

Plus photocopy of a review of this by Chris Small in the *Glasgow Herald*. This version of the script was eventually submitted to Binkie Beaumont by the author's agent, Frances Head.

Folder: 4] *The Fall Of Kelvin Walker*, TS 1975 with amendments from 1983. Fourth and final stage version.

This has an ending which is cheerful (for Kelvin) and dramatically stronger, and was achieved through pressure from Binkie Beaumont which, exerted through my agent, got me to produce this after Beaumont had lost interest. This version has not been performed at the present date (December 1985) but is the basis of the novel published earlier this year: with the addition of the scene with the Prime Minister in the first television version and the first and second stage versions.

Folder: 5] *The Fall Of Kelvin Walker*, 1972 & 1974. Two revised endings of the play, each a copy of an obsolete typescript with alterations in handwriting.

Folder: 6] *Quiet People*, recorded 17.9.1968, broadcast 25.11 1968 on BBC Radio 4 Scotland. TS of radio play.

Folder: 7] *Completed March* 1969
1. Two pages of a carbon copy of a character study of *Lindsay* on whom *Mavis Watson* was based (eventually *Agnes Belfrage*). With MS comments about the original person.
2. Two large exercise books with spiral bindings containing the manuscript of *Mavis Watson*: TV play. The first version of a play originally conceived in discussion with Shaun McLaughlan of BBC television sometime in 1968, but rejected by his superior who disliked it, and eventually taken up by Granada TV through my agent, Frances Head, in 1972 and broadcast under the title *Triangles* given by the director (my own preferred title by this time was *Cholchis* or *Agnes Belfrage* which I will keep for it).
3. *Mavis Belfrage*. TS.

Loose in Box: Typescript inventory of Accession 9247 [contains several errors].

Accession 9247
Box 2

Plays:
 Agnes Belfrage
 Mr Goodchild, Phillipo Lippi And Lucrezia, treatments.
 Dialogue
 Honesty
 Thomas Muir Of Huntershill
 The Night Off
 Martin
 The Golden Key
 5 Interviews For Sound Radio
 The Loss Of The Golden Silence

Folder: 8] *Agnes Belfrage*
1. *Cholchis*. A stage version of *Agnes Belfrage* submitted to a competition (hence the pseudonym, Talisker) but with 5 missing pages. This differs from the final version by opening with Eric speaking to a whole class, as at the start of the original TV version.
2. A copy of the above script adapted to sound radio production through handwritten additions, but with the first 18 pages missing (never used).
3. *Agnes Belfrage*, the final stage version. Bound by the Scottish Society Of Playwrights for 2 readings in Newbattle Abbey and Traverse Theatre at a conference circa 1975–6.
4. 2 payslips notifying of repeat performances of the TV version (*Cholchis*) – 3.12.1973 and (*Triangles*) – 11.2.1976.

Folder: 9] *Mr Goodchild*
 Fillipo Lippi And Lucrezia ? 1980 [XR 9417.1 NB60]

Folder: 10] *Dialogue*, a half hour play
1. BBC radio script recorded 16.7.1969.
2. A stage and/or TV version made by cutting the typed dialogue out of a copy of the sound radio version and pasting them into a bound notebook with handwritten stage directions between. 3.8.1969.
3. A typecopy of the stage version performed by the Scottish Stage Company (in a double bill with CP Taylor's *Block's Play*) August 1971.
4. Carbon copy, with first page missing, of the play's TV version submitted by my agent to London BBC television and broadcast November 1972. This has some changes of place names and a few other words since the TV people wanted (as in the case of *Agnes Belfrage*) an English play.

Folder: 11] *Honesty*, TV for Scottish BBC Schools. [XR 9417.1 NB 19]
1. First synopsis (or treatment) sent 1.6.1970. TS.
2. Second synopsis sent 10.6.1970. TS.
3. First MS version posted 23.6.1970.
4. Final version: spiral bound notebook with paste-up of typescript made from first version, cut and interspersed with MS additions and modifications, posted 18.8.1970.

Folder: 12] *Thomas Muir Of Huntershill*.
1969–1970. Treatment for the play (dramatised documentary) submitted to William (or Alexander) Gray of Scottish documentary radio. And carbon copy of play as acted, with last page and page 27 lost. [? called *The Trial Of Thomas Muir*]

Folder: 13] *The Night Off*. Completed 10.1.1966.
[XR 9417.1 NB 37]
1. Treatment for a TV play, 6 pages.
2. The TV play itself. Carbon copy dated with day of completion: 10.1.1966. This was not performed.
3. Radio version, photocopy of BBC script produced by Stewart Conn and transmitted 15.5.1971.

Folder: 14] *Martin*
[XR 9417.2 NB 48]
1. TV play written circa October 1971, recorded 6.1.1972. The last of a Scottish BBC Schools television series called *The Group*.
2. Letter concerning the character from the producer, 17.8.1971.
3. Payment statement of repeat fee, 14.11.1975.

Folder: 15] *The Golden Key*
Half hour sound radio play: to be set to music by Wilma Purser. This project was wished onto Stewart Conn, Scottish Radio Drama producer, by his neighbour Wilma, at one of her parties: the book of the play having been a Christmas present to her from Alasdair (who had loved it as a child) but though Stewart commissioned it [26.1.1976], on receiving it in 1976 neither he nor his superior in London liked it, alas.
1. MS copy.
2. TS copy, bound.
3. Letters from BBC: 17.5.1976; 7.7.1976; 7.8.1976.

4. Agent's receipt for first half of commission fee.
5. Letter from BBC with sketches, 27.8.1976.

Folder: 16] *5 Interviews For Sound Radio*. Undated.
[A small programme. Spiral bound notebook with paste-up of TS with MS additions. Contains exerpts from *The Fall Of Kelvin Walker*, *Agnes Belfrage*, and *The Night Off* and an unidentified dialogue: linked by a first person commentary].

Folder: 17] *The Loss Of The Golden Silence*. Completed early 1973.
[XR 9417.2 NB 48]
1. TS of stage version.
2. Two contracts and a letter referring to first stage performance: 26.5, 22.6, 9.7 of 1973.
3. BBC radio script of sound version recorded 28.12.1973, transmitted 24.4.1974.
Letter from Stewart Conn about item 3.
5. Note from Frances Head, my agent, dated 29.11.1973 telling me she has signed a Granada TV contract for the play (and asking how *Lanark* goes). I don't think this play was ever televised, however.

Accession 9247
Box 3

Plays:

 In The Boiler Room
 James Watt (fragment) [this folder is in 9417.4]
 The Homecoming/Homeward Bound
 The Strathaven Revolution (fragment)
 The Man Who Knew About Electricity
 Sam Lang And Miss Watson
 McGrotty And Ludmilla — radio version
 [also called *Daniel And Ludmilla*]
 McGrotty And Ludmilla — stage version
 Beloved/Henry Prince

Folder 18] *In The Boiler Room* TV play, circa 1974. TS.
[XR 9417.1 NB28]
1. Commissioned by Naomi Capon for BBC arts programme *Full House*, but never used, she having left the programme through illness and not being reappointed.
2. A slightly altered version done in 1985 for Eddie McConnell (who had it typed) to make a film of, if he could . . .
3. Letter from STV, undated.

Folder 19] *James Watt*. Circa 1973 [in 9417.4]

Folder 20] *Homeward Bound/The Homecoming*
Half hour play written 1972 [XR 9417.2 NB 48]
1. MS in notebook
2. TS of TV play

3. As for 2, but with MS corrections to make it a guide for a one act stage version.

4. Stage version

5. Letter from Stewart Conn, 13.12.75. [TV version is found unsuitable for radio adaptation]

6. Contract with Pool Lunchtime Theatre, Edinburgh, for the stage version 30.4.1973.

Folder 21] *The Strathaven Revolution*, TV play.

[XR 9417.1 NB 52; 9417.2 NB 48]

This was originally commissioned by Andrew Forester of Glasgow Schools TV in 1971 or 1972 but not used. Then submitted (5.9.1973) to Pharic McLaren of BBC. Treatment and first scene only.

1. Two MS pages and Glasgow Schools TV script.

2. TS of 1.

3. Two letters from the BBC.

Folder 22] *The Man Who Knew About Electricity*.

MS for 20 minute BBC TV play with note of final payment for it 29.1.1973.

Folder 23] *Sam Lang And Miss Watson*. 1973.

1. TV version. (Note: this play was never used on TV.)

2. Radio version.

3. Stage version.

4. Letter from BBC Scottish drama, 8.6.1973.

5. Letter from agent informing of final payment from BBC, 12.8.1987.

Folder 24] *McGrotty And Ludmilla, or The Harbinger Report*: a political pantomime, 1975. Also called *Daniel And Ludmilla*.

[XR 9417.1 NB 54,55,61; 9417.2 NB 57]

1. MS draft of radio version.

2. MS sent to BBC radio.

3. BBC TS with cast list. Recorded 25 & 26 June 1975, broadcast in July.

4. Note from agent for payments for commissioned work 10.3.1975.

Folder 25] *McGrotty And Ludmilla*, stage version performed 4th–27th March 1986.

1. A copy of the sound radio script with MS modifications making a stage version, in cardboard wallet.

2. A typed version of 1. with further MS corrections for a retyping for the Tron Theatre stage version.

3. Photocopy of a letter from author to producer.

4. Tron Theatre programme of productions.

Folder 26] *Beloved/Henry Prince*.

Written as *Beloved* in 1975, broadcast as *Henry Prince* in 1986.

[XR 9417.2 NB 57] For Granada TV *Victorian Scandals* series. Broadcast late in 1986 under the name *Henry Prince*, the author being given as Martin Green, since I had removed my named from the script.

1. MS rough notes

2. TS with MS additions.

3. Payment advice slip from agent, 10.3.1974.

4. Payment advice slip from agent Frances Head's estate, 23.7.1976, because she, alas, had died.

5. Certificate from Register House, 2 copies.

6. Correspondence from author to Michael Cox, Granada TV, concerning revisions. Photocopied MS.

Accession 9247
Box 4

Plays:

> *The Wisest Man*
> *The Gadfly*
> *The Rumpus Room*
> *Today And Yesterday*
> *Near The Driver*
> *The Story Of A Recluse*

Folder 27] *The Wisest Man*
TV play 1976. MS of play that became 'The Gadfly'. [see below}

Folder 28] *The Gadfly*
TV play 1977, stage play 1986.

1. TS of first 27 pages.

2. Bound TS of entire play as written for Granada and broadcast in a series called *For God's Sake*, but greatly shortened from this for transmission.

3. Photocopy of pages 1–18 and 23–57 of the above, with MS additions and compressions to make a two act stage play of it.

4. TS of stage play.

5. Photocopied articles from *The Listener* by M.I. Finley, about Plato. [used in composition}

6. Payment statement.

Folder 29] *The Rumpus Room, or A Solution To The Problem*
The libretto of a modern opera. Conceived in discussion with Robert Lacey, when Robert headed the music department and I the art department in the Glasgow Arts Centres, Washington Street: and written between November 1976 and 31 March 1977.
[XR 9417.1 NB 53}

1. MS version.

2. TS version.

3. Final TS of libretto.

4. Two pages of MS descriptive of the libretto's origin and dated 31.3.1977.

Folder 30] *Today And Yesterday*
Three TV plays, recorded 1972. A series of plays about life in 19th century Scotland, contrasted with the present, commissioned by Malcolm Hossick of Scottish BBC Educational Television, who had left the BBC and Scotland before the transmission date.

1. This folder contains a copy of the scripts of programmes 1 and 2: 3 is missing. Programme 2 has the recording date 23.10 marked on it.
2. Payment statement for repeat fee.

Folder 31] *Near The Driver* [written 1976]
Radio play, broadcast in a German translation 1983. [XR 9417.1 NB 59]
First conceived on a train returning from London recording of *McGrotty and Ludmilla*. A half hour radio play (not broadcast in Britain yet) originally submitted to, and rejected by, Stewart Conn of BBC Scotland after showing it to his chiefs in London. Submitted to Shaun MacLaughlan in Bristol BBC who wanted to produce it, but eventually had it rejected by his chiefs in BBC London. Played on West Deutsche Rundfunk in a translation by Berndt Rollkotter in early 1983. Submitted to James Runcie in April 1984: accepted by him, subject to his London superiors' approval, which they did not give.
1. MS drafts.
2. Complete MS.
3. Complete TS with MS corrections (photocopy).
4. Four letters from the BBC.
5. Contract for German translation.

Folder 32] *The Story Of A Recluse*, TV version.
[XR 8799.5; 9417.1 NB 54,55; 9417.5; TD 2227.3]
Completed 18.11.1985. TS bound with card. First version, and version most favoured by the author.

[Folder numbering is continued in TD 2227.3]

Accession 9247
Box 5

Miscellaneous Pieces

Folder: *Four Published Reviews*
1. Review of Single/Recent paintings by Martin Baillie from the *Glasgow Herald* ? 1973. MS on a single bright yellow page, a big one.
2. Review of *Intimate Voices* by Tom Leonard. MS draft of article published in the *Glasgow Herald* probably 1984.
3. Review of Chicago American Paintings show and James Cowie paintings. Published in the *Sunday Standard* circa 1981–1983. TS.
4. Review of Hugh Casson's diary for 1980. Published in the *Sunday Standard* circa 1981–1983. TS.

Bound TS: *Old Negatives*, Verse sequences [XR 8799.9]

Folder: *5 Scottish Artists Retrospective Show*
December 1986. Five colour catalogues and an introduction by Alasdair Gray. For an exhibition featuring work by Carole Gibbons, John Connolly, Alan Fletcher, Alasdair Gray and Alasdair Taylor.

Folder:
1. Treatment for a documentary on art in New Towns, commissioned and

researched by, and for, the London BBC TV arts magazine *Full House*, but not used. August-November 1973 (Naomi Capon was the producer who mainly employed me).

2. Payment statements from author's agent 6.8.1973 & 12.11.1973.

3. *A New Way For Scottish Art*, TS. Part of another abortive attempt to make money out of the sociology of contemporary art, using parts of previous abortions.

Folder: *Glasgow Arts Centres*
Unpublished article in TS. October 1977. [XR 9417.1 NB 58; 9417.3 Folder 1976–1977]

Folder:

1. *Bypassing A Predicament*, article for *Chapman* magazine, written February 1983. MS with typed portions [published as *A Modest Proposal For Byepassing A Predicament*, issue 35/36].

2. TS of questions from Glenda Norquay and Carol Anderson (January 1983) with MS replies. Used to write *An Interview with Alasdair Gray*, *Cencrastus* magazine, summer 1983, 6–10.

3. TS with MS annotations of replies to questions put by Christopher Swan and Frank Delaney, August 1982, used in preparation of TV programme about Gray's work.

Folder:

1. Review of *Man Descending* by Guy Vanderhaeghe, MS drafts.

2. Cutting of this from the *New York Times Review Of Books* 3.10.1985.

3. Letter to author which accompanied proofs of the review.

4. Publicity material about the reviewed book and its author.

5. Documents indicating when review was telefaxed, and how much it cost.

Folder: Reminiscences of John Glashan: letter to an enquirer in MS and TS, with letter of enquiry. 27.1.1986.

Folder: *A Resident Reports*. Written February or March 1978, 4 pages of MS of an article for a student magazine, reporting on my first 6 months as writer-in-residence at Glasgow University.

Folder:

1. Questionnaire from Swan and Delaney, as above.

2. Questionnaire from Norquay and Anderson, as above.

3. Questionnaire from Ronald Binns for his book 'Writers Write', March 1986.

4. Transcript of interview by Kathy Acker at the ICA Gallery, London. TS with MS amendations 'to make it pithier and more logical'. ? 1986. Published in *Edinburgh Review*, 1986, August, Number 74, pp.82–90.

5. Literary curriculum vitae.

Folder: *Afterword* to Agnes Owens's *Gentlemen Of The West*. Penguin edition, 1986.

1. MS notes for first draft.

2. 9 pages of first MS version.

3. First TS with MS corrections.
4. *Edinburgh Review*, Number 69, pp. 131–2. Unsigned review of *Gentlemen Of The West*, reprinted from the *Scotsman* magazine, Christmas 1984: with MS annotations.
5. Final TS sent to Penguin, 11.11.1985.
6. Correspondence from Penguin.
7. Final proof corrections.

Folder: *The Mean City*, 1962. TS of an unpublished article dealing with Glasgow pictorial art. This material, or much of it, went into *Portrait Of A Painter* in *Lean Tales*.

Folder: *An Apology For My Recent Death*. Article written 18.1.1965. Refers to the BBC documentary *Under The Helmet*. Not printed, the *Glasgow Herald* editor thought the BBC might sue him for libel if he printed it. MS and TS pages. [XR 9417.1 NB 42 & 43]

Folder: *Instead Of An Apology*. Article printed in the *Glasgow Herald* 18.4.1969. MS fragments and a complete TS. This refers to the TV play which was eventually broadcast under the name *Triangles* by Granada in 1972: but it was commissioned by Shaun McLaughlan for the BBC first, paid for and not used. [XR 9247.1]

Folder: *Scotty Wilson*. Review of *It's All Writ Out For You* by George Melly. Published in the *TLS*, 14.3.1986.
1. MS of article.
2. Printed article in *TLS*.
3. Publicity material for Scotty Wilson exhibition.
4. Letter from *TLS* with exhibition publicity material, 12.2.1986.
5. Photocopies of photographs of Glasgow buildings. [unidentified]

Accession 9247
Box 6

Lanark: early published forms in magazines etc.
Lean Tales: proofs [XR 8799.5]

Folder: *Lanark*
1. *The War Begins*. Which is the first Chapter of Book one of the first novel, written 1954 and submitted as a short story to the *Observer* Short Story Competition in 1959 under the pseudonym Robert Walker. It was mentioned as one of the runners up. This is a carbon copy of, I think, an original typed by Dad. [XR 9417.1 NB 6]
2. *The Complaint*. Circa 196?. A self contained little story which at length became the first part of *Prologue* chapter. TS.
3. *Autobiography*. 1966–1968 period. A revision of *The Complaint*. MS.
4. *Autobiography*. TS.
5. *Autobiography*. BBC performance script recorded 6.10.1970.
6. *The Oracles Prologue* In *Oasis* magazine, 1969 or 1970, Volume 1, Number 2, pp. 9–14.

7. *Nature*, TS. Written before 1963 but regarded as part of *Lanark*.
8. Two stray MS pages from the last two chapters of *Lanark*.
9. *Climax*, in *Words* magazine. 1976, autumn, pp.3–6. Illustrations by Malcolm Hood (the original for Kenneth McAlpin in *Lanark*).
10. *Alexander Comes*, in *Words* magazine, Number 6, 1979–1980, pp.5–9.
11. Reviews of *Lanark*, 1981–1985.

Loose: *Alasdair Taylor*, article in *Scottish International* magazine. October/November 1973, Numbers 8 & 9 pp.18–21.

Folder: *Lean Tales*
Published May 1985 by Jonathan Cape.
1. Uncorrected bound proof copy.
2. Unbound page proofs, with the final corrections in MS to Gray's section.

Folder: *Lean Tales*
Published 1987 as Sphere paperback version. Page proofs with cover, MS corrections. Contains three pieces extra to the Cape edition: *The Domino Game; Money; A Small Thistle.*

Accession 9417
Box 1

Notebooks in approximately chronological order (sixty-three including Box 2) 1 August 1950 – sometime in 1983.

NB 1 : 1.8.1950–6.9.1950
 At Whitehill School, age 15, Notes for illustrations to Book 3 of *Gulliver's Travels*: Laputa: my favourite. Record of hysterical narcissisms garnished with doodles, feeble verses, reference to Audrey Hughes under the pseudonym Oothoon, reference to masturbation using the verb 'joyed', ending in a God–Adam creation anecdote: the earliest form of Pollards introduction to the *Prometheus* story.

NB 2 : Autumn 1951
 At Whitehill School, age 16. Start of Mum's illness. References to the *Personal View Of History* lecture. The start of a novel with an asthmatic glum hero, whose heroism and asthma derive from his being an extraterrestrial agent sent down by a higher authority to save the world. His name is Boreas Brown.

NB 3 : 1952
 Whitehill School. Reference to Two Hills picture.

NB 4 : March 1952.
 Last year at Whitehill School. Mother sick but home from hospital. Reference to ambitions to write books about ordinary life which were also strange, perhaps escapist.

NB 5 : September – October 1952
 Staying in Coolgreena HF guest house, Rathmullen, Donegal on holiday with Dad. List of past pictures. Notes on sexual frustration.

NB 6 : 1952
 After Mum's death and before starting Art School. Diary starts
on the walls of Londonderry — a trip with my father. Some material here for
The War Begins chapter of *Lanark* under the name *Private History Of The Second
World War*. Also notes used in *Mrs Thaw Disappears* chapter, and last chapter
of Book 2, and list of chapters indicating that the Art School is now part of
the hero's trajectory before clerking, conveyor belt work, insanity and death (a
gap is left after/during the Art School chapter, I assume this can only refer to
the after death fantasy sequence). Description of an interview in Lairds box
making factory, already put into the third person for the *Gowan Cumbernauld*
narrative. Verse efforts.

NB 7 : October 1952.
 The early weeks of Art School. Doodles for the mechanical
apocalyptic picture (never finished) and the *Dead Trees In Back Court* picture.

NB 8 : October 1952
 Art School, first year. Autumn. *Beast In Pit* picture finished
22nd November. Mrs Swain's portrait. Doodles for mechanical monsters
destroying a city.

NB 9 : Late 1952–mid 1953
 End of first Art School term, start of second. Fragments of
Gowan Cumbernauld novel [precursor to *Lanark*]. Sketch of detail of Cowcaddens
landscape, tree and canal details, *Beast In Pit*. Verse fragments. Broodings on
sexual frustration, masturbation guilt, relation to family life. The Art School
outing to Culrose missed and hitch hike up with: coronation decoration.

NB 10 : Christmas 1952
 At Art School. Christmas Ball and the first pleasures of
drunkenness. Moulin Rouge theme: photo of myself as a waiter. Brief notes for
a Kafka-esque novel to be called *John Ingram*; involving a brother and sister and
the occupation of a city by an alien power, and the recognition that I am
inclined to mix up this story with the story of Thaw, which is more immediately
autobiographical. Most of this notebook is scribbled sketches for a monthly
composition set by the Art School, *View From A Window*. It has a view of the
back green from 11 Findhorn Street near window, one I last did, *Dead Trees In
Back Court*. Art School architecture lecture notes.

NB 11 : 27 December 1952 – 1 February 1953.
 At Art School. References to starting the portrait of Mrs Swan.

NB 12 : Circa February 1953.
 Art School. Refers to making *Tam O'Shanter* picture.

NB 13 : 1953.
 Art School. References to Cazdow Park on the Hamilton estate:
where taken by Dad and revisited myself (lost domain feeling). I was fascinated
by its ancient trees, gorge etc. Plus poem on it: and notes for *Gowan
Cumbernauld* novel with Hector Thaw a character in it: and notes for insanity
episode in the Thaw section. Gowan enjoys a hallucination of descending to

earth in a balloon when he is actually drowning in Blackhill Locks — part of the canal.

NB 14 : Easter — May 1953.
 Fragment of novel *Gowan Cumbernauld.* Reference to crucifixion painting which eventually gave the central figure for the Scottish–USSR war murals. From the opposite end of the notebook: a sequence of 5 poems dated 1952, illustrated title pages to each, and the general title *Poems Of Adolescence.*

NB 15 : Circa February 1953.
 Art School. Descriptions of the Monkland canal. Diary becomes a first person narrative of an interview between Gowan Cumbernauld and an idealised psychiatrist. Reference to painting of Tam O'Shanter.

NB 16 : September — October 1953. This contains sketches for the title page of a novel called *Thaw*, diaries referring to the painting of a portrait of George Swan's father (oil on plywood, drawing done first with indian ink and pencil). Also dialogue with a highland minister about God. Art school refectory encounters and some other matter tributary to chapters 18 and 21 of *Lanark*, but attributed to a Gowan Thaw. Also sketches for a painting of three people setting a table: a set subject, which I eventually did using Dad, self and Mora. Also sketch for (unpainted) perspective picture: a Piranesi prison inhabited by huge beetles (Kafka influence).

NB 17 : [In Box 2]

NB 18 : August — September 1954.
 Done on a fortnights Art School outing to Rome, Florence and Venice. Heads for *Marriage Feast Of Cana* painting. List of titles for adolescent poem sequence. [Fragments of this notebook are in 9417.3 Folder 1953–1954]

NB 19 : [In Box 2]

NB 20 : [In Box 2]

NB 21 : 1955, but with notes on *The History Maker* from 1965.
 Odd job notebook containing 1955 measurements of the Scottish–USSR friendship society downstairs room for the mural after Art School holiday when I had been in Stobhill hospital after breaking with Veronica. What seem contemporary experiences of dreams etc. had just after split with Veronica translated at *once* into 3rd person past tense for use in a book (these were employed eventually in the *Lanark* chapter called *Breaking*). Minute notes for the Scottish Society of Playwrights, circa 1974.

NB 22 : [In Box 2]

NB 23 : 21 August 1955—
 Art School. Post-Veronica. 3rd year. From last few days in Stobhill hospital.

NB 23A: [In Box 2]

NB 24 : [In Box 2]

NB 25A: [In Box 2]

NB 25B: [In Box 2]

NB 26 : November 1956 – March 1957.
 Diary notes of last Art School days: conflict between teacher and
deputy director (Pritchard-Barnes and Peel) used in *Breaking* chapter of *Lanark*:
also some other notes used in this chapter and the preceding. The origin of two
or three lines of dialogue used in *The Fall Of Kelvin Walker*. Reference to poems
including *Inside The Box Of Bone* almost complete.

NB 27 : May – June 1957.
 Mural at Scottish–USSR friendship society and poem *Inside The
Box Of Bone*.

NB 28 : July – December 1957.
 Still working on war mural though I had left Art School and the
mural had been officially opened. Fragments of Book 2 of *Lanark*, and plan
showing that the plot as it stands has been discovered, including the hospital,
painting of mural, despair caused by frustration, insanity, crime, departure,
drowning (but nearly all this, minus mural, was fixed in 1956). Sketch of boiler
room which gives setting of the later play *In The Boiler Room* (Alan's Dad's
boiler room). References at the start to my Jonah puppet play sent in a radio
version to the BBC. Plus sequence of poems called *Prologue*. Diary ends in
Gibraltar in hospital.

NB 29 : [In Box 2]

NB 30 : 2 December 1957 – early 1958.
 George V Hospital, Gibraltar. Moves to Toc H Hostel. Most of
it fragments of Book 2 of *Lanark*, some used and some rejected later?

NB 31 : 11 March – End of June 1958.
 Rear end: list of completed *Thaw* chapters, with cast list of real
women friends and their fictional titles. Front end: reminiscences of Alan
Fletcher. Notes for the *Lanark* chapter *The Tree* and *Marjory* and the start of
the Greenhead mural and *Faust In Her Study*, and a list of London dialogue used
eventually as the opening lines of *The Fall Of Kelvin Walker* play.

NB 32 : Circa 28 July 1958 – after a gap 5 March 1959.
 Fragments of theological stuff, small part of which got into *The
Work* chapter of *Lanark*. Fragments of a play called *Gibb* a scene of which
became the part of *The Fall Of Kelvin Walker* in which Kelvin pinches Jill from
Jake. Submit design for creation mural. 1st August, Alan Fletcher died. Poem
to him.

NB 33 : September – December 1958
 Teaching in St Patrick's at Whifflet and St Mary's at New
Stevenson. Draft of letter, perhaps not written, to Margaret Gray in Tokyo,
who had typed the chapters of *Lanark* (at that time called *Thaw*) I had written
while at Gibraltar, she in Glasgow. I refer to Tom Graham, the original of
Sludden, and to ten completed chapters – these were exclusively about Thaw:

parts of the Art School experience and some of the Whitehill School ones. References to holiday with Hilary (jilted by Bob) in Arran. Notes for the hero's arrival in the city of the dead: the railway carriage one. Reference to stopping painting the USSR mural, starting the Greenhead Church one. Sketches for creation mural and poems notes.

NB 34 : 8 April – 1 September 1959.
After Gibraltar teaching in Whifflet. Note on *Thaw*, showing it to be conceived (at this stage) as one book, with his life after death a fully planned sequel. Note on novel to be called *Lanark*: the sequel. Date of Alan Fletcher's memorial exhibition, 11 June. Notes on writing *A Report To The Trustees*. Working on the creation mural. Also note on start of *The Great Tower* story (later *The Start Of The Axletree*), and *Old Negatives* poem ending 'And nothing to do. And nothing to do', caused by failure with Hilary Leeming.

NB 35 : March 1959.
When I was working on the Greenhead Church mural. Easter holiday from teaching in the catholic school in Whifflet, writing the report on the Bellahouston Travelling Scholarship, and preparing to entertain Hilary Leeming. Impotence with a girlfriend decides me to have Thaw die without sexual fulfilment (if I cannae have it, *he* wont).

NB 36 : 1959–1960.
At Jordanhill teacher training college. Lecture notes and doodles.

NB 37 : 26 January – 13 December 1960.
At Jordanhill and Wellshot Road School. Descriptions of experiences used to make *The Answer* story, sometimes described in the words of the story itself, which was written in Pensione Brera, Milan, when there with Mrs Fletcher to arrange about Alan's grave. Working on the mural in church still, allowed extension by the minister. Suggestion for a story, never written, at last became part of *The Night Out* [?*The Night Off*]. *Most Hearts Grow By Love* poem. Third encounter with June Haig [from *Lanark*].
Exhibitions: Malcolm Hood and I in RSA Gallery, Blytheswood Street. May.
Artists Against The Bomb.
KOK Show, in Paisley.
Man exhibition organised in conjunction with Rev. Colin Day.

NB 38 : 1 August 1961 – 5 January 1962.
Starting with the return from Neriagh with Andrew Sykes. References to the church mural; to *Prologue*, the poem sequence intended to introduce my Grrreat Novel; to the typing of it by Pat Shardlow, friend of Brian Smith, paid for by painting the safe door in her office in West Regent Street; to Brian asking me to perform in his Edinburgh festival nightclub. References to an exhibition *Man* for which I painted *The Triumph Of Death* – organised by CND, hence Brian Smith and Keith Bovey connection. Not much about the *Festival Late* nightclub, because too busy, but this was what the *1982 Janine* nightclub was based upon, and where I met Inge, married her a few weeks later, gave up living with her and my father in the home where I was born because she disliked doing so and – when she returned for a holiday to her

parents in Denmark – shifted to 158 Hill Street, Glasgow. Tried to be a muralist, then went back to schoolteaching.

NB 39 : *Circa* June 1962.
 In 158 Hill Street, teaching school. Fragments and plans for what became Book 1 of *Lanark*. List of chapters for the *Thaw* novel which indicates it will be in four parts. 21 June rewrote the chapter called *Underworlds*.

NB 40 : 2 October 1962 – 30 July 1963.
 Transition from teaching to scene painting *Dick Whittington* pantomime at the Pavilion. Fragment of *Nature* chapter, end of Book 1, start of Book 2 of *Lanark*. Ends 5 weeks before Andrew was born.

NB 41 : September 1963.
 Address book with plan contents of what is now chapter 21 *The Tree* in *Lanark*, here called chapter 13. Meditation in the lavatory of the Citizens' Theatre the day before leaving my job as a scene painter there (a week or a fortnight after Andrew was born).

NB 42 : 10 February 1964–
 Refers to painting of Eden for Neville Davidson. Has sketches for Cowcaddens landscape – gas lamp with bracket. Parts of the first chapter of *Lanark* book 2. Notes on Bob Kitts from *Under The Helmet*. Fragments of poem to Andrew, *He Holds The Spoon*. References to the *Underworlds* chapter of *Thaw*. Start of a pornographic thriller. List of pictures for an exhibition.

NB 43 : 15 November 1964–
 References to the making of TV documentary *Under The Helmet*. The start of the play *The Fall Of Kelvin Walker* and main scenes. Poems: *The Tide Ebbed Before Flowing Strongly . . .* and *He Had Wounded Himself . . .*

NB 44 : [In Box 2]

NB 45 : October 1967 – April 1968.
 Reference to work for Rotary Tools, at whose opening I met Flora with the lodgers Kitty and Alasdair who had come in with me at 160 Hill Street after Inge left with Andrew. Then she returned, was with me at the TV showing of *The Fall Of Kelvin Walker*, and with me at the exhibition at Cuthbertsons the night I met Marion. CND demonstration. Loss of Inge. Poem notes *Love Is An Evil God*.

NB 46 : [In Box 2]

NB 47 : 15 November 1967 – 7 March 1968
 (Started in London on the way to TV rehearsal of *The Fall Of Kelvin Walker*). At the time Inge and Andrew were living in Kirkintilloch: I in 160 Hill Street with lodgers. Start of poem *Stay With Him Or Return To Me Soon* (I later cut out the first 3 words) with stages which made it *Love Is An Evil God*. *Lost* marriage poems, though within marriage. And the small cheap poem I gave Urquhart in 1981 or 2 for *Logopandocy*. Bits of dialogue for *The History Maker* play. Entry after Inge and Andrew returned and references to filming of TV version of *The Fall Of Kelvin Walker*. References to the first extramural lecture in art history at Paisley YMCA (African Art).

NB 48 : [In Box 2]

NB 49 : 1970.

Notebook almost empty, except for sentences for *Council Corridors* chapters [? of *Lanark*], letter and sketches about Rock painting for Lesley McKiggan and an extra mural art gallery appreciation curriculum.

NB 50 : Circa September 1970.

While working on *Falls Of Clyde* mural in The Tavern, Kirkfieldbank. Chiefly sketches for that. Lands, trees, canyon edge between Bonington and Cora Linn. Fragment of conversation with Monboddo from last chapter of *Lanark*. Done when separating from Inge was underway but I kept hoping not. And feeling for Bess McCulloch was a comfort. Bess And Emily picture.

NB 51 : 7 October 1970 – 4 February 1971.

Fragments of *Lanark* chapters 33,34,40, and *Epilogue*. Logo for Scottish Stage Co. 4 February 1971, must be about when Inge and I parted. Saltcoats harbour: sense of final separation. Fragment of sketch for *North British Review*, Yes man and Nasty man (later part of *Tickly Mince* revue). Drawings of late 18th century costume for *Legend Of The Excise Commission*.

NB 52 : Circa 1971.

A fragment of *The Strathaven Revolution* and some notes on the economics of the early 19th century system (the play commissioned them) with material for *Lanark* chapters 25 and [?] 54 [no such chapter].

NB 53 : September 1971 – September 1972.

The posting of Books 1 and 3 of *Lanark* to my London agent, Frances Head. Drawing indicates this was when I illustrated John Barleycorn for *Scottish Field* (January 1972 issue). Also notes made in a Dumfries hotel for 'A story in the russian manner . . . an interior monologue' starting with the words 'I am a drinker, not an alcoholic, but a drinker', and the words 'I will stand on the railway platform with the assurance of a ballet dancer . . .' which became *1982 Janine*. Also notes for Ritchie–Smollet encounter, and the climbing of the Falkland Hills by Andrew that got into the *Climax* chapter of *Lanark*. Also completion of the Bovey family portrait, doing of the Emmy Stokes portrait. Two attempts at poems, one of which became popsong in *Cathedral* chapter of *Lanark*, one the last song in *The Rumpus Room* opera libretto. Also the start of *The Great Bear Cult* as TV treatment. And abortive June 1972 encounter with Binkie Beaumont and Viviene Matelon regarding the play of *The Fall Of Kelvin Walker*. Plus the Jackie Clydesdale portrait, June 1972, before going to London.

NB 54 : 30 January 1973–

Engaged on the Greenbank *Book Of Ruth* mural. Notes for later parts of *Lanark*. Dad's obituary. Notes for TV play based on *The Story Of A Recluse*. Notes (drawings) of Alasdair Taylor's painting for the article on him. Fragments of *Cathedral* chapter of *Lanark*. Fragments of *McGrotty And Ludmilla*.

NB 55 : September 1973 – October 1973 or later.

Notebook with sketches of scenery from rocks of Millport shore,

September weekend. Plans for *Cathedral* and *Alexander Comes* chapters of *Lanark*, and notes for details of *Climax* chapter. Extracts from a book about medieval history borrowed from Glenrothes town artist. Engaged on Greenbank mural. Notes for a song cycle commissioned from Wilma Paterson. Dads death 4.3.1973. Notes for *The Story Of A Recluse* TV play. Fragment of *McGrotty And Ludmilla*.

NB 56 : July 1958 and September 1974.
 Starts 6 July, reference to Thaw and June Haig episode in *Lanark*. Reference to Malcolm's coming marriage. Dialogue for a sexually triangular play — warm, messy artist, neat engineer — that became an element of *The Fall Of Kelvin Walker*. Started teaching (non-certificated) in New Stevenson on the day following the last entry on 5 October 1958. Jumps to September 1974, when I have almost finished the David Stevens oaktree ecological mural at New Cumbernauld Nature Reserve, Palacerigg. Finished portrait of Christine Davis; Keith Bovey and family portrait not quite finished. Andrew visiting me for lessons. Plan of last *Lanark* chapters to be written, end of Book 2 and all of Book 4.

NB 57 : [In Box 2]

NB 58 : 1977.
 References to portrait of *Juliet In Red Trousers*. Working for The People's Palace as artist recorder, with lists of pictures. Title pages for *Lanark*. Financial information for article on Glasgow Arts Centres. Some addresses relating to Anderson Church Street mural. [23.2.1977 Canongate Press acknowledge receipt of MS of *Lanark*]

NB 59 : Circa September 1979 and December 1980
 From when I left work at Glasgow University, then during the time I was starting to finish work for *Unlikely Stories, Mostly*. Notes for *The Axletree* (planned as one story then) plus *Logopandocy*, plus the start of *1982 Janine*: then planned to be a short story called *Autobiography* or *If This Is Thursday, This Is Selkirk, Janine*. Also first notes for *Near The Driver*. Sketch of Campsies across Loch Carron, with tree stump on nearer shore. Done on a day outing with Marion and Robert Lacey. Sketches from Tinto for Book 4 frontispiece of *Lanark*.

NB 60 : Circa May and June 1980.
 Start of an essay on the evolution of the novel. Fragments of start of story that became *1982 Janine*. Time I got the Arts Council grant [to visit Paris]. Notes (some sketches) on visit to Louvre which revived the notion of a play about *Fillipo Lippi* and stimulated fragment of dialogue. Also gave me the *Prometheus* story setting (did this Paris weekend) so here are bits of it. Also bits of *Epilogue* of *Lanark* finally being revised.

NB 61 : 1982 and 1983.
 Additions to *McGrotty And Ludmilla* for stage version and stuff for *The Pie Of Damocles* revue. Reference to the Preface to Elias Ashmole's *History Of The Order Of The Garter*. *Pockets* dialogue for *Pie Of Damocles*. Unused fragment intended for *1982 Janine*.

Accession 9417

Box 2

Twelve bound diary notebooks in no order because their sizes are too irregular. Numbered in (approximately) chronological sequence with those in 9417.1. Plus an address book, a passport and a sketchbook.

NB 17 : 12 February 1954—

References to the *Thaw* book and its one completed chapter, with discussion of what recent or past experiences to include/exclude. Also to a second book called *Macbeth* or *Ogilvie*, which takes place in a city like Edinburgh, ruled from a Kafka-esque castle and subject to supernatural crises. Ogilvie's character is described like Lanark's, and there is a suggestion that he is a form of Thaw.

NB 19 : Summer holidays. July — August 1954.

Diary fragments. Fragments of poem sequence. Doodles for *Marriage Feast Of Cana*. References to work on a building site to raise money for an Art School trip to Italy. Firstly as a joiner's labourer (which helped with the *Honesty* play) then as a watchman during the fair fortnight. Part of this diary is transposed into the third person of Thaw.

NB 20 : Circa May, June 1955.

Art School 3rd year. Diary notes written from opposite ends charting an actual romance and half the time putting the experience in the third person as occuring to Thaw. Material for the *Breaking* chapter of *Lanark* already half digested into narrative prose. First form of *The Cause Of Some Recent Changes* story.

NB 22 : July — August 1955.

Stobhill hospital. Starting Glasgow fair fortnight. Material of some of *Chaos* chapter of *Lanark* as diary reportage. And the start of the second chapter of the Thaw section now called *Hostel*, and some material used at the end of *Prologue*.

NB 23A: 1956.

Mora's Whitehill School Book with blank pages in the centre containing diary reference to asthma-ridden visit to sister Mora who was at Dunfermline Girls' Physical Education College, Aberdeen. Fragment of not used dialogue for end of *Thaw*. First work on *The Comedy Of The White Dog*.

NB 24 : Last half of 1956.

Attempts at the three *Prologue* poems with efforts to bring all the past stuff up-to-date. The start of an unfinished story *Notes On The Discovery Of A New Science*. Scene two (first two thirds of it) of the *Jonah Puppet Play* with scenic sketches. Also a rewriting of *The Star*.

NB 25A: 1956. Art School.

Much gossip about Alan Fletcher, Carole Gibbons, Malcolm Hood, June Mulcahy, the Newscine Cafe, Margaret Gray etc. References to the completion of the *In A Cold Room* poem sequence, also *Autosection* story, *The*

Journey In story, fragments of the novel called *Thaw* with first person narrative about life after death by drowning told by someone called Ogilvie.

NB 25B: 1956, at Art School. [Contents as for 25A]

NB 29 : 25 October 1957 – Gibraltar.
 Notes for the Thaw at Art School chapters of *Lanark* and the first Unthank chapters (Unthank here called Ahloblast) and a last supper symposium at which Thaw bids farewell to his friends and the world.

NB 44 : 17 September – October 1964.
 Poem: *Andrew Before I Say I Will Not Be* . . ., bits of *The Fall Of Kelvin Walker* etc.

NB 46 : October 1967, and 1982 or 1983.
 Working part time in Glasgow Art School library in the evenings. 1967 circa the death of Che Guevara. The time I painted the cellar of Rotary Tools for its opening. Met and drew Flora. Painted backdrop for CND rally in the Broomielaw shed (organised by Brian Smith when the death of Che Guevara was announced). Design for a planetary zodiac for Dave Livingstone's office in the Engineering Employers Federation (never completed). Around the time Inge and Andrew were with Jimmy Guy in Kirkintilloch. An early version of the story that became the first half of *Prologue* in *Lanark*. Draft of letter to James Brabazon, TV director, with references to *The History Maker* play with the rewritten domestic beginning. Designs for planetary zodiac panel for David Livingstone's office. Sketches of fig tree in Kibble Palace. Then from 1982 or 1983 material from the end of Chapter 12 of *1982 Janine*.

NB 48 : 7 April 1969 – March 1975.
 This covers the period of working on all but the first chapters of Book 3 and all but the last chapters of Book 4 of *Lanark*; and of leaving Kersland Street and wife in 1971 sometime and going to 39 Turnberry Road. Also notes for many plays: TV play *Martin*, bits of *Strathaven Revolution*, *Homeward Bound*, *The Loss Of The Golden Silence*. (Unsure whether I left Andrew and Inge late in 1970 or early in 1971. Suspect early in 1971.)

NB 57 : Circa June 1975.
 Notes and plans for Book 2 of *Lanark* especially the chapter now called *The Work*. Reference to sketches of the Bovey family begun about this time. Great quantity of matter relating to the play called *Beloved* commissioned for TV by Michael Cox. Rehearsals for BBC radio version of *McGrotty and Ludmilla*. Steven's mural Palacerigg (illustrating *A Scent Of Water* poems by Carl MacDougall). References to the *Chapterhouse* chapter in Book 4 of *Lanark*. References to the Greenhead mural work. And Andrew going to Kilquanity House School, and Dad being cremated a year (roughly) after his body going to [illegible] University.

Passport: Dated 26.7.1960.

Address Book.

Foolscap hardcover sketchbook.

Accession 9417
Box 3

Diaries and fragmentary writings.
A Report To The Trustees.
1976–1977 material about Glasgow Arts Centres.

Folder: 1944–1950.
 Juvenile Writing. While at the hostel, Wetherby, Yorkshire
[evacuated there]. Riddrie Primary (1946) and the first 3½ years at Whitehill
Secondary School (September 1946).
 Ten paper folders containing a variety of puerile verse, prose and
adaptations in MS or typewritten by the author's Dad, or in stencilled
publication form. One school exercise book.
 This does not contain some prose pieces published in the
Whitehill School magazines of 1947, 1949 and 1950. I saved these magazines
and later cut out my contributions to include in *Thaw*, but decided not to, and
lost them. They were chiefly interesting for *The Wise Mouse* in 1947, which
incorporated a salvation by submitting to swallowing.

MS Pages: 1945 or 1946.
 Single page play adapted from a popular prose version of *The
Illiad* for children, acted by the author and some classmates in the Church
School, Wetherby, Yorkshire, when the author took the part of Polyphemous.
Typed by the author's father. MS and TS versions of puerile poems written in
the same year.

MS Sheet: 1947.
 The first page, with illustrations, of an adaptation of *Aesop's
Fables* which, with two or three of my verses, was broadcast as a 4 minute radio
programme on Scottish Radio Children's Hour, producer Kathleen Garscadden.
I think the work was submitted (it was a competition) while I was still at
Primary School, but broadcast (live in those days) when I was in my first year
at Secondary School.

Whitehill School Magazine: June 1948.
 Edited in the relaxed period after the exams and before the
summer holidays. Three editions of a classroom magazine: Whitehill School
first year, Mr Hamilton's form class. Edited with the help of Mr Scott, the
English teacher.

Jungle Rhapsody: March 1949.
 Story published in *Collins Magazine For Boys And Girls*.

Whitehill School Magazine: June 1949.
 Two editions of a classroom magazine. Mr Hamilton's form class
(Joseph). Edited with the help of Mr Scott, English teacher. My contribution
was the comic strip cartoon at the bottom of the last pages.

Illustrated Fictionalised Diary: 3 January 1949.
 This (I seem to remember) was used by some children's publi-
cation (perhaps Collins). The date is established by *Sinbad The Voyager* book,

being a Victorian slim green hardback volume in very tiny print containing some other tales, including Lucian's imaginary voyages, which I made a strip cartoon of for the second year pupils magazine in July of this year.

MS Sheet: 1950.
 First page of a set of verses typed by Dad, most of them lost. In Arran this year, during the summer holidays.

MS Pages: circa 1950. Verses.

Magazines: 1950.
1. Story *The Yellow Dream* in *Collins Magazine For Boys And Girls*. June 1950.
2. Page of Imaginary animals (much influenced by the collected works of Thurber found in Riddrie Public Library) and reproduced in the *Whitehill School Magazine* which was printed around November.
3. Two other cartoons from the same issue, or from the 1948 or 1949 numbers.

MS: Circa 1950. Start of story about a boy who hears colours.

English Exercise Jotter: 18 September 1950 – 20 February 1951. School essays.

Juvenile Writing: 1951.
 Diaries and fragments of the starts of novels: *Obby Pobbly*; *Edward Southeran*; *Ian Thaw*; *Gowan Cumbernauld*; and the earliest story I ever republished, *The Star*.

Folder:
1. Foolscap Diary.
2. Foolscap Diary.
3. Exercise Book. Diary of June 1951. Returning with Mum from an Arran holiday cut short by asthma.
4. Diary fragment from 1951 or 1952.

Obby Pobbly: 1951 and 1952.
 Three doodled title pages for a four part work of fiction, in which my potato-headed depressed intellectual schoolboy, Obby Pobbly (who later became Edward Southeran, then Gowan Cumbernauld, then Duncan [or Ian] Thaw) would go on a pilgrimage which would lead him out of the everyday drabness of post-war respectable working class Glasgow, through a fantasy pilgrimage, ending in an era of untrammelled artistic production, which by 1952, when I knew I was about to enter Art School or had actually done so, was embodied in the dream of wandering scholarship: a journey whose rules were self-imposed, and whose hero was now called Gowan Cumbernauld.

 1953. Also some fragments of aborted beginnings, one of which had Gowan being summoned from a drab job in an office in Glasgow Municipal Buildings (I had been interviewed for a job there by the deputy town clerk, an acquaintance of my father's) to what was to be a mysterious new Co-ordination department which was quietly taking over the running of the world, by acquiring unused space in unused lofts and basements in central and local government offices, disused factories, cinemas etc., and installing a staff and

machinery to facilitate communication. Gowan was to have some sort of privileged role in this department.

Juvenile Writing: circa 1951.

The start of a whimsical (consciously whimsical) story for children with an Edinburgh setting and a Hero called Ian Thaw (discontinued for its lack of ambition). The *architectural* feel of Old Edinburgh is much as I found it to be at the Festival Late Club in 1961.

Exercise book containing chapter 1 of *Obby Pobbly* novel and first pages of chapter 2.

1951: A notebook of fragments intended to be worked into a novel of a semi-Firbankian-Aldous Huxley sort. My narrator would be an onlooker. The artist-writer-rebel would be one of the grotesques he would encounter.

May 1951: *Collins Magazine For Boys And Girls* with the first version of *The Star* in it: plus MS with note from the assistant editor, dated 5.4.1951. The story was written, however, on my happiest holiday at Annfield, Pirnmill, on the Isle of Arran, which must have been July or August 1950. The story got me corresponding with Ann Weller. Not my illustrations (though I like them).

The first page of a lecture on lesser known historic monsters of the Clyde Basin (I delivered a slightly more sophisticated version of the same thing as a cabaret turn in the Festival Late nightclub, 1961).

1951: Three title pages of nonexistent works and 2½ dialogues from a work called *Dialogues With A Familiar Demon* written under the prose influence of Oscar Wilde. Mum was working in the Glasgow office of Collins Publishers, and got me a yellow volume of his complete works for nothing because it had a slight manufacturing defect.

1951: The start of a novel set on a flying island whose staff are intermediaries between God and the world. The central character – a boy called Bruin – was to be sent down as an agent to report on the state of the world beneath, with orders to disguise himself as an earthling. He had special powers but was only to employ them as a last resort in conditions of extreme difficulty. His lungs being used to a more benign and heavenly climate, on earth he would suffer from asthma.

1951: My first effort at a poem sequence based on my life.

Late August or September 1951: 2 pages of a diary dealing with the start of school after the holidays.

1951 or 1952: The start of another novel intended to lead the author (and therefore reader) from the drably commonplace into realms of wonder: which could never get past the second chapter because the content of the wonderland could only be a combination of things filched from other people's stories and pictures.

Envelope: 1952 [& 1953]. From Whitehill School to Art school. Amy Gray [mother of Alasdair] died 24 May.

1. Near start of Art School. List of places of which I wanted to make paintings: because I found them mysteriously glorious at the time or in memory. The title page refers to places in Wetherby or near it.

2. Diary fragment February or March 1952.

3. Notes referring to me and Mora [sister] 1952 or 1953.

4. January 1952: diary for this month. Mother at home, but bedridden. I and my sister quarrelling. Dad aware of Mum's coming death but telling nobody yet.

5. 2 March 1953. Notes negative epiphany in the Art School refectory.

6. April or early May 1952. Diary notes made not long before Mother's death on 24 May. They don't mention her.

7. Probably late November 1952. Diary fragment referring to Art School politics.

8. Fragments of a novel to be called *Gowan Cumbernauld* (a successor to *Obby Pobbly*). The use of a school exercise book indicates it was scribbled while the author was asthmatic, describes a frustrated Gowan attempting to relieve himself by caressing a caryatid on the facade of the municipal building where he is clerk. Another dismembered exercise book contains fragments referring to asthma, housework, a recently dead mother.

9. Late September, October 1952. Diary written with the audience of Anne Weller in mind – in old school exercise book – striving hard to take in contemporary politics and to find Glasgow colourful, however grey.

10. Christmas 1952. *In Sickness: A Meditation*. 8 pages of ill-disguised self-pity. The reverse of these pages tells a more interesting story. At some time this year my father gave up a job for the Scottish Tourist Board, because it had become mainly a matter of touting for money from hoteliers to support the board itself. My ability to use his *curriculum vitae* of this year – Gestetnered or reproduced by some wax stencil process – indates that he had got employment as a costing and bonus clerk with the Scottish Special Housing Association: a job he kept until the graduation of his son in 1957 made him feel free to give up clerking (which he hated) and live by working at less well paid jobs for the Scottish Youth Hostels Association and the Holiday Fellowship. -

Envelope: 1953–1954.

1. The start of *Thaw*. Contributary diary and letter fragments and Art School notes. First folder 1953. 9 diary or letter fragments in paper folders, the last of them from 28 December 1953 – February 1954 and written in three school exercise books.

2. 1954 folder. A diary page date 13 March, half diary torn in two horizontally in an envelope. Two reproductions of poem illustrations for the end of the second year exam design course.

3. 3 paper folders containing references to building site work in July. 1 folder of stuff about Italian trip and a picture made after it.

4. Folder 1953 and 1954. Art School. During the Art School holidays this year (July to September) I did not work but concentrated on writing my *Thaw* novel. I was sure I could write all, or most of it, on the basis of notebooks and diaries accumulated or imagined. I managed chapter 12 of *Lanark* (it used to be chapter 1 of *Thaw*) and a few pages describing Thaw's hallucinatory delirium (chiefly the part describing the city expanding like a telescope and him killing – perhaps – the girl) in chapter 29 (which was the

second last chapter). 1953: 4 detached diary sheets referring to people at Art School and Anda Paterson, who was my current Beatrice. I have clearly no idea what an objectionable exhibitionist I am when I am not being shy and withdrawn. A fragment of recorded experience is rewritten, an entry later, as if it had befallen Thaw. 28 December 1953 – February 1954. Diary started on my birthday and going on for a month or more. Starts with describing the climbing of Cathedral spire the day after my birthday: deals with my first and most embarrassed visit with Glasgow Art students to Edinburgh College of Art, and glimpse of Alan Fletcher etc. The writer is now deliberately amassing material for a book about a man called Duncan Thaw, and knows he will become delirious, go insane and die.

5. 1954. Art School. Summer Holiday work. Trip to Italy. *Marriage Feast At Cana* painting. Met Bob Kitts and Hilary Leeming on 31 December.

1954. Top half of an exercise book torn in two horizontally, probably in a fight with Mora. It stems from the first half of 1954 (reference to an Italian visit – I'm already plotting to make that useful to a character called Ogilvie). Also to an interview with D.P. Bliss, the Art School director, about Malcolm and I starting a debating society, and also about Jimmy Simpson's choir and a walk alone up the Campsies to see the sunset over Ben Lomond.

Two pages of a letter, either a draft of one posted to Ann Weller or not posted at all. Pompous and facetious. Starts 'Say I with four complete chapters behind me, a fifth destroyed during a quarrel with my sister (I provoked her beyond endurance) and several hundred to go'.

Three sheets of a letter to Anne Weller. Six highly moralistic pages, me being a Scots intellectual working-class sermoner.

Folder: 1955–1956.

1. First attempt at poem 19 'Because The City . . .' in *Old Negatives*, completed 25 June 1986.

2. Facetious doggerel verse for a black-mooded Xmas card.

3. Cryptic diary entry.

4. *The Spread Of Ian Nicol* in *Ygorra* magazine, 1956. Alan Fletcher was art editor. He also collected most of the written material. First published version of Ian Nicol with illustrations by the author. Also a six verse rhyme *George Square Incident*. A facetious short story *Two Leaves And A Bud* with a heading illustrated by Alan Fletcher. A poem by someone else but illustrated by me.

5. Envelope: Early 1955. The start of my friendship with Veronica; Diary entries. 1955, Art School, end of third year. School holidays in Stobhill Hospital. Letter to Ann Weller describing the break with Veronica. I suspect I did not post it because it contained material I would be able to use in my book. *A True Account Of Certain Happenings In North Britain* – February 1955 if not a whole year earlier. An article intended for the *Glasgow Herald*, but rejected. About a student charities rag week stunt involving the Art School and the Technical College. This got some newspaper coverage. A popular Church of Scotland clergyman mentioned the students' conduct (which involved an Art School model, Jessie Moon, posing on the cenotaph in George Square, and some businessmen getting flour on their coats) as tending to the state

predicted in Orwell's *1984* which had been televised a few weeks earlier; 29 December 1955. Unfinished and unposted, or else a draft of a posted letter to Hilary Leeming. The references to lovelessness and detailed descriptions of eczema fortell *The Spread Of Ian Nicol* as well as the dragonhide in *Lanark*. Also the *Autosection* story [see below].

6. Folder: December 1956. Art School. Spent Glasgow Fair in Southern General Hospital. Hitch hiked to London to see Bob and Hilary this year, with Jane Mulcahy. Very bad asthma. Was it the summer holidays after hospital? or Easter holidays before? Jonah puppet play, Art School Christmas Ball.

7. *A Report To The Trustees Of The Bellahouston Travelling Scholarship*, 1959.

Completed in ballpoint pen, lined foolscap, in April 1959, and fronted by a large doodled bird with a photograph of the Toc H centre in Gibraltar: and with 20 photographs taken by the author stuck to pages 17–24 inclusive. This work, with some additions and excisions, became the story of the same eventually printed in the *Lean Tales* anthology, 1985.

Envelope: 1956–1957.

1. Folder. *Autosection: Notes Upon The Discovery Of A New Science*. circa 1956. Fragment of MS beginning of story [about skin disease], very morbid, in graph paper exercise book in very bad condition. Plus one foolscap sheet.

Inner page of list of nine chapters for 'Thaw', most of these not written, but intended:

The War Begins – wholly written.

Evacuation –wholly written, very short.

The Island – diary notes.

Mrs Thaw Dies – I don't think I had written about this and had had the grace, I think, to make no notes, but I perfectly remembered.

Diary notes that Thaw was to go to Art School and fail there.

The Building Site – diary notes.

The Perfect State – diary notes (Stobhill Hospital).

The Fall From The Summit – partly written (madness and murder).

Epitaphs – pretentious utterances, written (a last supper at which all Thaw's friends would assemble at a symposium to bid farewell).

North – nothing written (Lanark was to drown himself in Cape Wrath).

2. Folder. *Janet*, a story circa 1957 but composed of incidents which occurred in 1955 and 1956. Not to be published. TS. Written out of materials derived from Alan Fletcher, Carole Gibbons, Dan Ferguson, and the party at Dan's at which Alan first met Jane Mulcahy (and Penny De Vesca) and I got cured of my stasis asthmaticus on leaving Stobhill. Much is transposed, reworked, but well connected. I shamelessly used the end of my mother's death and my sensations at same to enrich this. Nothing, not even the dialogue in this, has been invented. All the incidents occurred, but in different order, places and times. Some were reused in *Lanark*: one, which involved Carole kissing me in a dance at a party in Veronica Mathieson's house with Alan there, I eventually used in *The Fall Of Kelvin Walker*.

3. Folder: *The Cause Of Some Recent Changes* early version in

Ygorra magazine, 1957; MS sheet of a dream; Sheet of paper with purposed (but not used) fragment of *Thaw* on one side, diary note on the other (written onboard the Kenya Castle); Note in Alan Fletcher's writing; Art School dissertation in MS. Theme: epic painting. Submitted May 1957.

Folder: 1976–1977

Letter from the director of Glasgow Arts Centres offering me the post of head of art department. 1.10.1976.

MS of an article entitled *Glasgow Arts Centres*, and a typed version, distributed to several newspapers and individuals early in November 1977, with an acknowledgement from a member of Strathclyde Regional Council, dated 10.11.1977.

[Further folders of biographical material are in *TD*2227.5]

Accession 9417
Box 4

Unsorted Biography Stuff.

Envelope: Domestic and Criminal. Assorted letters and official documents. [Many are undated].

− Letter to Alexander Gray (father of Alasdair) from R. McEwan (headmaster), 29.5.1952.
− Tenants Rent Card. First entry, 28.12.1968.
− Gas Meter Payment Card, 3.1.1969.
− Letter to Kier, Moodie & Co (solicitors), copy, 18.4.1969.
− Tenants Rent Card. First Entry, 4.12.1969.
− Eviction notice, 9.7.1970.
− Eviction notice, 9.1.1971.
− Letter from Clerk of Court, 13.7.1971.
− Letter from Mrs M. Clark (social worker), 17.4.1972.
− Letter from income tax office, 4.7.1972.
− Letter from Dean Foster (Virginia Military Institute), 21.3.1974.
− Letter from Dean Foster, 15.4.1974.
− Letter from Dean Foster, 17.7.1974.
− Letter from income tax office 24.7.1974.
− Letter from inspector of taxes, 9.8.1974.
− Letter to Malcolm Smith (Glasgow corporation housing manager), draft, 9.12.1975.
− Letter to Mrs Burns, draft, 8.2.1976.
− Summons to court, 18.3.1977.
− Summons to court, 1.4.1977.
− Letter from Scottish Society of Playwrights, 6.5.1977.
− Summons, 11.6.1977.
− Letter from income tax office, 15.7.1977.
− Income tax form, 20.10.1980.
− Letter from Scottish Telecom, 4.12.1980.
− Programme of Strathclyde writers' May festival, 5–13.5.1984.

— Letter from Margaret Ferguson, 4.2.1986.
— Restriction of Ribbon Development Act 1935 etc. Official Document.
— Ministry of Pensions and National Insurance benefits card.
— Card saying 'Beat No 12'.
— Writ in causa, Alasdair Gray versus Leslie Nurse.
— *National Emergency Seasonal Greeting Card* signed by Gray.
— Highly commended certificate, UNESCO essay poster and scrap book competition.
— Letter to Scottish Artists Benevolent Association.
— Mural Partners, circular letter by Gray and Alasdair Taylor.

Folder: Contains photographs and negatives, many of prewar vintage.

Folder:
— *The New World*, story, MS & TS.
— Chequebook.
— Letter from the *New Statesman*, 1.9.1986.

Folder:
The History Maker, play, TS.
— *James Watt*, play.
— Letters: personal, official, circulars.

Folder: Certificates and Legal Documents.
— Birth certificate of Alasdair Gray, born 09.50h 28.12.1934 at 11 Findhorn Street, Glasgow.
— Petition for divorce from Alasdair Gray. Inge Gray, 21.11.1983
— Divorce certificate (Decree Nisi absolute) of Alasdair and Inge Gray, 17.4.1984.
— The will of Annie Miller, 16.4.1987.

Folder: Letters and Documents regarding paintings and exhibitions
— Charing Cross mural project, 28.11.1973.
— New Lanark Craft Community, 21.11.1975.
— Publicity booklet for the above.
— Street decorations for the Anderston Fair.

Folder: Recent letters, business pending. ? all 1985. Mainly personal letters to Alasdair Gray.

Folder: Documents about Teaching, Lecturing, Readings and job references for Alasdair Gray.

Folder: Post Art School — Pre Inge.
— TS of poems written 1953.
— Circa 1958: Letter to the original of Rima (Margaret Gray) about the original of Sludden (Tom Graham).
— Letter to Bob.
— A fragment of the chapter which eventually became part of the *Mouths* chapter in *Lanark*. It gives part of Duncan Thaw's life after death, calling him by his pre-death name.
— MS writing on the use of colour in painting.

— *Quiet People*, radio play.
— *The Fall Of Kelvin Walker*, script for radio version: *A Book at Bedtime.*
— *Not Striving*, a poem in *The Glasgow Review*, summer 1972, Volume 3, Number 1, p.34.
— Exhibition programme: *Men And Women*, The Regent Gallery. 15.6–1.7.19??.
— Notes for a play about the planned breakdown of the Clydeside ship-building industry by its owners.
— Illustrated poem, photocopies.
— Photographs of ? walking holiday.

Loose In Box:
— *The Answer*, short story, in *The Fiction Magazine*, summer 1984, Volume 3, Number 2, pp.62–4.
— *Thaw's Trilogical Theory* on the cover of an exercise book.
— *The Comedy Of The White Dog*, booklet, Print Studios Press, Glasgow, 1979.
— *Curriculum vitae* of Alasdair Gray.
— *A Short And Curious History*, preface to this book. MS & TS.
— *The Grumbler*, TS, short story.
— *Portrait Of A Vital Witness*, later *Portrait Of A Playwright,* essay.
— *Glasgow Arts Centres*, essay.
— Letter from Tina Reid, undated.
— *Reminiscences Of Childhood*, short story by Andrew (son of Alasdair) Gray.
— Correspondence.

Accession 9417
Box 5

Uncatalogued And Unsorted Material

List Of Accession 9247 and some of 9417: by Donald Goodbrand Saunders. In MS: with the following headings: novels; correspondence regarding books etc.; short stories; essays and book reviews; essays and reviews etc. with regard to art and artists; plays (and play treatments); chronological information now on card index; poetry.

Folder: 1963–1986.
Correspondence from, and drafts of letters to, agents and publishers. Listed above by Donald Goodbrand Saunders.

Folder: *The Story Of A Recluse*. TV play.
Version with notes from director and producer suggesting modifications to the script completed 26.3.1987., with TS of the foregoing script made by the BBC.

Folder: *The Story Of A Recluse*. TV play.
Version of the BBC video filmscript completed 26.3.1987, broadcast 25.12.1987. TS with extensive MS additions and illustrations.

Folder: [Wrongly labelled Old Negatives]
MS diary entries, a version of the chapter *Mouths* from *Lanark* and miscellaneous other material.

List of literary works.

5 *Scottish Artists*, exhibition catalogues and introduction.

Folder: Alexander Gray [Father to Alasdair]
— Notes on early life in Glasgow by Alexander Gray.
— Letters from Alasdair to Alexander.
— Letters to Alexander Gray from various people.
— Folder: 'Abortive Beginnings 1969'.
— Folder: 'Alexander Gray, born 4.4.1897, died [] 197[]. This folder contains letters and postcards from Alexander to Alasdair and a letter to his sister in law, Annie.

Folder: Curriculum vitae and questionnaires.

Loose in Box: *Education*, short story, in *The Glasgow Magazine*, winter 1982–1983, pp. 7–9. (This story is not one I want republished (too condescending)).

Accession TD 2227
Box 1

Unsorted:

Family photographs
Photographs of Alasdair Gray
Photographs of artwork
Certificates (Art School, Teaching).
Items of correspondence.

Accession TD 2227
Box 2

Graphic Art In Published Form:

— *Scottish Theatre Magazine*. January 1972. Cover portrait of Robert Trotter.
— *The Glasgow Review*. Autumn 1972. 6 drawings.
— *A Scent Of Water*. Stories by Carl MacDougall. Molendinar Press 1975. Illustrations and cover.
— *Dwell's Gaelic To English Dictionary*. Gairm Publications 1977. Jacket.
— *Imaginary Wounds*. Poems by Aonghas MacNeacail. Glasgow Print Studio Press 1980. Cover.
— *The New English–Gaelic Dictionary*. Gairm Publications 1981. Jacket.
— *Grafts/Takes*. Poems by Edwin Morgan. Mariscat Press 1983. Jacket.
— *A Bad Day For The Sung Dynasty*. Poems by Frank Kuppner. Carcanet Press 1984. Cover.
— *The Glasgow Diary* by Donald Saunders with additional entries by Alasdair Gray. Polygon Books 1984. Jacket and illustrations.
— *Sonnets From Scotland*. Poems by Edwin Morgan. Mariscat Press 1984. Cover.
— *Gentlemen Of The West*. Novel by Agnes Owens. Polygon Books 1984. Jacket.
— *Fiction Magazine*. Volume 4, Number 1. March 1985. Scottish Writing edition. Cover design. Also interview with Frank Delaney containing photo,

taken by Oscar Marzaroli, of the artist with black and white mural on the stairwell of 10 Kelvin Drive, and story *The Grumbler*.

— *Shoestring Gourmet*. Recipe book by Wilma Paterson. Canongate 1986. Cover and illustrations.

— *Chapman* magazine. Covers to Numbers 35/36 [containing *A Modest Proposal For Byepassing A Predicament*], 38–41, 43–46.

Accession TD 2227
Box 3

The Story Of A Recluse, TV play.
Numbering of folders continued from Accession 9247.

Folder 33:
 Typescript of the story from *Lean Tales* which the Scottish BBC commissioned as a TV play. MS of first version, *circa* September 1965. MS notes for the above.

Folder 34:
 Material and correspondence whereby the first version becomes another, October 1985.

Folder 35:
 Third version and correspondence suggesting revisions thereof, March 1987.

Folder 36:
 Final shooting script and schedules. May — June 1987.

Accession TD 2227
Box 4

Unsorted material, mainly slides and photographs of Alasdair Gray's paintings.

Accession TD 2227
Box 5

Miscellaneous

 — Colour photographs of portraits.
 — Folder: Mural Stuff. Photographs of murals and of Gray. Photographs of artworks.
 — Pre-Art School. Family photographs.
 — Art School. Works and people.
 — Folder: March 1958–August 1961. Between Gibraltar and Festival Late. Photographs of people and artworks.
 — Folder: Inge [ex wife of Alasdair Gray]. Hill Street late 1961 onward. Photographs of artworks.
 — Folder: Inge. Photographs and pictures of Inge Gray. TS of poems, artworks, big MS ink drawings with marginal diary entries, illustrations of hippopotami.
 — Folder: Post Inge. Photographs of Gray and of his artworks.

Biographical Information

8.12.1890: Uncle Ned, Edward Millar, was born. His sister was Aunt Medda who worked for Haig Whisky (admin. secretarial). He married Aunt Annie on 2.7.1937.

2.1.1896: Marriage certificate of Alexander Gray, widower and blacksmith journeyman (whose father, William, was a shoemaker), married Jeanie Stevenson, spinster and power loom weaver (whose Dad, Archibald, had been a coalminer). This Alexander was the father of my father, Alexander, and Aunt Agnes.

4.4.1897: Alexander Gray (my father) was born.

12.4.1898: Emma Needham married Henry Fleming (My mother's parents).

1.4.1899: Aunt Annie was born in Govan.

11.1.1902: Amy Fleming (my mother) was born. My mother and Aunt Annie also had a little brother, Edward, who died at the age of seven.

16.2.1916: Certificate of Merit. This indicates that the Lords of the Privy Council on Education in Scotland are pleased to sanction this certificate to Amy Fleming through the managers of Onslow Drive public school, Glasgow, the certificate declaring her very good at English, Arithmetic, Handwriting, Laws of Health, Civics, Empire Study, Drill and singing, Cooking, Laundry, Housewifery and Dressmaking: she is a pupil of over 14 years.

13.4.1931: Amy Fleming (aged 29 years 3 months) weds Alexander Gray (aged 34 years 11 days).

28.12.1934 at 9.50 pm.: Extract from the register of Births. Alasdair James Gray born to Alexander Gray, folding box maker (Lairds in Bridgeton) and Amy Gray, maiden surname Fleming, at their home 11 Findhorn Street, Riddrie (the baby was delivered by Mrs Liddel, a neighbour who had been a nurse, while Dad was cycling around the streets trying to find a doctor).

4.3.1937: Birth of Mora Jean Gray (my sister) at 11 Findhorn Street.

1941–1946: My father was manager of a Royal Ordinance Factory residential hostel at Wetherby, Yorkshire, for 1,000 workers. He was responsible for administration from the opening to the close of the hostel, and for a staff of nearly 200. This was a war-time post which ended when the factory (at Thorpe Arch) ended production. He obtained the appointment through the offices of J.S. Edbrooke, secretary of the Holiday Fellowship, who were then managing agents for the Ministry of Supply. His family (wife Amy, daughter Mora, son Alasdair) came soon to live with him: circa 1942.

31.10.1947: Extract from the Register of Deaths. Agnes Nelson Gray (my paternal aunt), Baker's saleswoman, single, resident at 1314 London Road, died of mitral stenosis with congestive cardiac failure, at Gartlach Road Hospital at the age of 46.

1947–1950: My father was 'Site Clerk' in charge of building and engineering contracts with responsibility for wages, PAYE, materials, records, costing and

banking. When the last contract ended no others were available, and after a month at the head office waiting possible contracts, he was advised to find alternative employment. Refs. Mr McDonald, secretary, Messrs Dundas and Whitson Ltd. (from Alex Gray's own employment curriculum dated December 1952).

11.12.1948: Extract from the Register of Deaths. Henry Fleming (my maternal grandfather), Boot Clicker, retired and widower of Emma Minnie Needham, died at 1801 Govan Road (? a hospital) though usually resident at 863 Cumbernauld Road. He died of cerebral thrombosis. His father, William Fleming, was a hairdresser. His mother was Hannah, maiden surname Masters. He was 76.

24.5.1952: Death of Amy Fleming (my mother): married name Gray, at 11 Findhorn Street, Glasgow G12 8BP.

1952: Scottish Leaving Certificate. Awarded to Alasdair Gray: higher grade in English and Art, lower grade in History, a pass in Arithmetic: from Whitehill Senior Secondary School.

Summer 1953: Art School holiday. I began to write the *Thaw* section of *Lanark*, and completed *The War Begins* chapter, and the hallucination part of the *Breaking* chapter.

31.12.1954: I met Bob Kitts and Hilary Leeming with Joanne Wright and wee Dougie (?) : or rather, they greeted me enthusiastically, I drunkenly supporting myself against a parked car as the State Bar closed (9.30 or 9 o'clock in those days), and took me off with them to parties, during which I sobered and got conversational and Bob and I decided we were geniuses.

July 1955: Swiss postcard from Dad to me in Stobhill Hospital. This was my first, longest and worst time in hospital (with asthma: status asthmaticus) which I attribute more to my rejection of Veronica [than] to hers of me. Mural teacher (Walter Pritchard) had given me permission to work in the Gills Lodgings in (?) Terrace by this time: as did Malcolm Hood.

December 1956: The Christmas Ball at the Art School. I and Malcolm Hood had proposed the theme 'Monster Rally' and did huge murals on cardboard all over the assembly hall. I was also doing work for next February's *Ygorra* magazine (*An Explanation Of Recent Changes In European Geography* story with various illustrations) and doing scenery, or maybe rehearsals, or maybe just explaining the puppet play *Jonah* to the puppet carvers and Miss Hamilton (the puppetry mistress) and I was writing to Margaret Gray: where, when did I first meet her? Of course! Through Tom Graham (the original of Sludden) who visited me in Stobhill. I probably first visited the Newscine Cafe in autumn 1955.

31.10.1957: Left Glasgow on the Bellahouston Travelling Scholarship. Northampton (where I met Anne Wheeler) to London to Gibraltar.

16.11.1957: Telegram from the Kenya Castle [ship] to Alex Gray saying Alasdair was suffering from [?] lobar pneumonia [not true].

March 1958: Return to Glasgow from Scholarship trip.

25.4.1958: *Marriage Feast At Cana* drawing (first shown in Art School show 1954) exhibited in the 123rd Annual Royal Scottish Academy Show. This day I went to the opening *I think* with Alan Fletcher, whose painting of a sheep's head on a plate was also exhibited, and bought for the Duke of Edinburgh.

27.6.1958: Mora Grey marries Bert Rolley (doing research for the Ministry of Agriculture and Fisheries) in a Church of Scotland in Aberdeen the day, or day after, she has graduated with great acclaim from the Dunfermline College of Physical Education.

1.8.1958: Alan Fletcher dies in Milan.

1958: Executed ceiling mural of the firmament in Belleisle Street Synagogue.

March 1959: In the magazine of the Glasgow Group of the Holiday Fellowship, an article by Alexander Gray about his pleasure in mountaineering. The magazine also has a cover illustration by Alasdair of Scottish mountains in winter and summer: the Cobbler left, Ben Lomond right.

28.3.1960: Provenance: Teachers Training Certificate. I started as a trainee art teacher at Wellshot Secondary School. (A great art department with Dan Ferguson, Connie Cochrane and Minelli Laird in it; working in the prefab huts in the playground.)

14–28.5.1960: Exhibition. Two man show with Malcolm Hood in the Blytheswood Square Gallery of the R.G.1.

24.8.1960: Stopped teaching at Wellshot Secondary School. According to the certificate I then started at Riverside Secondary [see below]: that is probably the official record which assumes one is employed even on holidays.

25.8.1960: Provenance: Teachers Probation Certificate. Started teaching at Riverside Secondary School full-time. On my first day I arrived 2 hours late by taxi from Central Station after a sleepless overnight ride, having missed two earlier trains the day before.

January 1961: *Countdown* exhibition: *Artists Against The Bomb*. With Carole Gibbons, Johnnie Taylor, Douglas Abercrombie. *Triumph Of Death* picture.

11.4.1961: Changed from teaching art full-time at Riverside to doing it part-time, presumably because I wanted more time for painting, especially the Greenhead church mural.

28.6.1961: Stopped teaching at Riverside altogether: but unconscious of this. During the school summer holidays I moved to Edinburgh to help Brian Smith with his Festival Late cabaret: which lasted at least a week into the start of school after: and I had met Inge, and thought I had a mural commission, so told them I would not be back.

3.11.1961: Marriage Certificate. Alasdair Gray, aged 26 years, Mural Painter, weds Inge Sørensen, aged 18, Nurse: she being the daughter of Marius Wilhelm Sørensen, Gardener, and Gudrun MS Hanson: both resident at 11 Findhorn Street, district of Provan.

13.11.1961: Started part-time teaching at Sir John Maxwell School (I was unable to support myself and wife out of the art alone, after all). The proposed Bill and Mary Gray mural commission didn't happen because he'd decided to start his own legal firm.

20.12.1961: Gave up teaching part-time and on:

4.1.1962: Started teaching full-time.

25.3.1962: Inge Gray returned from her holiday in Denmark to her new home in 158 Hill Street, having left 11 Findhorn Street, Riddrie, some weeks earlier. Her husband now teaches full-time in Sir John Maxwell School, and has bad eczema, and feels miserable because he seems to be unable to be an artist, now.

14.5.1962: Birth (to sister Mora and Bert Rolley) of their daughter, my niece, Katrina.

14.9.1962: Left teaching forever to take up scene-painting for the Pavilion pantomime *Dick Whittington* in the church-converted-into-scenery-warehouse in Bluevale Street.

15.9.1962: Letter from John MacKenzie, new minister of Greenhead Barrow-fields Church of Scotland, telling the time of the service of dedication for the completed work, and of Dr. Honeyman's preparedness to open it.

21.10.1962: (Sunday) 11 forenoon, *Creation Mural* opening, Greenhead Church.

March 1963: Show in Citizens' theatre foyer gallery with Alasdair Taylor.

6.8.1963: Letter from Curtis Brown Ltd. rejecting MS of *Thaw* (Book 1 of *Lanark*) which the author had completed.

4.9.1963: Extract entry of birth. Andrew Gray, born at 158 Hill Street, top flat, at 0 hours 50 minutes pm. Father: Alasdair J. Gray, Scenic artist (Citizens' Theatre: production of *Macbeth*). Mother: Inge Gray.

1964: I started painting the big North Glasgow cityscape view from the top flat, 158 Hill Street, having bought the canvas and a wealth of paint at the expense of the BBC: with a view to completing many pictures to be filmed for Bob Kitts *Under The Helmet* documentary about me.

10.7.1964: Meal at the Shandon Buttery, 654 Argyle Street, given by Bob Kitts during the making of *Under The Helmet*. This attested by photocopy of a portrait drawing and of the menu it was on the back of.

16.8.1964: My niece, Tracy Rolley, born in Stevenage.

14.1.1965: (Provenance of date: Alex Gray's letter to his son, dated from the next day). Broadcast of TV documentary film *Under The Helmet* by the BBC. Bob Kitts was director – the whole was his idea – Huw Weldon was producer. This shows some murals and paintings which no longer exist, and some poems which their author wishes did not exist. Also I had a small show of pictures in the Duthie art gallery, Sauchiehall Street.

1966: One man show at the Armstrong Gallery, Charing Cross. Two pictures bought: one by Scottish Arts Council and one by The Hunterian Museum.

1967: One man show at the Blythswood Gallery. 2 works purchased by the Scottish Arts Council.

28.12.1968: Inge, Andrew and I came to live in 39 Kersland Street.
1969: Grant from the Scottish Arts Council to make prints: a series of them based on my poems. The money was only sufficient to make designs for prints. These were eventually sold to the Fine Art Department of Glasgow University, and now belong to the Hunterian.

1970: Probably in late August. I entered Gartnavel Royal for a night. Mora and Bert were on holiday at (was it?) Dad's place by Carbeth. And I was drawing Bill Skinner's portrait, starting before, stopping after, the Kelvinbridge railway station burned down.

28 May – 7 June 1970: Exhibition, announced by private letter to acquaintances, in 39 Kersland Street, of work 'Not sold from' my 'late exhibition in the Armstrong Gallery'.

March 1971: Poem On A Small Boy At Eight Month later called Andrew, Before One in Glasgow University Magazine. Tom McGrath, the editor, then a mature student, reproduced a copy of a manuscript version I wrote in his home in Bank Street and which omitted the ends of the 16th and 17th lines because I couldn't remember them. The poem had been written long before; I think actually in Andrew's first year. I suspect that this was the year I left Inge and Andrew and Kersland Street. It had to be quick. I visited Tom McGrath, looking for a room to stay, and Tom (after taking me to a couple of rooms nearby, all occupied) remembered Tom Kirrirmont [? Kinninmont] . . .

2.5.1971: I was living with Gordon and Pat Lennox in Turnberry Road and working on the first scene of a play for Andrew Forester of Glasgow Education Department TV (never performed) called The Strathaven Revolution and about to redraw one of Gordon McPherson's hippo drawings for lithoprint.

8.12.1972: Letter written by Dad concerning his wife's reaction to some publicity in either the Radio or TV Times: an article which quoted me as saying he had been 'a builder's labourer', which he had once been, for a few months. I think the occasion of the publicity may have been the play called Triangles (proper name Agnes Belfrage) which must therefore have been broadcast in November 1972.

4.3.1973: Dad died (Alexander Gray) a month short of 76 years, of heart illness in intensive care unit of a hospital serving the area of Cheshire where he lived (Alderley Edge) with his second wife, Lyn.

28.11.1973: Mural Project. Submitted to Bill Buchanan, of the Scottish Arts Council. Three or four big display cards showing a variety of American approaches to open air murals on buildings, with an essay (typed) indicating which was most appropriate to the Scottish climate and Glasgow gable end: and a photographic survey of the four gables at the end of Garnethill overlooking the Kingston Bridge approach road, with maps and indication of

ownership of the whole: showing the four gables with and without murals. Also tinted drawings of each mural (I received soon after £100 for my submission and these display cards eventually disappeared without trace).

22.5.1974: Painting. Leeds Art Gallery received painting of the two Smout children at a table: bought by Sheila Ross from retrospective in the Collins Gallery.

18.6.1974: I was paid £106 for helping the Bellsmyre Arts Festival, Dumbarton: visiting the protestant and catholic schools, setting up the publication of newspapers, one each class, for three or four classes in each: getting them typed, edited, photocopied, distributed, and compering a public free reading with writers from all schools delivering their best work to a free audience. This was organised through the good offices of the Kirk of Scotland minister, main organiser of the festival.

1st and 2nd May 1975: Visited Register House, London to get copies of the death certificate of Marthy Prince and marriage certificate of her widower husband. I was researching for the *Beloved* play in the British Museum about this time.

September 1975: Andrew went to Kilquanity House School.

1976: This year I think I returned from Turnberry Road to Kersland Street, and Frances Head died, alas.

13.5.1976: Received £50 for soundscript of Museum Documentary for Ogam Films (done for, with Oscar Mazarolli and Joanne Semple and though filmed and edited, the Scottish Film Council boss disliked it and did not sanction its use).

23.7.1976: Received £89.20 from Granada TV, Manchester as final payment for my contribution to the Queen Victoria's *Scandals* series with the play I call *Beloved* but which was so mutilated that I refused to let my name be attached to it. They ascribed it to 'Martin Green'.

4.10.1976: Started work at Glasgow Arts Centres.

Late October or early September 1976: Designs for Garnethill Tapestry to be executed by a German Jewish lady, former resident of Garnethill, at Third Eye Garnethill exhibition and receive £60.

5.2.1977: Leave Glasgow Arts Centres apart from afternoon old folks art class (not paid for it, but it heartening and decent work).

Spring 1977: Painting. Receive £45 from Karl McDougall for portrait of himself with son and cat begun in the previous year.

31.3.1977: Libretto. *The Rumpus Room*. Typed version completed this day. Robert Lacey (putative composer) proposed it as an idea sometime in October 1976, started working with him on it in November, visiting Heatheryhall Cottage near Biggar in the snow where he and his wife Marion lived.

31.3.1977: A letter drafted for Kay Scott, Arlene Leitch and Ian Baxter, Linda McClosky to send to Sir William Gray regarding their reinstatement.

1.4.1977: Painting. Received £50 for portrait of son of Libby Brown (drawing and painting on brown paper mounted on board).

22nd to 24th April 1977: Writers conference, Scotland Hotel, Pitlochry. Idea for the porny bit of *1982, Janine* conceived and some pages written.

2nd to 16th May 1977: Anderston Festival: The mural along Argyle Street was painted in this fortnight.

September 1977: Start of Glasgow University autumn term. I leave the People's Palace where I have been Artist Recorder and become Writer In Residence to the University for 2 years.

21.1.1978: Exhibition. *The Continuous Glasgow Show* with invitations and poster designed by me, opened in the People's Palace Local History Museum. All the pictures I had done while working in the store facing Templetons were on show there: and those I had begun there but finished at home.

24.2.1978: 8 am. Joan Ure died in hospital.

9.3.1978. 8 o'clock. Death Certificate. Testifies that Annie Miller, widow of Edward, a clerk; and daughter of Henry Fleming, boot clicker, and Emma Minnie Needham, died of myocardial infarction and hypertension at 51 Minard Road. She was born 21.4.1899: my mother's elder sister and a very good Aunt. Thank Goodness I was with her when she died.

8.11.1982: Reading at The Burn, Edzell, arranged by St Andrews University English Department. 10.11.1982: another at St Andrews itself. I stayed overnight with ?, whose wife, Jenny, was on the board of Quartet Books, and said Quartet regretted having lost *Lanark* now, and would I like to contribute to an anthology of Scottish short stories? (Why not?). But not the usual sort. One with only two other authors in it (Good idea). Who would I like the other two authors to be? (Hence *Lean Tales*: though another and more crucial director questioned some of the stories I submitted, so I gave the book to Cape.)

12th to 13th December 1985: Went to Belfast for reading at the Queen's University: event organised by Edna Longley: saw Ted Hickey, curator of Ulster Museum regarding *5 Artists* show in Ulster Arts Council Gallery, also editor of *The Honest Ulsterman* to whom will send poems.

18.5.1987: Started writing the Saltire Self Portrait while Michael Knowles started his portrait of me (finished writing it 18.6.1987).

29.9.1987: Letter from Charles Midge pp. Anne McDermid of Curtis Brown acknowledging the receipt of *Something Leather* which I asked her to market. She said she'd try the only three or four good quality outlets which existed. (I retrieved the story from her in January 1988 and began negotiations with Maschler of Cape. Then made Xandra Hardie my agent.)

26.2.1988: A novel in manuscript, *McGrotty And Ludmilla*, begun on this date and completed 23 March. This is a hardcover navigation type book posted to Jack Knox on 25 March, having photocopied contents and made corrections and footnote additions to the copy on the 24th.

4. The Alasdair Gray archive in Glasgow University Library

BBC Radio Drama Scripts — with transmission date.

Edinburgh Studio:
Muir of Huntershill. 14.5.70

Glasgow Studio:
The Loss of the Golden Silence 24.4.1974
The Night Off 15.5.1971
Quiet People 25.11.1968

Play Texts — Index G-I

Agnes Belfrage STA Jc
Dialogue STA Hj 59
The Fall of Kelvin Walker STA Jc
The Vital Witness STA Jc

Materials relating to *Lanark* (MS General 1575)

BOX 1: [TS and MS]

Brown paper and loose folder:
 Note to typist and sketches on cover.
— MS Ch *The last failure.*
— TS Ch 21 *The Tree*, with MS annotations.
— MS Ch 25 *Breaks.*
— TS Ch 25 *McAlpin.*

Green envelope:
 Addressed to:
 John Boothe
 Quartette Books
 29 Goodge Street
 London W1

[Written on envelope] *Lanark* by Alasdair Gray. Agent Frances Head. Posted in Glasgow 15.7.1974. [Description of contents — chapters from Books 2 and 4. Now contains numbered TS from:]
— Ch 24 *Meetings.*
— Ch 25 *Marjory.*
— Ch 26 *Breaks.*
— Ch 29 *The Crow Comes.*
— Last sentences of Ch 30 *The Way Out*].

Loose MS and TS pages.

TS Ch 21 *The Tree*

TS Ch 28 *The Crow*

Closing sentences of Ch 30 *The Way Out*

BOX 2: [TS, MS & NB]

MS several hundred loose foolscap leaves from *Lanark* Books 3 and 4.

TS loose fragments of Chs *Employers, Provan, Dearth, Work, Breaking, People*.

TS [Summary of] *Lanark* a novel by Alasdair Gray . . . First half completed 15.10.71.

List of chapters in Books 1 and 3 plus 'the unperfected second half'. 'This second half will be complete by the autumn of 1974. With economic luck, earlier.'

TS list of completed chapters, October 1975. In progress are 38 [*Unthank*], 39 [*Provan*], 40 [*Arrest*], 41 [*Monboddo*], 42 [*The Dawn*].

MS list of plagiarisms. Early draft of annotations to *Epilogue*.

Draft MS letter to Susan [?] from 6 Turnberry Road, Glasgow G11 5AS re *McGrotty and Ludmilla* – play for radio.

Summit Students Pad: MS of Ch *Alexander* comes.

BS6 ring bound Baberton notebook containing mostly loose MS drafts of *Epilogue*.

BS4 Baberton notebook. Ch 37 *The Chapter House*.

MS leaves of school work in a child's handwriting. ? by Andrew (son of Alasdair) Gray.

BOX 3: [Loose TS sheets from Books 2 and 4 and *Epilogue*.

TS Chs 12, 13, 15, 17, 18, 19, 20, *Interlude*.

TS Book 2 Ch 28 *The art school*.

MS draft letter to John Boothe [publisher, Quartette Books, 29 Goodge Street, London] dated 29.10.1975 re *Lanark*. [Says] 90 000 words completed, 10 000 to go [5 chapters and the epilogue). Offers to finish the book in 8–10 weeks if accepted for publication.

<div align="center">Envelope [Entitled: Book 2] contains TS:</div>

– Book 2 numbered 225–353.
– Ch 30–34 numbered 1–44.
– Ch 38 numbered 431–454.
– *Epilogue* numbered 480–?500.
– Ch 41 numbered 501–520.
– Ch 42 numbered 521–536.
– Ch 43 numbered 537–550.

Large maroon hardback book contains 15.5.1976 'accounts of Alasdair Gray'. MS of part of Book 2 – the Art School visit to Edinburgh. Sketches, especially faces. Design of *The Fall of Kelvin Walker* cover of playbook. ?Revue sketch – parody of political oratory. ? Television play draft.

BOX 4

Lanark page proofs from Lippincott & Cromwell, Publishers, New York. Heavily annotated in MS.

BOX 5

TS of Ch 1–26.
TS of Book 2 Ch The Tree.
TS Book 4 Ch 30–34.
Chapter list dated July 1976.

BOX 6

Lanark page proofs of complete novel, apart from index of plagiarisms, as for BOX 4.

Page proofs for index of plagiarisms from *Epilogue* chapter.

TS letter 7.1.1924 'To whom it may concern' [job reference] from WB Nicholson, Scientific instrument maker and laboratory furnisher, 166a Bath Street, Glasgow.

TS Ch 33 *The zone.*

BOX 7

Uncorrected bound proof copy of *Lanark*, with MS annotations. Lippincott & Crowell, publishers, New York. Minus list of plagiarisms.

BOX 8

Cloth bound maroon ledger with alphabetical index [accounts book]. Mostly filled with accounts but not in Gray's handwriting. Gray's MS contributions include some illustrations, diary note dated 18.3.65, draft of poem 22.3.65.

MS of Book 1.

TS leaf ? story featuring characters named Paddy and Betty.

MS fragments of *The fall of Kelvin Walker*

Notes for a series of ?10 lectures on language.

Bundles of typed stencils for *Lanark* with MS corrections by author on the covers.

5. Alasdair Gray materials in the Mitchell Library, Glasgow

These materials are held in the Department of Rare Books and Manuscripts. I am grateful to Mr. Hamish Whyte for providing details from the Mitchell's catalogue.

Material relating to the novel *Lanark*:

TS with autograph corrections, 1977.

Printing copy of TS, author's proofs, corrected proofs, printers' artwork, 1980.

Printed copy of 1st ed., 1981, with autograph corrections.

Related correspondence, TS lists of corrections, etc. MS. 210 (891256)

4 TS stories (photocopies): 'The Star', 'The Spread of Ian Nicol', 'An Explanation of Recent Geographical Changes', 'The Crank That Made the Revolution', n.d. 891283.

TS script (mostly photocopy): *Tickly Mince*, a revue by A.G., Liz Lochhead and Tom Leonard [1982]. 891284

TS (photocopy) novel: *1982 Janine*, [1984] 891357

Collection of typed Roneo stencils:
 Play: *Dialogue*, 1971.
 Play: [No title], [c. 1971].
 Revue: *The North West Review*, [c.1971].
 Poems: '30 Negatives' [c. 1971].
 Play: The Fall of Kelvin Walker' [c. 1971].
 Drafts of parts of *Lanark* [c. 1971]. (3 bundles)
 Related correspondence. (BAILLIE's) 775032

About the Contributors

S.J. BOYD is a lecturer in the Department of English, University of St Andrews, where he directs the M. Phil. in Scottish Literature. His books include *The Novels of William Golding* (Second Edition, Harvester Wheatsheaf, 1990) and a study of Mary Shelley's *Frankenstein*.

BRUCE CHARLTON is a Lecturer in Anatomy at Glasgow University, as well as a cultural commentator who has written for a variety of publications including *New Scientist* and *The Times Higher Education Supplement*. At Durham University he wrote a thesis on Alasdair Gray; his work has been broadcast on BBC Radio 3; he is presently collaborating with K.C. Calman and R.S. Downie on a book on medical education.

CAIRNS CRAIG is general editor of the recent four-volume *History of Scottish Literature* (Aberdeen University Press) and author of *Out of History* (Polygon, 1992). He lectures in the Department of English Literature, University of Edinburgh.

ROBERT CRAWFORD is Lecturer in Modern Scottish Literature in the Department of English, University of St Andrews. His books include *The Savage and the City in the Work of T.S. Eliot* (Oxford University Press, 1987), *A Scottish Assembly* (Chatto, 1990), *Sharawaggi* (written with W.N. Herbert, Polygon, 1990), and *About Edwin Morgan* (coedited with Hamish Whyte, Edinburgh University Press, 1990).

CHRISTOPHER HARVIE is Professor of British Studies at the University of Tübingen. His books include *Scotland and Nationalism: Scottish Society and Politics 1707–1977* (Allen & Unwin, 1977) and *No Gods And Precious Few Heroes: Scotland 1914–1980* (Arnold, 1981).

DAVID HUTCHISON'S *The Modern Scottish Theatre* (Molendinar, 1977) is the standard work in this little-studied area. A contributor to *The Oxford Companion to the Theatre*, he is Senior Lecturer in Communication Studies at Glasgow College.

EDWIN MORGAN'S *Collected Poems* was published by Carcanet in 1990, as was his *Crossing the Border: Essays on Scottish Literature*. He was formerly a titular Professor of English Literature at Glasgow University and is now Honorary Professor, University College of Wales, Aberystwyth.

THOM NAIRN teaches for Edinburgh University's Centre for Continuing Education, is Managing Editor of *Cencrastus* and Review Editor of *Scottish Literary Journal*. He has just completed a study of Sydney Goodsir Smith.

CORDELIA OLIVER's books include *Joan Eardley, RSA* (Mainstream, 1988) and *It is a Curious Story* (Mainstream, 1987). Trained at the Glasgow School of Art, she has worked as a painter, teacher, writer, and critic for the *Glasgow Herald* and *The Guardian*.

RANDALL STEVENSON lectures in the Department of English Literature, University of Edinburgh. His books include *The British Novel Since the Thirties* (Batsford, 1986). He writes regularly for *The Times Literary Supplement* and several other journals.

ANNE VARTY is Lecturer in English and Drama at Royal Holloway and Bedford New College, London. Her study of Walter Pater is forthcoming from Yale University Press, and she has published various articles on post-Enlightenment Scottish literature.

MARSHALL WALKER is Professor of English at the University of Waikato, New Zealand. As well as various publications on Scottish writing, he is author of *Robert Penn Warren: A Vision Earned* (Paul Harris with Barnes and Noble, 1979) and *The Literature of the United States of America* (Macmillan, 1983, second edition, 1988).

Index

Note: This index does not include references to the final chapter, by Bruce Charlton: Checklists and Unpublished Materials by Alasdair Gray, or to his Chronology which concludes Chapter 1.

c/o McAlpine
2 Marchmont Terrace
Glasgow G12.9LT
13 June 1991

Dear Robert Crawford,

Thank for the photocopies of all the material I had printed in Mr Meikle's magazine archives. I enjoyed re-reading and pondering over them after a 40 year interval. It was good to know that you have known him, too. At present I am writing a story called, <u>Mr Meikle</u> which is a meditation on the connections between education and imagination in Scotland — a celebration (God no! Strike that commercially debased word out) an effort to reflect what is good in teaching, and locate the modern cop-outs from it.

I'm also very glad that most of your essayists in the book have not contacted me, have used their wits on the products, distinct from producer.

One thing occurs to me. I have nearly finished a book for Bloomsbury called <u>Ten Tall Tales</u> (<u>Mr Meikle</u> is in it, for though starting soberly factual it goes dreamy at the end) also a new novel called <u>Poor Creatures</u>, a 19th century historical novel with a 1881 Glasgow setting*. Though undertaken mainly to get money to pay for my work on the anthology of prefaces[1], I think these two books as honestly artful as my others. I say this in case there is time to briefly say so in The Arts of A.G.

* publisher of this not decided yet. It was originally to be among the stories but swole up enormous.
1 oh for a scholarship to let me finish it in peace!

P.S. or Postscription: Please print this letter as an illustration on the final page. I look forward to designing the cover. Sincerely Alasdair Gray. I think you may want it in your introduction: or add to them in your notes?